BRUCE GRENVILLE WITH TIM JOHNSON, KIYOSHI KUSUM

KRA

THE DELIRIOUS WORLD OF ANIM

VANCOUVER ART GALLERY, DOUGLAS & MCINTYRE VANCOUVER/TORON

ETH, ART SPIEGELMAN, TOSHIYA UENO AND WILL WRIGHT

ZY!

COMICS + VIDEO GAMES + ART

ND UNIVERSITY OF CALIFORNIA PRESS BERKELEY/LOS ANGELES/LONDON

FOREWORD

Recent years have seen the emergence of a broad public interest in comics, "graphic novels," animated cartoons, anime, manga and computer/video games. These fields are closely linked, often sharing similar narratives and formal characteristics. The impact of these media can be felt throughout culture and, significantly, within the field of contemporary art production, where their direct and crossover influences are widely recognized.

KRAZY! The Delirious World of Anime + Comics + Video Games + Art brings together, for the first time, these seven media – animated cartoons, anime, manga, comics, "graphic novels," computer/video games and visual art – in a single exhibition to explore their histories, their interrelations and their future trajectories. Despite the pervasive presence of these media, little has been done to document their significance for contemporary visual culture. Past exhibitions have tended to focus on a single medium, providing a detailed but limited perspective. *KRAZY!* fills a void in this field by presenting a survey of these popular modes of production, offering an interdisciplinary account of contemporary visual culture. In bringing together these media we seek to create an opportunity to assess their influence and their collective presence as a sustained cultural force.

The Vancouver Art Gallery is committed to the presentation of visual culture in all its forms. The Gallery's landmark exhibition, *Massive Change: The Future of Global Design*, was conceived and presented in collaboration with Bruce Mau Design and the Institute without Boundaries in 2004. In this exhibition we described a new world of design in which the goals and means of production had radically changed, for the better. We conceived of *KRAZY!* with the same purpose, recognizing the pervasive and expressive presence of visual culture and seeking to build a greater understanding of its values and purposes in our culture.

This exhibition was conceived and developed by Bruce Grenville, Senior Curator at the Vancouver Art Gallery. I thank him and the six co-curators – Tim Johnson, Kiyoshi Kusumi, Seth, Art Spiegelman, Toshiya Ueno and Will Wright – who agreed to assist us in the creation of this challenging project. They have given generously of their precious time and extensive knowledge to guarantee its success. The exhibition's design was envisaged by Atelier Bow-Wow; I thank Yoshiharu Tsukamoto and Momoyo

Kaijima for their remarkable contribution. The production of this project touched all areas of the Gallery, and I thank the staff for their extraordinary efforts. A project of this scale requires significant financial resources; I thank American Express Foundation, the exhibition's presenting sponsor, as well as The Keg Steakhouse and Bar, the exhibition's major sponsor, and I acknowledge the generous support received from the Vancouver Foundation and Gallery Trustee David Aisenstat. This book would not have been possible without the collaboration of Douglas & McIntyre, our long-standing partner in publishing; I thank them for their commitment to this partnership. Many of the works in this exhibition are shown publicly for the first time; I thank the artists, the collectors, the public museums, the private galleries and the companies that loaned works to this exhibition. Finally, I thank the artists, both past and present, who produced these moving and thought-provoking works of art so that we might share their vision and insight.

Kathleen S. Bartels, Director, Vancouver Art Gallery

THE ART OF VISUAL CULTURE

Bruce Grenville

In many ways, *KRAZY! The Delirious World of Anime + Comics + Video Games + Art* was inspired by George Herriman's *Krazy Kat*. The principal characters of that remarkable comic – a cat, a mouse and a dog – are engaged in a constantly shifting relationship that is rooted in a love and a loathing that are as inexplicable as they are reasoned. This strange relationship bears a remarkable similarity to the affiliations one encounters among the diverse fields that are the subject of this exhibition. Comics, "graphic novels," cartoons, anime, manga, video games and art; each seems an entity unto itself, as different as dogs and cats and mice, and yet these diverse genres are inextricably linked together in ways that have come to define the scope and the purpose of their mutual endeavour.

The tendency in most exhibitions to separate the various fields into measured and defined activities seems increasingly restrictive and problematic. An exhibition on video games is woefully limited if it cannot acknowledge techniques shared with other media such as anime and cartoons; in the same way, the subtlety of manga can't be fully understood without seeing it juxtaposed with the subjects and narrative strategies of comics and anime. Within all these fields, tradition and cultural bias have done much to enforce a strict segregation among the various media. But like Krazy Kat, who imagines that the bricks lobbed at her by Ignatz the mouse are a sign of affection, this exhibition has been wilfully conceived to provide an insight into the shared purpose and interdependence of these diverse forms of visual culture.

The field of visual culture may be said to comprise what the French philosopher Jean-Luc Nancy has called an inoperative community, or a community without community. An inoperative community may be described as one that cannot be represented, based as it is in a network of relations that are inescapable and yet resistant to a verifiable and consistent set of actions that would classify it as a group, that could be assigned an ideal form, or designated as a truth. This shouldn't be construed as a derogatory description of the visual culture community; on the contrary, the inoperative community exists outside the constraints of normative communities, which tend to be finite, bound, obligated, indebted and rule bound. At its best, the community

George Herriman **Krazy Kat**

of visual culture producers maintains an affinity of purpose without the constraints of hierarchical organization, clearly defined identities and practices, or sanctioned subjects. Those producers who are truly members of this inoperative community move across old boundaries with an ease and clarity of purpose that signals the emergence of a new model of cultural production.

KRAZY!

This book and the exhibition that it accompanies were conceived as a survey of visual culture, the first of its kind to provide a much-needed opportunity to examine the changing nature of visual culture and explore its links to mass media and the traditional visual arts. One could imagine several other configurations that might include different media – film and video, illustrated books, magazines, zines, fashion, design, etc. – or some subset of this group, but it is increasingly clear that comics, manga, anime, cartoons, video games and art are among the most popular and innovative media in the field of visual culture.

The artists and works in the exhibition were selected by a small group of co-curators, some working in collaboration, others working independently. This configuration mirrors the nature of the field, where some media share a close relationship, with common techniques, characters, narratives, and so on, while others are more distant relations. Each curator was invited on the strength of his unique knowledge of his particular field. Where possible, we favoured practitioners, artists and cultural producers who are highly regarded for their work in the medium. It was also important that the curators had a strong historical knowledge that could guide them when choosing work for the exhibition. Will Wright, for example, is among the best-known computer and video game designers of his generation. His games – *SimCity*, *The Sims* and the forthcoming *Spore* – have done much to shape the field of contemporary game design. Significantly, he has also conceived and shaped each of his games as a critical response to other game designs of the past thirty years. It was this type of forward thinking allied to a strong historical consciousness that made Will Wright an ideal curatorial contributor for the computer and video games section.

All the co-curators were given some specific constraints. Each was asked to select seven or eight artists who had made a significant contribution to their field through a particular work or body of work. To give the overall selection some historical context, we recommended that they include one or two of their precursors in the field,

three or more artists who had established the genre, and a couple more who were leading the way to the future of the medium. The co-curators were also encouraged to consider artists from anywhere in the world. This was obviously a daunting task, and so we reminded the co-curators that they were chosen for their individual vision; their selection would naturally be subjective, and more interesting for it. The curators' task was made even more challenging by the fact that each was asked to include one of his own works in the exhibition (this was doubly true for Will Wright when I proposed that not just one but two of his games – *The Sims* and *Spore* – be presented; he reluctantly, but kindly, conceded to this request).

Each co-curator responded to the task differently. Tim Johnson, who selected the animated cartoons, took the proposed criteria as a reasonable template and selected works that ranged from one of the first feature-length animated films (Lotte Reiniger's *The Adventures of Prince Achmed*, 1926), through the classic Disney (and non-Disney) cartoons of the 1940s and 1950s and the independent animated cartoons of the 1980s, to the cutting-edge computer cartoons of the present day. His selection is erudite and creative and provides an insight into a wide range of production strategies, stylistic genres, narrative themes and the interrelation between cartoons and other media such as live-action film, theatre, literature, music and visual art.

Toshiya Ueno and Kiyoshi Kusumi, who co-curated the manga and anime sections, considered a wide range of options and chose to omit many of the well-known "precursors" in the fields of manga and anime, focusing instead on Japanese artists and their work from the late 1980s onwards. Citing Nietzsche's concept of "eternal recurrence," Ueno proposed that the work of the precursors or "gods" of manga and anime, such as Osamu Tezuka, Hayao Miyazaki and Yoshiharu Tsuge, would already be present in the work of the current generation and that it was only necessary to acknowledge that presence and not to focus on that well-known earlier work. This decision, while excluding the work of several widely acknowledged masters, nonetheless opened the door to a broader group of contemporary artists. There can be little doubt that many of the artists they have chosen will become precursors in their own right to the next generations of anime and manga creators. It is also important to note that Ueno and Kusumi chose two specialists in the field of anime – Ichiro Itano and Yoko Kanno – rather than focusing uniquely on film directors. The selection of these two specialist artists highlights the fact that much of the chosen work relies on the efforts of a large team of creative individuals who come together to produce the final work.

Initial conversations with Art Spiegelman, whom we invited to co-curate the section on "graphic novels," were largely focused on his questioning of the appropriateness

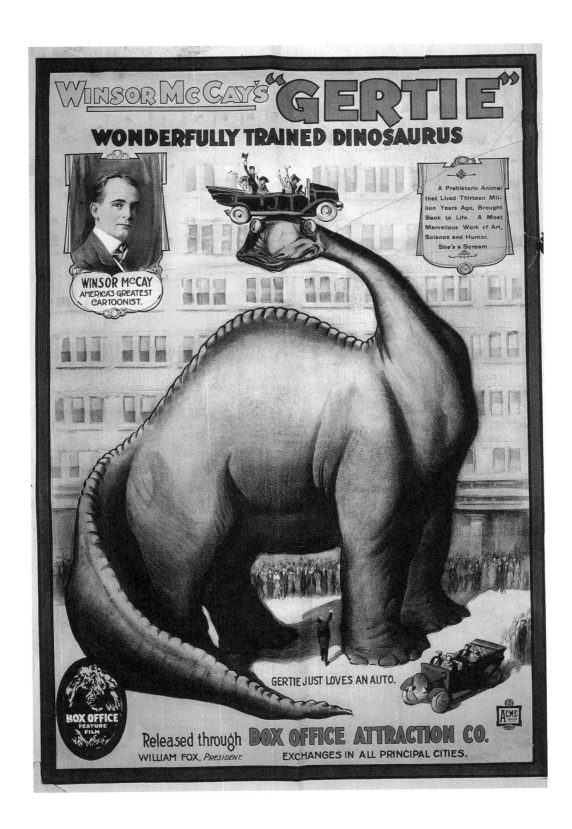

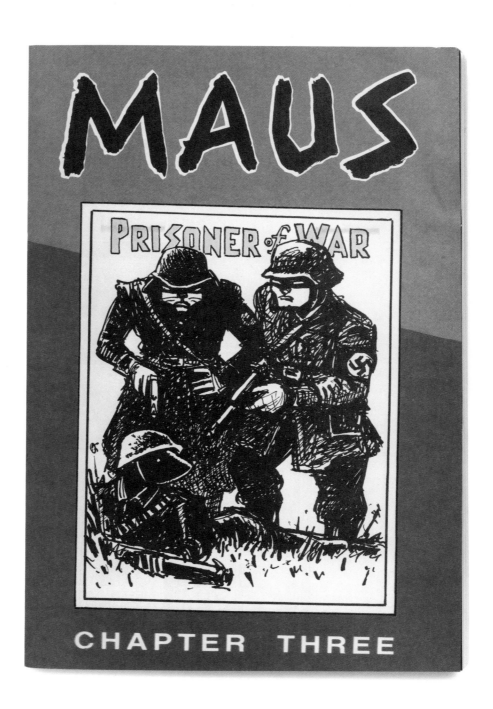

CHAPTER THREE

of that term. Coming from the artist whose book *Maus* has been largely responsible for the current revival of interest in the form, this had all the hallmarks of an interesting discussion. "The early-nineteenth-century Swiss artist Rodolphe Töpffer is arguably," said Spiegelman, "the first maker of that thing that might be called the 'graphic novel,' a novel in pictures, a sequential story that takes place over a series of eighty or so pages. His influence throughout the nineteenth and twentieth centuries is such that there is no doubt that we recognize in his work the form of the 'graphic novel' today. But even in our brief discussions around this exhibition it is clear that whenever we talk about any of these long works we're constantly referring back to artists who worked short. The truth is that each comic has its own formal problems to solve, and some of those problems require twenty pages, forty pages or a hundred pages, and others need only eight pages or one page. What we are really talking about is an expressive approach to narrative that can either be more visual, more writerly, or some combination, rendered in as many expressions as there are skilled artists."

In the end, Spiegelman and the well-known comic artist Seth proposed that they collaborate in choosing the work for two closely related sections of the exhibition, which they suggested calling, *Comics: The Long and Short of It*. They contended that the fields of long-form and short-form comics were, for the most part, an inseparable continuum and that artists and works that might logically be assigned to one field could easily be argued for in the other. The term "graphic novel," they asserted, was now so widely applied that it had become a catch-all phrase to describe everything from collected volumes of comic books to literary works published in graphic form. In the end they finally conceded to using the section titles Comics and "Graphic Novels" but provocatively decided that the latter should only be used in quotation marks so as to acknowledge its contested state.

For my own section on the visual arts, I chose artists whose work marked a fundamental shift in the traditional relationship between visual art and visual culture. In the early 1960s a handful of pop artists, notably Andy Warhol, Roy Lichtenstein and Claes Oldenburg, looked to popular comics as an image source for their painting and sculpture. Their appropriation was intentionally transgressive; both the subject matter and its mass media sources were strategically inappropriate subjects and therefore perfect fodder for their art. This tactical appropriation, widely regarded at the time as daring and hip, was, for the most part, a re-articulation of the high/low debate that had dogged visual culture since the onset of mass media. The notion that certain subjects, media and techniques are appropriate either for high art or low art, but not for both, has a long and illustrious history, and the pop artists of the 1960s

were really no different from the Dada and Surrealist artists of the early twentieth century in their willingness to exploit our cultural expectations regarding the appropriate uses of high and low culture.

But even as the pop artists' appropriation of comic book imagery and media unintentionally confirmed the status quo, it also set in motion a steady and progressive flattening of that same hierarchy, to the point, in the past twenty or thirty years, where visual culture, including the traditional visual arts, is best described as a field of production, with points of intersection and points of divergence. At the points of intersection we see shared modes of production, output and distribution, such as computer-generated imaging, digital printing and digital video, as well as shared subjects, narrative structures, compositional techniques, even characters and plots. The blurring of the line between video games and animated cartoons is a result of the fact that they not only share the same production media, narratives and artistic vision, but also share many of the same artists who move easily from one medium to the other and back again. Anime and manga have a long and productive history of integration, with notable artists such as Katsuhiro Otomo and Osamu Tezuka moving seamlessly between the two.

More importantly, as co-curators Kiyoshi Kusumi and Toshiya Ueno suggest, a younger generation of manga and anime artists intentionally work across a wide variety of fields – manga, anime, visual art, illustration, music, and so on – in order to give the most appropriate form and meaning to their subjects. Even in the world of comics – which is one the most self-contained media in this survey, occupying a corner of the field where it rarely intersects with others – a fundamental and marked shift is occurring, not only because artists are turning to computers and new media to eliminate repetitive tasks but also because the field is opening up, as Seth and Spiegelman note when discussing the work of Philip Guston, Jerry Moriarty, Shaun Tan and others, to whatever techniques, styles and modes of expression are necessary to convey the artists' ideas.

For contemporary artists such as Marcel Broodthaers, Raymond Pettibon, Chiho Aoshima, Mr. and Christian Marclay, the traditional distinctions between high and low culture are largely irrelevant. Their primary concern is to present their subjects through the most engaging medium they can employ. In most instances their subjects and their chosen media are inextricably linked, so that one could be said to manifest the other. Pierre Huyghe and Philippe Parreno's multimedia installation *No Ghost Just a Shell* is a fine example of this. This distributed project incorporates contributions from a surprising range of people, including filmmakers, video artists,

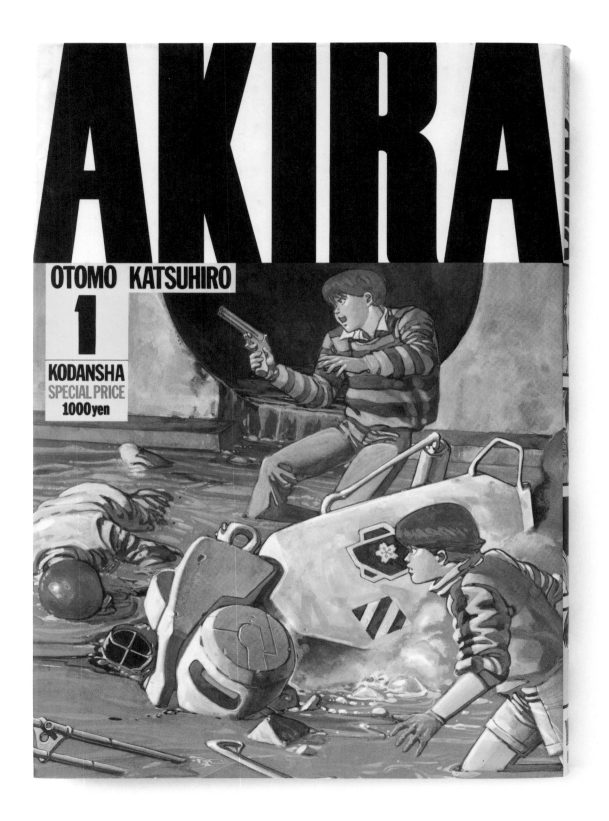

painters, sculptors, conceptual artists, animation artists, graphic designers, writers, musicians, curators, even a lawyer. The subject – a manga character named AnnLee who is ultimately released from her identity as a representation – can only be fully explored by the diverse media the artists use to bring her into being. The artists could be called a community without community, a self-organizing micro-group that has come together to realize a particular aspect of the project but is not bound by any overarching set of rules of production or subject to a hierarchy of organization. The relationship of these artists and cultural producers to the character of AnnLee and to each other might best be described using Jean-Luc Nancy's term "being-with"; it is not defined by race, class, gender, sexuality or modes of production, but rather by a shared ethical response to the circumstances that have brought them together.

Now, more than ever, visual culture is on the cusp of a major transformation. The various sub-fields have significant and individuated identities, some aspects of which have been highlighted in this exhibition, but there are many others that have been left out. For visual culture to evolve into a community without community it will be necessary to acknowledge and support the new network of relationships that it offers. These are relationships that are formed across categories, relationships that resist isolation and specialization and are not bound only by the concerns of the market or the accumulation of capital. This exhibition is not a story of convergence, of a movement towards a new unified æsthetics, a common point of view or a synergistic combination of media and methodology that will result in a new and as yet unimagined practice sharing resources and efficiencies. On the contrary, it is a call to resist convergence, to instead form a community in which we can recognize the value and necessity of being-with those whose presence and practice forces us to consider the ethics of our actions. While it is a long stretch back, it is worth recalling that George Herriman, Krazy Kat and the denizens of Coconino County were not simply enacting a morality play with sharply defined characters that represented the absolute forces of right and wrong. Instead, Herriman gave us a constantly shifting set of relations, a community that never settles – in essence, a community without community.

SETH AND ART SPIEGELMAN

COMICS

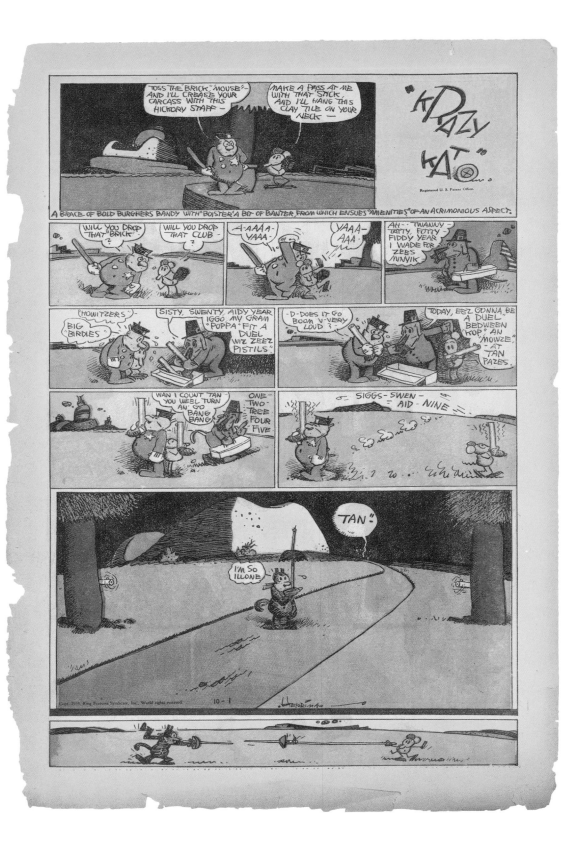

GEORGE HERRIMAN

Krazy Kat 1913–1944

George Herriman's *Krazy Kat* comics come from the tradition of the daily comic strip, in which the artist has to work within certain given constraints to produce 350 or 360 variations per year. It is a remarkably odd and idiosyncratic achievement to have produced thirty years' worth of art built around a cat-mouse-dog love triangle. It actually sounds more like a task that might be imposed on you in Hell — to have to come up with a variation on this theme, week by week, year after year. And yet, Herriman used these constraints to create an epic poem. The fact that he was able to make each page and each daily strip into a graphically and narratively coherent poem is one of the reasons that all conversations about comics end up, at some point or another, invoking the work of George Herriman, an artist working from the earliest part of the twentieth century.

Herriman's *Krazy Kat* is pure cartooning. It's an art form that can't exist anywhere else, that can't be applied, understood or responded to in any other way or in any other context than that of the daily comic strip. With all its vivacity, slapstick and sublimely quiet moments intact and interwoven, *Krazy Kat* is a pure expression of what cartooning is about. We expect a gag, and it's delivered, and yet it is everything else that's going on that makes this something more than just mass media product.

In the field of short-form comics you'd be hard pressed to find a work that is more quintessentially its own universe of the page. Even though the pages all relate to each other, each page of Herriman is really best read on its own. It doesn't feel right, for example, to read *Krazy Kat* in big collected editions. Instead, every page is a perfectly cohesive little universe. The fact that he used the same formula repeatedly, always returning to the throwing of the misunderstood brick, shows how every page relates to the others. And there's something about the perfection of each of the variations wrung out of that formula that's so beautiful and so perfect that reading a bunch of them in succession almost feels wrong. No wonder people have studied his work for so many decades.

Seth and Art Spiegelman

(excerpted from a conversation with Bruce Grenville, November 8, 2007)

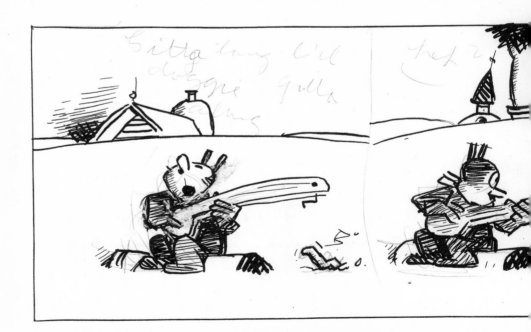

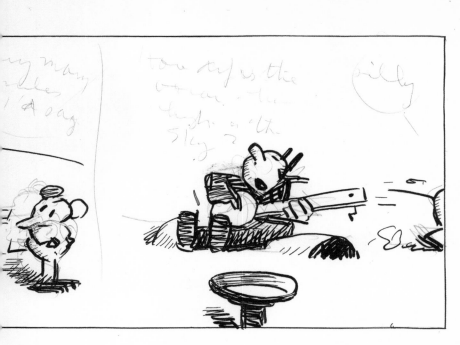

ELEVEN

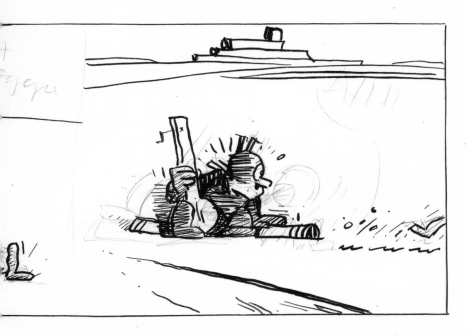

TWELVE.

HARVEY KURTZMAN

Corpse on the Imjin 1952

The Organization Man in the Grey Flannel Executive Suite 1959

It's odd that we're not including any of Harvey Kurtzman's one-pagers in this discussion, but when you talk about short-form comics, it is worth remembering that Kurtzman's *Hey Look!* pages are a paradigm of the kind of visual concision that one can get from a small unit of comics. Kurtzman was an original thinker who was able to synthesize what came before him in the history of his medium and give it back as a highly concise, codified kind of storytelling. In *Corpse on the Imjin*, in six pages he presents an intimate moment in the Korean War, using the most abstract means to tell a fully realized story, a humanistic tale that stands in sharp opposition to the jingoistic war stories of the time. Comics never had the equivalent of a D.W. Griffith, who gave you all the grammar you needed to tell a story in film. But Kurtzman was a really significant figure in showing the way towards using comics language to tell complex stories.

As a writer-editor of comics as well as someone who drew comics, Kurtzman's devotion to research has had effects that are still being felt today – for example, in the work of Alison Bechdel and Chester Brown. And I suspect that his "editor's brain," always trying to make things as taut and concise as possible, was there before he was even an editor. He brought that quality to the idioms he worked in, which resulted in work that is so clearly his, even when it's being illustrated by somebody else – because the comic is built on beats and rhythms. He sits there tweaking it to perfection.

There is a visual dynamism in Kurtzman's artwork that is integral to the design. What appears to be extraneous line work or brushwork has a visual, directional quality that leads you through each page. Everything is carefully placed, with significant consideration for geometry and design. That's also true of the more quirkily drawn comics in *The Jungle Book* such as *The Organization Man in the Grey Flannel Executive Suite*, pages where he's specifically trying to find a unique calligraphy, something different from the carved brush lines that he uses in his war stories. And the drawing itself, just the way the figures are constructed – this is vital, exciting, pure cartooning.

Seth and Art Spiegelman

(excerpted from a conversation with Bruce Grenville, November 8, 2007)

IT IS A DARK DAY IN MAY! LIGHTNING FLICKERS IN THE SOUTH KOREAN HILLS, AND A STORM WIND ROARS OVER THE IMJIN RIVER! OUT IN THE MIDDLE OF THE RAIN SWOLLEN IMJIN, A LONELY CORPSE FLOATS WITH THE RUBBLE DOWN TO THE SEA! FOR THIS IS WHAT OUR STORY IS ABOUT! A...

CORPSE ON THE IMJIN!

BUT MANY THINGS FLOAT ON THE IMJIN! DRIFTWOOD, AMMUNITION BOXES, RATION CASES, SHELL TUBES!

...WE IGNORE THE FLOATING RUBBLE! WHY THEN, DO WE FASTEN OUR EYES ON A LIFELESS CORPSE?

...THOUGH WE SOMETIMES FORGET IT, LIFE *IS* PRECIOUS, AND DEATH IS UGLY AND *NEVER* PASSES UNNOTICED!

YOU SEE HIM OUT OF THE
CORNER OF YOUR EYE AND YOU
KICK OUT WITH BOTH YOUR FEET!

YOU KICK CLU
BECAUSE THA
DO TO GET

Harvey Kurtzman **Corpse on the Imjin**

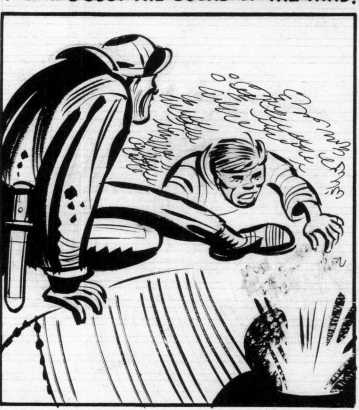

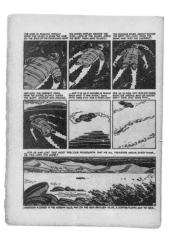

Detail of final drawing (top, ill. 18) and published pages (bottom, ill. 19) from *Two-Fisted Tales #25*,
Corpse on the Imjin material reproduced with permission of William M. Gaines, Agent, Inc.

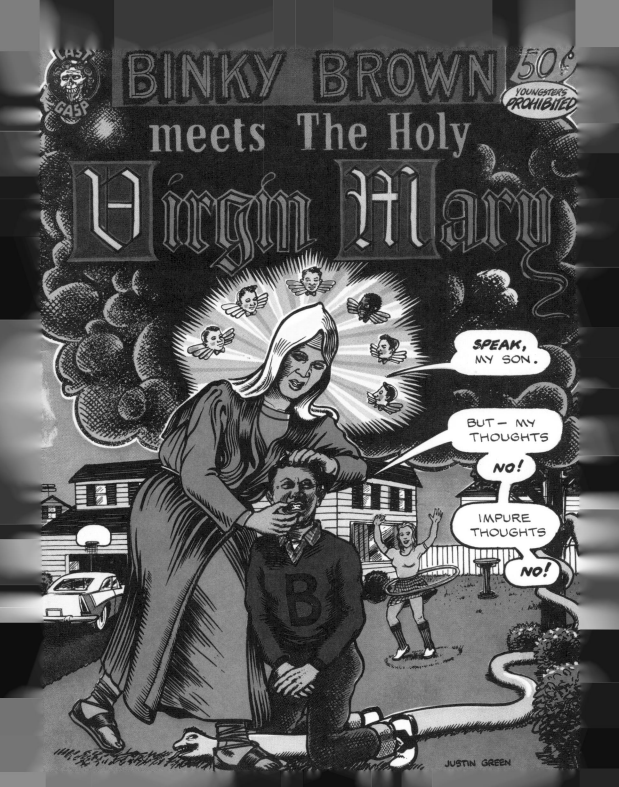

JUSTIN GREEN

Binky Brown Meets the Holy Virgin Mary 1972

Justin Green's *Binky Brown Meets the Holy Virgin Mary* (1972) is seminal to any under-standing of what are now called "graphic novels." It opened the door, for what appears to be the first time, to confessional autobiography as a central element of the comic story. Other artists – such as Jules Feiffer and Charles Schulz – had dealt with personal material before, but it was always disguised or indirect. Although Green has given credit to Robert Crumb for the first moment of confessional autobiography, Crumb insists it starts with Green. *Binky Brown* was an amazing breakthrough, the first use of comics, an inherently personal medium, for expressing the blatantly and frighteningly per-sonal. At times one even feels too close to the experience, and in this sense it echoes Philip Roth's *Portnoy's Complaint* as a radical reworking of what can be said in a book.

Binky Brown was conceived and published as a single comic book – one of the longest underground comics one could read at the time, and certainly one of the most ambitious in scope. The inventiveness of the storytelling makes it feel longer than its forty-one pages. Each and every page is a meditation on the best means or technique to express one aspect of the story. There is a tremendous breadth of vocabulary – from diagrams that feel like textbook illustrations of the inside of a brain to painful slapstick sequences – applied with great craft, even though at first glance the artwork appears to be oddly clumsy. Green's inspiration was certainly not the slick superhero comics that were around when he was a kid; he seemed more attracted to the clumsy composition and graphic language of the ads in those comics, as well as awkward drawings and medieval prints. And yet everything is handled with care – the vanish-ing points are carefully worked out in each perspective, and the lettering is done with a precision that hints at the fact that he made his living as a sign painter. And it's all applied towards such a quirky, obsessively personal end, which allowed Green to do something every great cartoonist must do: reinvent comics.

Seth and Art Spiegelman

(excerpted from conversations with Bruce Grenville, February 25/26 and November 8, 2007)

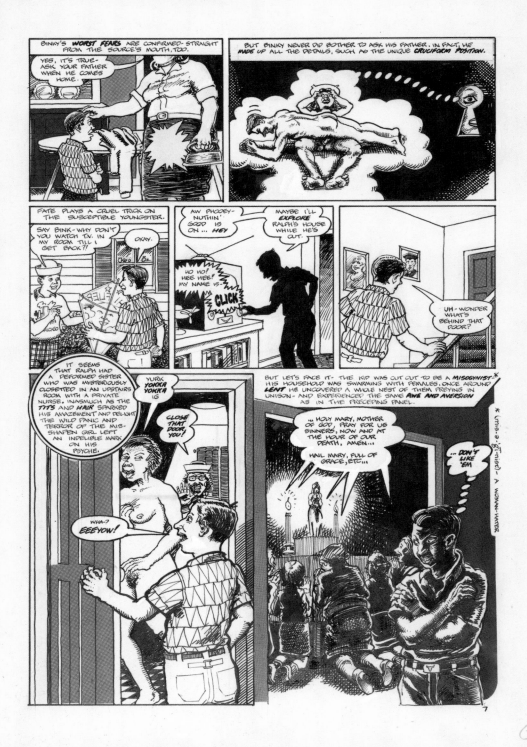

Justin Green **Binky Brown Meets the Holy Virgin Mary**

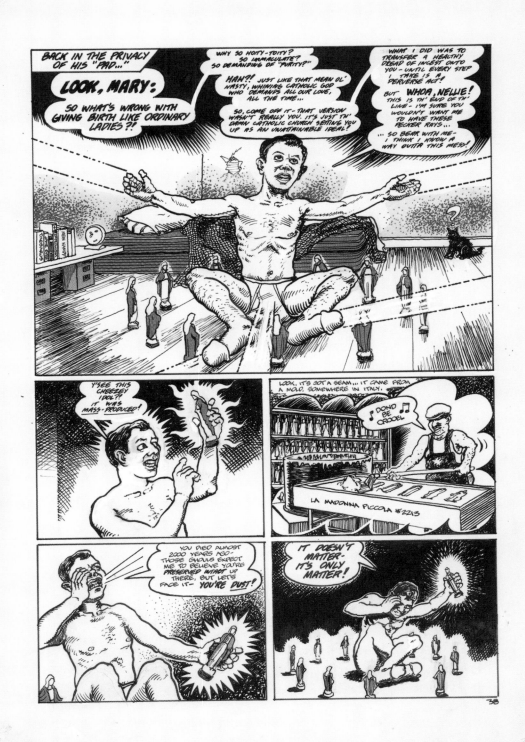

Final drawings (ill. 21 and 22)

JERRY MORIARTY

Jack Survives 1980-1984
Sally's Surprise 2007-2008
The Complete Jack Survives 2007-2008

Jerry Moriarty describes himself as a "paintoonist," a cartoonist who creates one-page works from a compositional set of interests more commonly associated with painting. One can see that the *Jack Survives* pages are built very slowly with the hint of an interest in, say, the compositional ideas of Edward Hopper. At the same time he's totally enamoured of Ernie Bushmiller's *Nancy* comics and the simplicity, or the deceptive simplicity and clarity, of their storytelling. That collision makes for pages that are unique.

Moriarty drew each panel of *Jack Survives* many times over. First he made a Flair pen sketch; then he copied that sketch in pencil on Arches paper and inked it with black ink, making changes with white acrylic paint and re-inking where necessary. In each of the drawings you see hints of the earlier drafts, the memory of its earlier state, because Jerry doesn't totally white out what's underneath. The process of drawing is very much like remembering; just as you go back over a memory again and again until it becomes like a clarified narrative, so too has each one of these images been refined through thinking and rethinking.

On the surface the work has a mundane quality to it. This could be a boring little tale of a man losing his wallet down a street grate, but there's a wealth of profundities just under the surface. Every strip feels as though it's about something much bigger. Life, death, loneliness: all these subjects feel present as Jack falls asleep on the couch or fails to answer the phone. They're remarkable existential strips. They feel like gag strips, but no gag is delivered. In a lot of ways they feel like Charles Schulz's *Peanuts*, except that the childhood loneliness of *Peanuts* is replaced with a darker, middle-aged confusion and despair. It's as though you're looking into someone's confused memories. They feel absurd and dreamlike.

The most recent works, *Sally's Surprise*, are in a direct line of thought from the *Jack Survives* pages. Whereas in *Jack*, Moriarty was thinking about his father, now he's thinking about his childhood self. Sometimes he draws himself as a late-middle-aged kid, other times as a barely pubescent young girl in his childhood haunts. These are remarkably potent works, charged with a real physical energy.

Seth and Art Spiegelman

(excerpted from conversations with Bruce Grenville, February 25/26 and November 8, 2007)

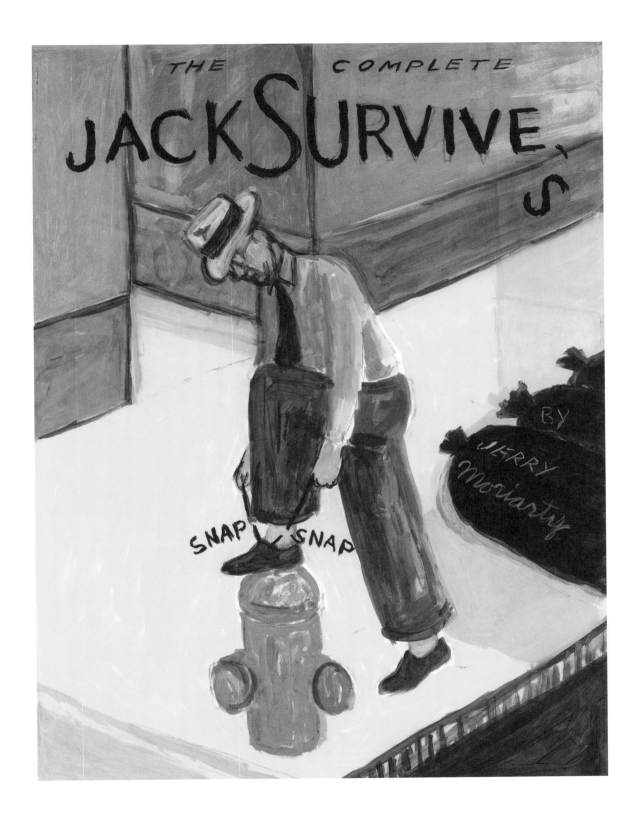

Final drawing for the cover of *The Complete Jack Survives* (ill. 23)

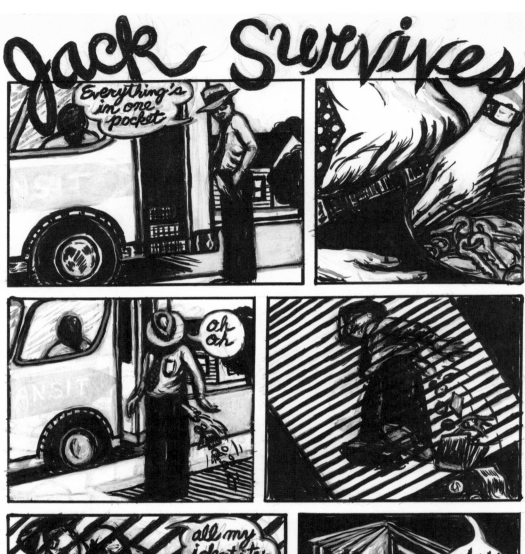
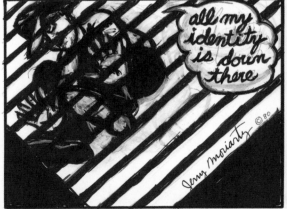
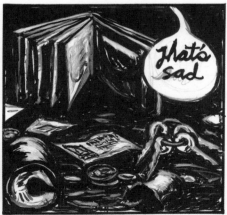

Jerry Moriarty **Jack Survives**

JACK SURVIVES

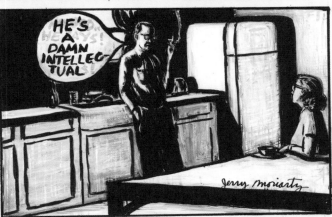

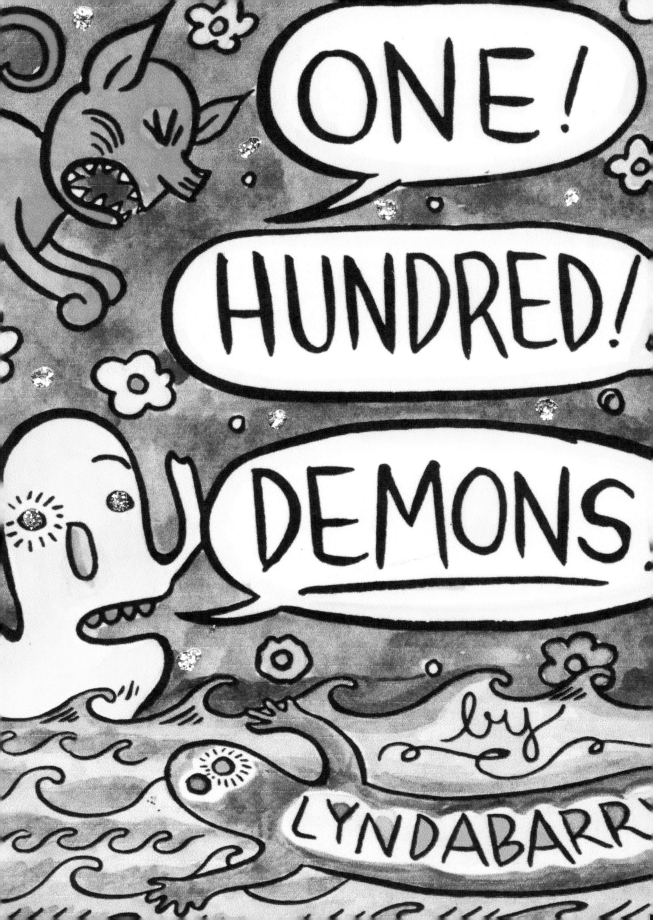

LYNDA BARRY

One Hundred Demons 2000–2002

Lynda Barry's work is about memories and their emotional resonance. It's full of all the rich materials of childhood, steeped in sentiment but free of any sweet or sappy sentimentality. She's one of the most emotional cartoonists working today. Her characters are always in the thick of the confusion of growing up. They are struggling to explain what's going on inside them, although they haven't yet reached the stage where they can understand it. As readers, we are aware of the sad disparity between her characters' sensitive inner selves and their inability to communicate this to the harsh world around them. They are simply not yet sophisticated enough to make things turn out any better. There's something about the way she constructs her comic pages that reminds one of an architectural dollhouse built to contain a memory. More than any other visual storyteller, the cartoonist constructs an imaginary world, built entirely out of memory. Alison Bechdel, Jerry Moriarty and Lynda Barry offer wildly different forms of this, but their work is all a reconstruction of a memory.

In some of her comics it sometimes seems as though the text is going to take over the frame. But Barry inevitably manages to unite text and image in such a way that, while they may appear to be in conflict, they are always working together. One comments on the other rather than repeating it, or acts as an illustration. Even when half the panel is text and the drawing appears to be squeezed underneath, you still sense that both are essential to the story; it never feels as though the characters have been squashed by someone who's not thinking about them – there's always a good dynamic between the two. The word "text" is deceptive here because the words are written in the same free-scrawl style as the drawings. Memories and observations are fabricated out of the same stuff, whether they are formed into written language or pictorial language.

Seth and Art Spiegelman
(excerpted from a conversation with Bruce Grenville, November 8, 2007)

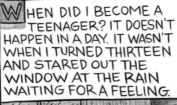
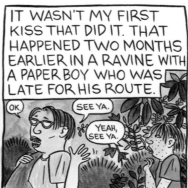

Lynda Barry **One Hundred Demons**

I WASN'T ALONE IN MY KNOW-
LEDGE. NEARLY EVERY KID IN
MY NEIGHBORHOOD KNEW TOO
MUCH TOO SOON. SOME PEO-
PLE CALL IT "GROWING UP TOO
FAST" BUT ACTUALLY IT MADE
SOME OF US UNABLE TO GROW
UP AT ALL.

HE WANTS TO GET
TOGETHER TOMORROW.

HE SAYS HE KNOWS
A BETTER PLACE.

MORE
"COMFORTABLE"

WHAT AM I GOING
TO DO?

I CRINGE WHEN PEOPLE TALK
ABOUT THE RESILIENCY OF
CHILDREN. IT'S A HOPE ADULTS
HAVE ABOUT THE NATURE OF
A CHILD'S INNER LIFE, THAT IT'S
SIMPLE, THAT WHAT CAN BE
FORGOTTEN CAN NO LONGER
AFFECT US. BUT WHAT IS FOR-
GETTING?

66
97

4
R4

I LIKED THE PAPER BOY A LOT.
HE WASN'T FROM MY NEIGHBOR-
HOOD. HE DIDN'T KNOW MUCH
ABOUT ME. WE HAD A MATH
CLASS TOGETHER AT MY
JUNIOR HIGH SCHOOL. WE
WERE NEW TO EACH OTHER.
THAT'S ONE WAY OF FORGETTING.

PSST. HEY. THAT GUY
IN MATH. HE LIKES
YOU, DOESN'T HE?

I GUESS.

SUPPOSED TO
BE A USER.

A USER?

USES GIRLS.

THERE WAS A GIRL IN MY
HOME EC CLASS WHO WAS
NEW TO ME TOO. I LIKED HER
RIGHT AWAY ALTHOUGH SHE
TOLD ME THINGS THAT FREAKED
ME. DETAILED THINGS SHE'D
DONE WITH BOYS. SHE WAS
TWELVE, JUST LIKE ME.

SEWING
CLASS
PROJECT:
REVERSIBLE
TOTE
BAGS

IT'S NOT THAT BIG
A DEAL, REALLY,
TO ME IT'S
NOT. HOW
'BOUT YOU?

YOU
EXPERIENCED
YET?

UH...

5
R5

67
99

CHRIS WARE

Building Stories 2002–
Thanksgiving 2006

Every page of Chris Ware's work, whether it is a long-form or a short-form comic, is built from well-realized fractals. This couldn't be clearer than in *Building Stories* (2005), where every page is a complete story, but together the pages form a thoroughly realized matrix. The best example of Ware's ability to deploy his incredible graphic skills to build a page are the four distinct Thanksgiving covers that he produced for *The New Yorker*. Each offers a fascinating insight into the way he unfolds and opens up the facets of an idea. If you think of comics as palimpsests of past and present, that sensibility is very clearly presented in the four different Thanksgiving covers and fully realized in what may be the richest and most complex single pages of comics ever made: a 256-panel grid that can't simply be read from left to right or top to bottom but radiates out from a central photograph of a dead soldier. That one-pager is as formally rigorous as one could ever hope for, and yet it packs a powerful emotional punch. Surprisingly, this page was first published only on *The New Yorker* website and is only recently available as a printed page published by Drawn and Quarterly.

One might point out the diametric distance from Milt Gross to Chris Ware. It is possible to admire and acknowledge both ends of the spectrum. But the kind of expressive doodles that are critical to Milt Gross's comics have been ironed out of Ware's work so that a rigid formality shapes the surface, allowing the emotional statements to come through in a very restrained way. He doesn't smother you with spittle as he tells you his woes. Another way of looking at this is to say that while Jerry Moriarty's work is suffused with his personal gestures, Ware's work is depersonalized in order to let you get at something personal through another door.

Both Chris Ware and George Herriman draw on their personal lives without making them the fodder for their work, and both use the cartoon language to produce highly personal art. They both have created remarkably real cartoon worlds that only exist at the end of a brush. This is cartooning in its purest form, the creation of a cartoon language that is infused with the actual sensibility of the artist's life and experience in the world right now.

Seth and Art Spiegelman

(excerpted from a conversation with Bruce Grenville, November 8, 2007)

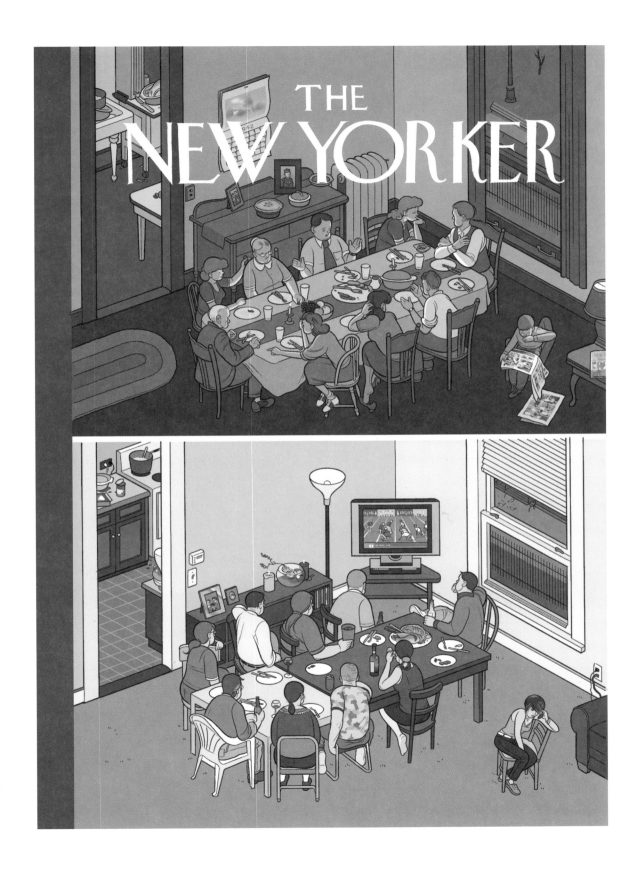

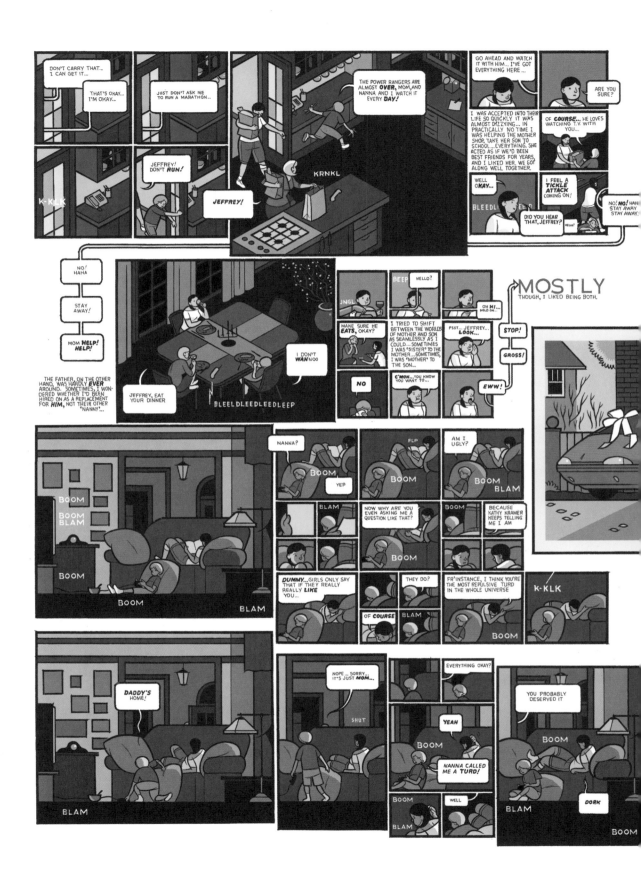

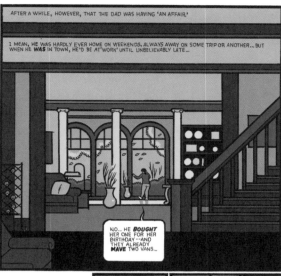

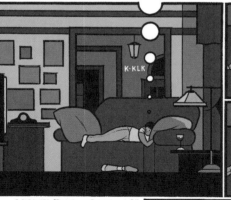
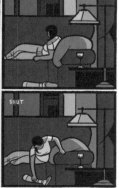

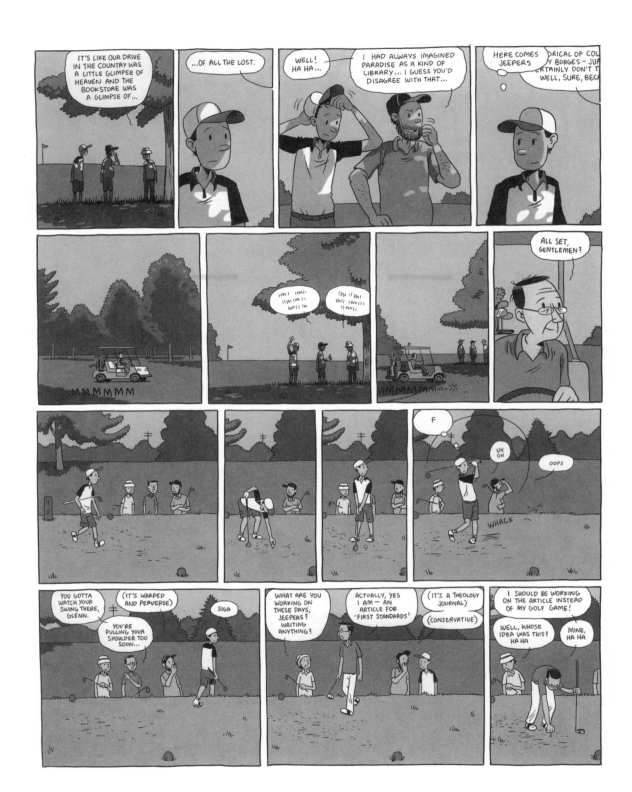

KEVIN HUIZENGA

Jeepers Jacobs 2004

Kevin Huizenga can really capture the workings of the human mind in everyday life. His characters feel as if they're alive at this time and place in human history. When you read his work, you feel as though you're conversing with a very bright friend, and when you get to the end there is always some insight that had not been evident before. To do this, Huizenga focuses on small, measured moments. His work isn't measured or considered the way Alison Bechdel's work is, although it too has a slow, thoughtful quality to it; it's not quite as crystalline in structure, with more cartooning verve.

Huizenga's work feels mysterious, as if there is an inexplicable distance between him and his subject. One doesn't apprehend or assume this distance right away, but it helps maintain a kind of mysteriousness that draws you in. It isn't the icy distance of Dan Clowes or the godlike view of Chester Brown. Instead, it's a form of introspection, which at times becomes so intense that it takes the form of a third-person narrative. This allows for an unexpected objectivity in what is otherwise a very subjective narrative.

Huizenga's drawing style offers an interesting visual counterpoint to the content of his story. He seems to have adopted E.C. Segar's old, ham-fisted style — made famous in his *Popeye* comics of the 1930s — and applied it to a wildly inappropriate new content, although without the exaggeration and the frantic action. There is a stillness reminiscent of the clear line drawing Hergé used in *Tintin*. This is one of the interesting things you see in cartooning today, this willingness to acknowledge the history of comic production while shaping it to an individual need. Whomever you talk about, from Jerry Moriarty to Kim Deitch, there is a willingness to stretch the net out, to pull in a variety of influences and not worry if the juxtapositions are appropriate. This produces some very interesting comics, and Huizenga's are among the smartest.

Seth and Art Spiegelman

(excerpted from a conversation with Bruce Grenville, November 8, 2007)

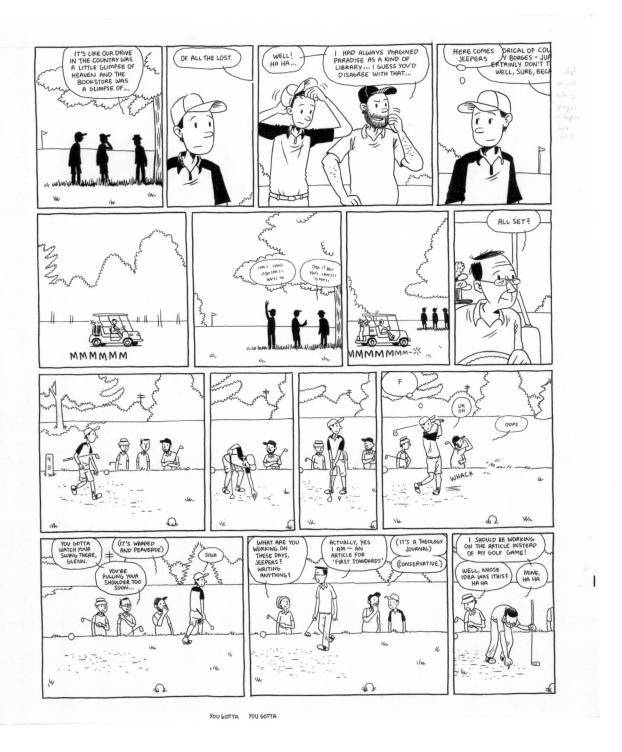

Sketchbook page (ill. 34) and final drawing (ill. 35)

SETH

George Sprott (1894-1975) 2006-2007

I was invited by the *New York Times* to produce a strip for their Sunday magazine, and *George Sprott* was one of the three or four ideas I'd had floating around in the back of my head for quite a while. I had been thinking about the local television station that I'd watched as a child, and there was a character much like George who had a travel show. In my mind he represented a certain kind of old-fashioned masculine figure that just doesn't seem to exist in the world today, at least not quite in the same way. There's something in their self-interest and self-importance that makes this type of character both humorous and kind of pitiable, and that struck me as an interesting subject, to try and get inside of a character like that.

Thinking about the overall composition of the strip, I decided to use a method I'd developed a year earlier in *Wimbledon Green* (2005), where I created a lot of shorter strips that were interconnected. The more I work on comics, the more I realize it's the gaps between the stories that make for interesting narrative. And I knew that by putting together these twenty-five slices of his life, it would somehow build into a bigger picture of George than I could have created if I'd had used one continuous narrative. Comics are a series of drawings separated by time. Every panel is disconnected from the others, even in a sequence of a person walking down the street. It's not like animation. Much of the effort in structuring a story is deciding how much time you want to lapse between those images.

I'm very interested in the objects in people's lives, in the characters' lives. It's important to me when I'm working on a story to know the place the characters are in; it says so much about them. In *George Sprott: Chapter 13* I realized that the easiest way to achieve this was through a large establishing shot in the middle panel showing the room where George lived. I knew that if I put the small objects in a sequence below it, your eye would locate them in the big drawing, follow them around the room, and give you a clear sense of what his life was about. I wanted that simple feeling of moving from that full room, a complete life, to an empty room, to remind us how quickly life passes and how quickly everyone forgets.

Seth

(excerpted from a conversation with Bruce Grenville, November 9, 2007)

GEORGE SPROTT
(1894 – 1975) *by SETH*

AN INTERVIEW WITH HADRIAN DINGLE HOTEL MANAGER, 1995

THE RADIO HOTEL OPENED IN 1925. THE NAME WAS MEANT TO SOUND ULTRA-MODERN--FUTURISTIC EVEN.

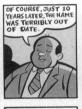

OF COURSE, JUST 10 YEARS LATER, THE NAME WAS TERRIBLY OUT OF DATE.

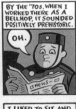

BY THE '70s, WHEN I WORKED THERE AS A BELLHOP, IT SOUNDED POSITIVELY PREHISTORIC. OH.

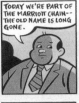

TODAY WE'RE PART OF THE MARRIOTT CHAIN-- THE OLD NAME IS LONG GONE.

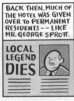

BACK THEN, MUCH OF THE HOTEL WAS GIVEN OVER TO PERMANENT RESIDENTS -- LIKE MR. GEORGE SPROTT.

LOCAL LEGEND DIES

HE MOVED HERE IN 1965. HE HAD THREE ROOMS UP ON THE TOP FLOOR. POOR GEORGE.

I GUESS AFTER HIS WIFE DIED, HE JUST FOUND IT EASIER TO LIVE IN A HOTEL.

I WAS HIS FAVORITE. WHENEVER HE WANTED SOMETHING HE CALLED ON ME.

AT NIGHT HE'D SEND FOR A BOTTLE OF RYE, AND WHEN I BROUGHT IT HE'D POUR ME A DRINK. TOP FLOOR, ED.

I LIKED TO SIT AND TALK WITH HIM. HE WAS A NICE OLD BIRD.

ONCE I CAME UP TO SEE HIM AND HE WAS VERY CONFUSED--DIDN'T KNOW WHO HE WAS.

SCARED THE HELL OUT OF ME. JUST A SPELL, I GUESS.

IT HAPPENED ONLY THE ONE TIME. 407 SPROTT

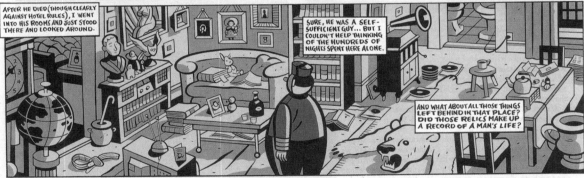

AFTER HE DIED (THOUGH CLEARLY AGAINST HOTEL RULES), I WENT INTO HIS ROOMS AND JUST STOOD THERE AND LOOKED AROUND.

SURE, HE WAS A SELF-SUFFICIENT GUY... BUT I COULDN'T HELP THINKING OF THE HUNDREDS OF NIGHTS SPENT HERE ALONE.

AND WHAT ABOUT ALL THOSE THINGS LEFT BEHIND IN THAT PLACE? DID THOSE RELICS MAKE UP A RECORD OF A MAN'S LIFE?

WALDENCOD LIVER OIL APPRECIATION SPROTT HAPPY BIRTHDAY UNCLE

FLEENS TRUSS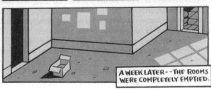

A WEEK LATER--THE ROOMS WERE COMPLETELY EMPTIED.

27

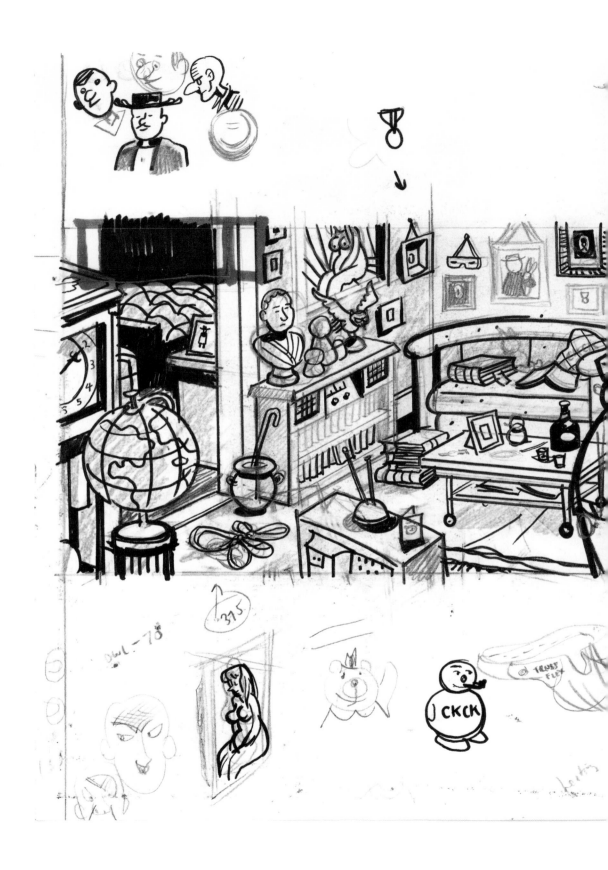

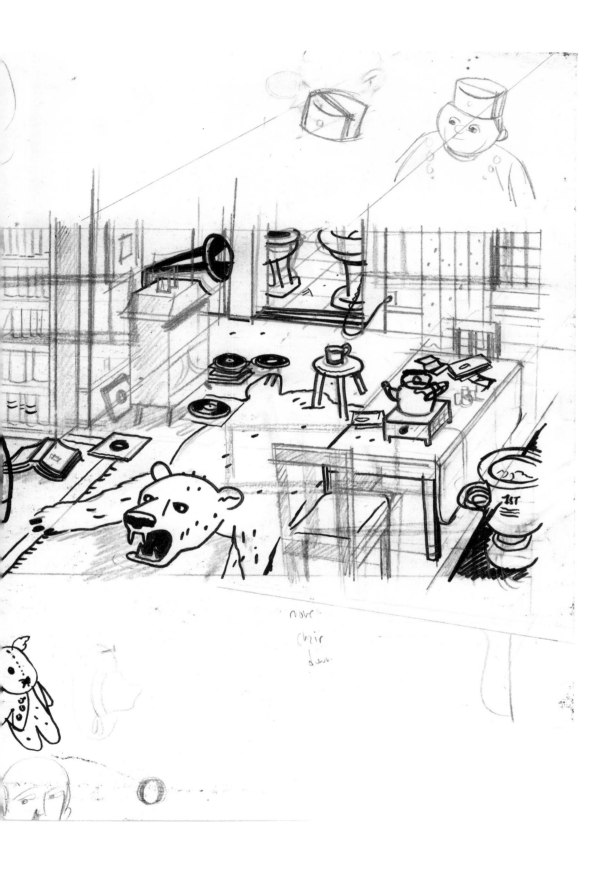

Rough production drawing for Chapter 13 (ill. 37)

ART SPIEGELMAN AND SETH

"GRAPHIC NOVELS"

MILT GROSS

He Done Her Wrong: The Great American Novel
and Not a Word in It – No Music, Too 1930

Milt Gross began work on *He Done Her Wrong* (1930) shortly after working with Charlie Chaplin as a screenwriter for his 1928 silent film *The Circus*. Gross was already a successful comic strip artist and columnist, as well as a lyric clown whose fractured Yiddish dialect humour had won him deserved fame, and this work was a kind of magnum opus, a book-length parody of the then-popular genre of woodcut novels, novels inspired by silent film and told only in pictures by people like Frans Masereel, Lynd Ward and Otto Nückel. Gross took the woodcut novel and pushed it beyond Expressionism and Social Realism, producing a work that is both a parody of that form and a contribution to the formation of the "graphic novel." It's smart and it's cynical, and it's stood the test of time incredibly well.

The chapter "No Help Wanted" gives you a wonderful sense of Gross's ability to parody the form and resist the woodcut novel's tendency towards melodrama. The woman – her husband has been tricked by the story's villain into running out on her – is looking for a job so that she can feed her family. She goes from office to office, interviewed by increasingly senior managers, the company president and finally the board of directors, only to appear on the final page scrubbing the lobby floors of the office building. That sequence is created through a strange repetition in which the narrative constantly builds to an anticlimax, from moody, melodramatic panels to slapstick action and back again.

From the opening pages it is clear that this is the work of a cartoonist, as opposed to one of the graphic artists whose woodcut novels he was parodying. Gross skillfully breaks up the action on the pages, establishing a riotous rhythm of storytelling. He plays with the dramatic composition of each page, giving you a lyrical full-page image followed by three small figures doodled across the next page. Gross was a master of humorous body language; he could draw "funny" better than anyone – his work has a physical, slapstick quality that basically defines the kind of funny drawing cartoonists have come to be known for.

Art Spiegelman and Seth

(excerpted from conversations with Bruce Grenville, February 25/26 and November 8, 2007)

PHILIP GUSTON

Poor Richard 1971

Poor Richard wasn't published in Guston's lifetime, although it dates from the time of his self-imposed exile to Woodstock, a period in which he reinvented himself as an artist surrounded by writers and poets rather than Abstract Expressionist painters. His friend and neighbour, Philip Roth, was in "hiding" in the wake of the public response to his book *Portnoy's Complaint*, and they both sat around agonizing about Nixon and his politics.

Guston's *Poor Richard* (1971) represents the cutting edge of what could happen in comics/"graphic novels" at this moment, now that they have demonstrated how sophisticated they can be in tackling narratives more traditionally associated with prose. It's the graphic aspect that has a chance to flower. Guston is an important figure in recognizing the implicit narrative possibilities of using a gestural cartoon language informed by an artist's eye or, in his case, a painter's eye.

For Guston, the drawings are drawings first, discovering what they can be as drawings, as opposed to the kind of sign system required when one puts these marks to use in a more traditional comic way. In other words, where Milt Gross had to draw the same figure over and over, with slight compositional shifts to establish the movement from one moment to the next, Guston had other concerns. He was conjuring up a world, a world that was at least partly informed by George Herriman but without having to worry about picking up the brick and then throwing it. Guston's work isn't sequential – it's panoramic. It gives you a world by offering you different scenes that together produce a kind of narrative. As one starts exploring the drawing, one gets more and more into those pathetic, loathsome lumps that are Nixon and Agnew. As much anger as there is in the drawing, there's also a strange kind of tenderness. The result is a rather sophisticated peeling away of the news headlines to get at the pathetic human condition.

Art Spiegelman and Seth

(*excerpted from conversations with Bruce Grenville, February 25/26 and November 8, 2007*)

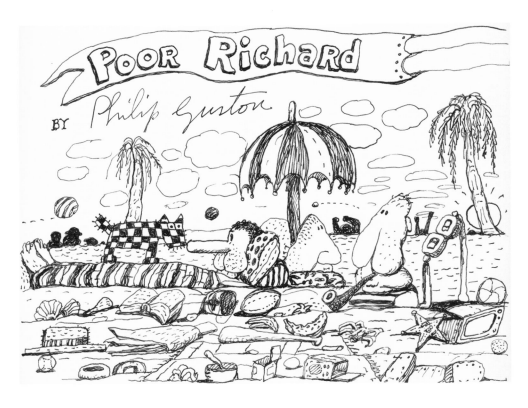

ART SPIEGELMAN

Maus 1972-1991

Don't Get Around Much Anymore 1973

Portrait of the Artist as a Young %@&!* 2005-2007

Maus (1972) was a breakthrough for me; after making comics for at least twelve years, I'd found a voice I could call my own. This three-page version was the seed of the later, longer work. It was a highly compressed narrative, dealing with an aspect of my past that I wanted to turn into a strip and approaching a subject – the Holocaust – that hadn't yet received much attention in the culture at large, let alone in comics. The drawing style was certainly informed by the underground comics I had drawn prior to that, but compared with my peers in San Francisco, it was more restrained and sober.

From that point on, every strip I made was drawn in a different way from the one before it. Each one was a rethinking of the problem of making comics. *Don't Get Around Much Anymore* (1973) took months to make because it was a compression of lots of different ideas – currents that were flowing through me. Stylistically it was a direct outgrowth from an immersion in Cubism. Until that time I'd avoided looking at painting – it was for snobs, for a different cultural class than the one I came out of. The notion that one could break up space as an aspect of moving through time was quite fresh to me, and the idea that the words and pictures could unhinge from each other was also important.

For me, style is an aspect of content. Certain moods are best expressed with certain kinds of marks, certain kinds of coloration, certain kinds of figure structuring. Style is the central motor that pushes the work forward. One strip may need to be drawn in the style of German Expressionism, another needs the inflection of pulp, and another needs to be as sober and quiet as possible, without much personal expression, as in *Don't Get Around Much Anymore*. With *Portrait of the Artist as a Young %@&*!* (2005-2007) I was linking the style to memory; one memory collage is butted up against another, because that's how memory works. It's very different from the notion of style as a trademark – it's the idea of style as inflection.

Art Spiegelman

(*excerpted from a conversation with Bruce Grenville, November 11, 2007*)

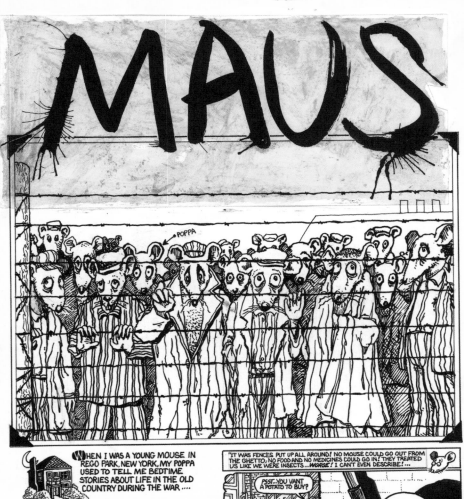

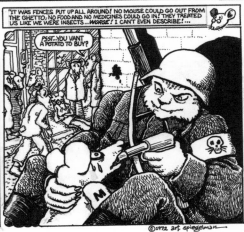

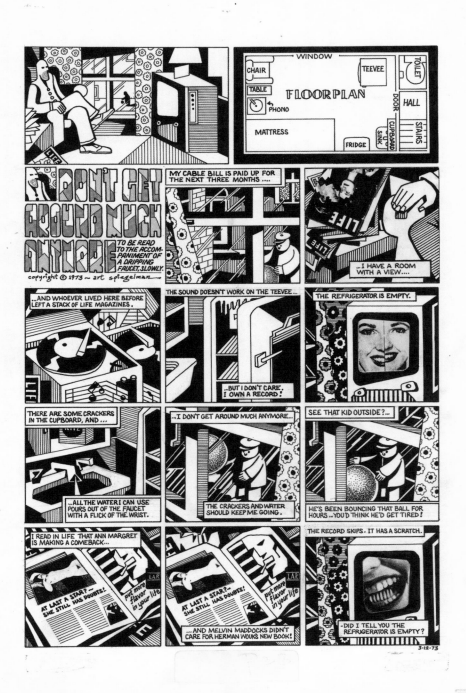

Final drawing for *Don't Get Around Much Anymore* (ill. 46) and published page
from *Breakdowns: Portrait of the Artist as a Young %@&*!* (ill. 47)

KIM DEITCH

Boulevard of Broken Dreams 1991–2002

Boulevard of Broken Dreams first came out in 1991 in *RAW* magazine and was only forty-two pages long; it was later expanded to 192 pages and published by Pantheon Books. All of Deitch's stories have a strong narrative pull; once you enter, the labyrinthine quality of the work pulls you in, tighter and tighter, and eventually you realize that almost everything he's done for over four decades is actually one extended story. It is as if he has created his own Faulknerian county where things that don't seem to belong in the world become the subject of the story and are cemented in place. His idea of narrative is built on an interest in nineteenth-century serial fiction, early-twentieth-century silent films, vaudeville theatre and early animated cartoons. It's an idiosyncratic cocktail that shows that when an artist of talent follows his own interests and trusts the reader to come along, he can build a fascinating world that's endlessly interesting. Kim Deitch's world is built on popular culture but without any of the pop smirking that's become common in recent decades. One of the exciting qualities is the joy of discovery offered in each new story. There is a real pleasure in seeing new layers being added to old work, some of which goes back decades, and in realizing that those stories are all interconnected in a real and compelling manner.

In preparation for a work Deitch does a number of elaborate preliminary drawings, but many of these drawings never get anywhere near the final story. Like the character sheets you'd see in an animation studio, these scenes are not part of the story but rather are aids to help Deitch understand the character's life. These sketches are evidence that what he is really doing is plotting out a world rather than just a story. When Kim Deitch is looking into that world and drawing it on the page, he is not seeing a cartoon world. It's a world that exists fully in his head, and he's drawing everything there as if he were looking at it.

Art Spiegelman and Seth

(excerpted from conversations with Bruce Grenville, February 25/26 and November 8, 2007)

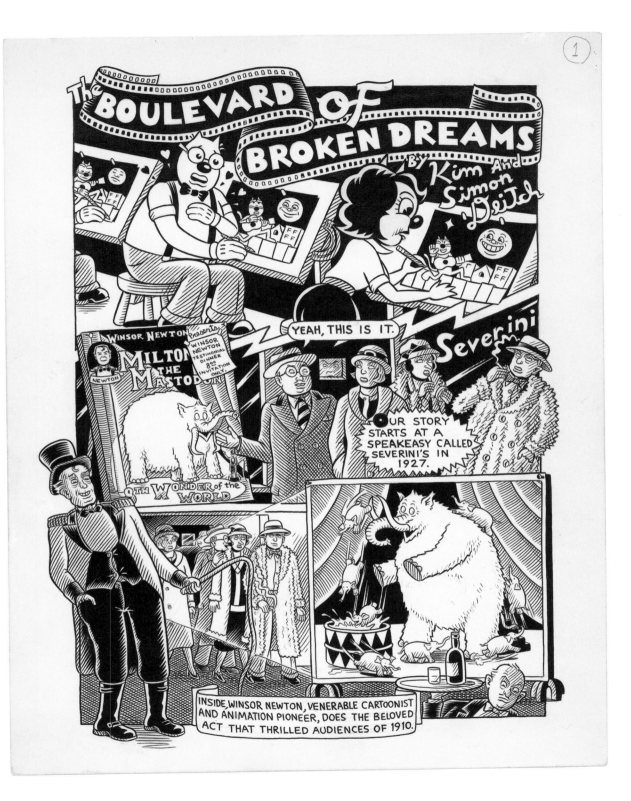

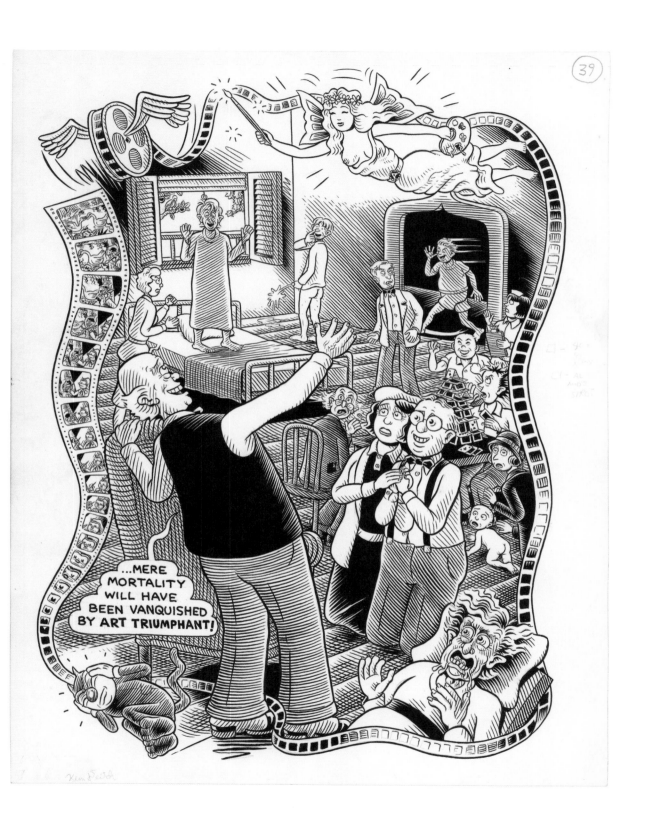

Pencil sketches (ill. 49 and 50) and final drawing (ill. 51)

DANIEL CLOWES

David Boring 1998–2000

Daniel Clowes is a great visual artist, but it's his complex storytelling skills that make him a really great cartoonist. His rich and layered fictional worlds are perfect examples of where the comic narrative has gone in the late twentieth century. Clowes is a fiction writer who has a strong understanding of narrative structure and writes characters well. *David Boring* (2000) is a tightly ordered story that works on a variety of levels and is extremely well thought out. Clowes is a world builder but not in the same way as Kim Deitch, because the worlds he's building are self-contained, and each serves the particular purposes of the narratives he's working on.

Daniel Clowes is a writer in the comics sense of the word: he uses pictures to tell a story. In some ways, Clowes's work might be seen as a continuation, in a more sophisticated way, of, say, that of Will Eisner and the '40s comic artists who looked to film for ways to build visual stories. In the same way that Eisner and his generation leaned on Orson Welles, Clowes really understands the kind of storytelling that takes place in the films of the last twenty to thirty years.

David Boring is a good example of Clowes's interest in genre. It clearly comes out of a strange blend of the personal and the impersonal, taking an impersonal, *film noir* approach and then mixing it with an intimate, memoir-type structure that is really quite poignant. But even though it is presented as memoir, one feels that one is outside the character looking in; this makes the work more cinematic, as opposed to the kind of intimacy that you often get when you read prose about somebody's interior life. You're always looking into Dan Clowes's world, but you can't inhabit the characters. Clowes once had a subtitle on one of his "letters" pages that read, "Maintaining an Icy Distance between Artist and Reader," which is very funny but also really explains how he operates. You can feel him as the artist behind the scenes, but you don't feel as though he's on the page personally, in the way that Robert Crumb is, for example. It's a very tightly controlled universe he's creating.

Art Spiegelman and Seth

(excerpted from conversations with Bruce Grenville, February 25/26 and November 8, 2007)

DAVID BO

I'M DAVID, YOUR EPONYMOUS NARRATOR. DAVID JUPITER BORING, THE FIRST. MY FATHER WAS A CARTOONIST (NOT THE GUY WHO DREW S------N IN THE 1950'S). I WAS BORN ON THE 6TH OF MAY IN 1978 AT 9:10 PM.

IT IS NOW FEBRUARY THE 24TH, 1998, 2:40 AM. SINCE MOVING TO TH CITY I'VE HAD SEX WITH SIX DIFFERENT WOMEN. PRIOR TO THAT, NOTHING.

ANY LUCK?

I SUPPOSE SO...

IS THAT A YES?

TECHNICALLY, YES.

HOW ROMANTIC.

2.

HAVEN'T YOU GOT THAT MEMORIZED?

I HAVEN'T LOOKED AT THIS IN **AGES**! ...YOU REALLY ARE SUCH A REPULSIVE PERVERT, DAVID...

I'M TRYING TO FIGURE OUT WHICH ONE IS YOUR FAVORITE...

HIS IS DOT. WE LIVE RE TOGETHER. SHE'S UGHLY MY AGE. SHE'S OKING AT THE SECRET RAPBOOK COMPILED BY UR NARRATOR IN HIS UTH.

IS IT HER?

NOPE...

THIS ONE.

REALLY? BUT IT'S ONLY A DRAWING...

ARE YOU BEING SERIOUS?

Final drawing (ill. 53)

CHESTER BROWN

Louis Riel: A Comic Strip Biography 1999–2003

Like many artists, Chester Brown has a polemical point of view when he's telling a story. But in the story of *Louis Riel* (2003) he's not trying to force the polemic into the narrative or leave it lying right on the surface. He places a certain distance between himself and the subject matter. Things are generally set at a medium shot, a distance that makes you feel as if you are watching from the outside. Brown places himself in the work as sort of an omniscient godlike figure that's looking down on these cartoon characters, on their world, and allowing us to peer in. Brown's work doesn't have that emotional connection to the characters, and that's likely quite calculated. The scenes may be emotional, but you don't feel the characters as emotionally alive. It's a "hands-off" kind of narrative style that demands readers plug in their own feelings. It's unique; I can't think of another cartoonist whose work is so deliberately distant.

Brown's figures have a monumental quality as if they were carved out of stone. They're like Inuit sculptures placed onto an empty landscape. He uses a very straightforward, rhythmic approach to compose each page, utilizing panels of the exact same size. I think he's trying his level best to avoid any kind of real, emotional manipulation, which is the exact opposite, for example, of what Harold Gray was doing in *Little Orphan Annie*, in which every word, every line, was intended manipulate your feelings. Gray's manipulation was surprisingly effective at making you care about these rather stiff, melodramatic characters. *Louis Riel* moves you in the opposite direction. It is as if he is trying to deploy Gray's toolbox to a very different ideological end.

Interestingly, the extensive endnotes in *Louis Riel* remind us that Chester has a personal stake, and a political point that he's making, in the story. He doesn't want that point to be completely lost, but he doesn't want to drill into you either. It's actually quite subtle. You really have to sit down and think about it.

Art Spiegelman and Seth

(excerpted from a conversation with Bruce Grenville, November 8, 2007)

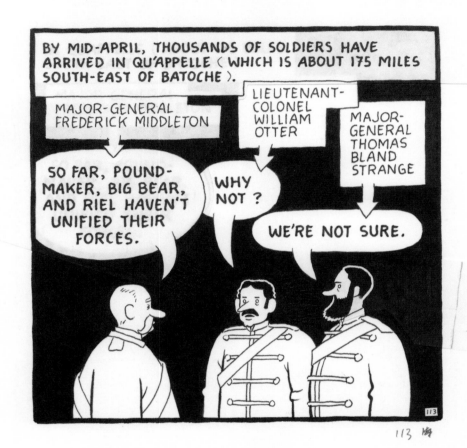

IN A SIMILAR KIND OF LANGUAGE FAILURE, IN THE LOCAL DIALECT THE BULLPEN WAS SAID TO BE SITUATED SIMPLY "OUT ON THE MOUNTAIN," THAT IS, ON THE PLATEAU. IN THE PRIMEVAL WILDERNESS BEYOND THE FRONT, SPECIFICITY IS ABANDONED.

AND HURTLING TOWARD NEW YORK CITY ON ROUTE 80, SPEED AND PAVEMENT ERASED NOT JUST THE NAMES OF THINGS, BUT THE PARTICULAR, INTIMATE CONTOURS OF THE LANDSCAPE ITSELF.

IN THE END, ALTHOUGH THE ANONYMITY OF A CITY MIGHT HAVE SAVED MY FATHER'S LIFE, I CAN'T REALLY IMAGINE HIM ANYWHERE BUT BEECH CREEK.

LISTENING TO THE MUSEUM-TOUR TAPE, I'M SURPRISED BY HIS THICK PENNSYLVANIA ACCENT. DESPITE THE REFINED SUBJECT MATTER, HE SOUNDS BUMPKINISH.

IN THE BACK DISPLAY ROOM IS A FINE, CHERRY HEPPLEWHITE CORNER CUPBOARD OF ABOUT 1790. THIS WAS DONATED BY THE KLECKNER FAMILY OF SUGAR VALLEY. ON THE WALL ARE KITCHEN TOOLS USED BY EARLY FARM FAMILIES IN THE NINETEENTH CENTURY.

144

ALISON BECHDEL

Fun Home: A Family Tragicomic 2006

Alison Bechdel's work has found a large audience by insisting on the literary and novel-istic qualities of the "graphic novel." It is an interesting indication of where comics are now, especially if you think of their hundred-year history. Not to imply that earlier comics weren't great art, but the fact that a book like Bechdel's, so literary in content, could be so widely accepted – and not simply because of its cartoonish qualities or ironic stance – shows that the goals of cartoonists have changed dramatically.

Memoir and autobiography have become a significant part of what's happening. *Fun Home* (2006) is both a coming-of-age story and a coming-out story, and at heart it's an intergenerational story, which is an ongoing subject for "graphic novels." Her father is presented as a rather prissy martinet, uncomfortably precise in his choice of antiques and furniture. He loves literature, and this allows the book to be peppered with quo-tations and allusions to many of the high works of Modernism. They are intelligently placed and used, because they flow naturally from the character of the well-read father.

Bechdel's style is different from the gestural, helter-skelter compositions and characters of Milt Gross or Kim Deitch, or the staid quality of the work of Chester Brown or Dan Clowes. There's a deep emotional reserve. Each page has been cut down and analyzed in detail, gone over and over again to try and create certain effects or rhythms or to capture something specific. This flows from Bechdel's work process: she takes pictures of almost every single thing she draws; she has an incredible amount of notes and family photos and whatever else is available. It all feels so carefully located – you know you're walking through real rooms; every bit of furniture has been plotted out, every pose is studied, so that she's really restaging her life in order to understand it. There is urgency in her obsessive reconstruction of these tragic scenes of loss. It really comes down to the details. She's remembered or reconstructed the minutest details of her relationship with her father, so much so that it produces a kind of airlessness. It's overwhelming, but this is what she was trying to achieve – the airlessness is the suffocating quality of being with this particular father.

Art Spiegelman and Seth

(excerpted from conversations with Bruce Grenville, February 25/26 and November 8, 2007)

IN A SIMILAR KIND OF LANGUAGE FAILURE, IN THE LOCAL DIALECT THE BULLPEN WAS SAID TO BE SITUATED SIMPLY "OUT ON THE MOUNTAIN," THAT IS, ON THE PLATEAU. IN THE PRIMEVAL WILDERNESS BEYOND THE FRONT, SPECIFICITY IS ABANDONED.

AND HURTLING TOWARD NEW YORK CITY ON ROUTE 80, SPEED AND PAVEMENT ERASE NOT JUST THE NAMES OF THINGS, BUT THE PARTICULAR, INTIMATE CONTOURS OF THE LANDSCAPE ITSELF.

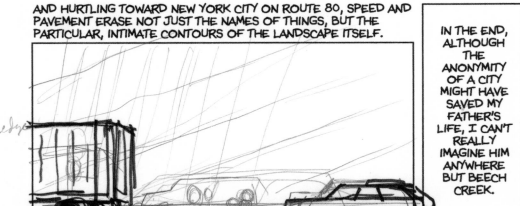

IN THE END, ALTHOUGH THE ANONYMITY OF A CITY MIGHT HAVE SAVED MY FATHER'S LIFE, I CAN'T REALLY IMAGINE HIM ANYWHERE BUT BEECH CREEK.

LISTENING TO THE MUSEUM-TOUR TAPE, I'M SURPRISED BY HIS THICK PENNSYLVANIA ACCENT. DESPITE THE REFINED SUBJECT MATTER, HE SOUNDS BUMPKINISH.

IN THE BACK DISPLAY ROOM IS A FINE, CHERRY HEPPLEWHITE CORNER CUPBOARD OF ABOUT 1790. THIS WAS DONATED BY THE KLECKNER FAMILY OF SUGAR VALLEY. ON THE WALL ARE KITCHEN TOOLS USED BY EARLY FARM FAMILIES IN THE NINETEENTH CENTURY.

SHAUN TAN

The Arrival 2006

Shaun Tan's book offers a new synthesis that doesn't result in anything like what we've been calling the "graphic novel" up to this point. I think we've finally reached a stage in the evolution of the medium where all styles and approaches that mix graphic arts and narrative are open to consideration. In doing so we create a productive confusion, in which readers look at a book such as *The Arrival* (2006) and say, "Wait, that's not exactly a graphic novel because 'graphic novel' is just a more reputable term for comic books, and the drawings are coming from the style of children's books that, say, Chris Van Allsburg used in his *Jumanji* book." And yet the narrative devices used by Tan are easily part of a picture-storytelling tradition that includes but isn't limited to what one thinks of as comics. And if that phrase "graphic novel" means anything it has to embrace these directions as well as the more obvious ones. *The Arrival* has the depth and breadth of a large, alternate-universe memoir, and yet it all takes place in fewer than 130 pages.

And to give Shaun Tan his due, one of the things that works especially well is that one is left disoriented as one works one's way through his picture story. Unlike Milt Gross's *He Done Her Wrong*, which is a book that builds off the expectations of the reader, who had seen lots of movies – silent movies at that time – in *The Arrival* the reader has to grope his or her way through a new world; reading it recapitulates the immigrant experience. It's actually physically built into the way one understands the work.

These glyphs and signs that constitute the new language that the immigrant can't read are also an invitation of sorts, to spend a long time reading the pictures. Good cartoonists know what they're doing when they pick the style they're working in. They know how much and what they're asking of the reader. This is a book that invites one to spend a lot of time looking at the artwork. And that in turn demands a more detailed and rigorous kind of drawing.

Art Spiegelman and Seth

(excerpted from conversations with Bruce Grenville, February 25/26 and November 8, 2007)

Final drawing (ill. 60)

or on the
bed - sit.

First dummy drawing (ill. 61) and final drawing (ill. 62)

TIM JOHNSON

ANIMATED CARTOONS

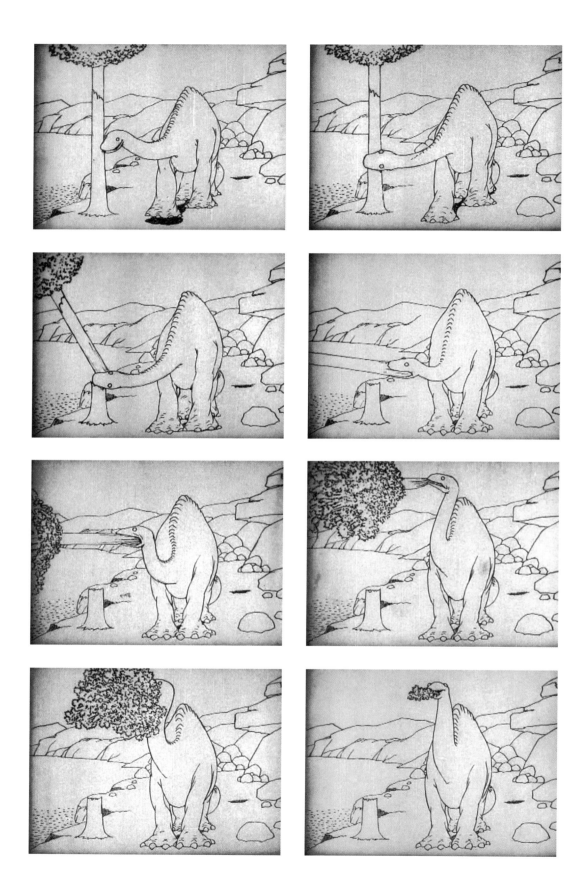

Winsor McCay **Gertie the Dinosaur**

WINSOR McCAY

Gertie the Dinosaur 1914

Gertie the Dinosaur is one of the great artistic leaps of the twentieth century. *Gertie* was the first real animated character, the first thinking character with emotion, pathos and personality. There were lots of drawings that moved, but *Gertie* was the first one that felt like a character, the first one that was capable of putting a smile on the viewer's face.

Gertie the Dinosaur began as part of Winsor McCay's vaudeville act. During his stage show he would project the film and interact with *Gertie*, getting her to bow and eat from his hand. It truly must have been unprecedented to be in the audience during McCay's performance. To see character animation for the first time and to have a man magically interacting with a dinosaur must have been enthralling. Animation is, quite literally, about giving life to something, and through his vaudeville act, McCay made Gertie come alive for the audience.

Winsor McCay did a couple of absolutely seminal things. In picking a dinosaur as his character, he appropriated a popular cultural fantasy and showed the audience what dinosaurs may have really looked like in terms of weight and movement. More than that, he brought a whimsical, believable personality to the screen, which had never been done before. All of the attempts at animation prior to *Gertie* were experiments in a new form of visual art, but they did not approach narrative art. *Gertie* got to the core of what makes animation unique – creating characters with personalities that inspire intense emotional responses from the audience.

McCay's level of draftsmanship and technical mastery were staggering. He drew *Gertie the Dinosaur* by hand and had to invent ways to register the frames. This was before the invention of cel animation, so he had to redraw the background for every frame. His draftsmanship was just daunting; he was capable of doing unbelievable three-dimensional rotations in his drawings that far surpassed anything else being done at the time.

The degree of technical expertise visible in *Gertie the Dinosaur* was unrivalled for a long time. Only when the great Disney animators of the 1930s and 1940s started to get a sense of draftsmanship and solidity in their drawing skills did anyone approach the artistry of Winsor McCay. His ability to create three-dimensional character movement predated everyone else by thirty years.

Tim Johnson

(excerpted from a conversation with Bruce Grenville, March 9, 2007)

Winsor McCay **Gertie the Dinosaur**

310

Production drawing (ill. 64)

LOTTE REINIGER

The Adventures of Prince Achmed 1926

Comenius-Film Production

I remember first seeing Lotte Reiniger's *Prince Achmed* in college on a terrible print. It was almost unwatchable, and yet I was (very nearly) moved to tears by it. This is a gorgeous, sophisticated, unprecedented work that has almost never been seen. I talk to animators all the time who have yet to see it.

Although there may have been a couple of earlier animated films that were more than sixty minutes in length, I don't think it's unfair to say that Reiniger's *Prince Achmed* is the first feature-length animated story. It has so much character, storytelling grace and visual sophistication that in spite of the fact that the technique seems very limited – only silhouettes and sound – you are as emotionally drawn to the story as you are to the most sophisticated contemporary computer-animated works. It's a real testament to the breadth of her vision. It's a very refined piece of narrative, an amalgam of stories from *The Arabian Nights* that is as powerful as any of the live-action feature films being made at that time.

On the technical front, Reiniger offered an unbelievably sophisticated use of hand tinting and multiplane camera. Imagine the effort that went into hand tinting each individual print – dipping each coloured sequence into a bucket of translucent dye, shot by shot sometimes, then cutting and taping them back together. Just look at some of the still frames, the sense of colour, the attention to detail; that is one of the reasons it is so frameworthy. On an animation front, remember each of those figures is hand cut: laced gowns, elaborate hair, architectural filigree, fantastic animals – she even animates the shadows. And she experiments so much – look at the way the sorcerer conjures; you have cloud-like animation that is done with pooled inks and dyes. She even invented, prior to Ub Iwerks at Disney, a sort of multiplane technique to give depth to her images and allow her to change the focus.

Lotte Reiniger proved that animation can be used to tell an extended story, and it's hard to imagine a medium, an artistic medium, more successful – creatively, commercially and emotionally – than feature-length film. She was the first to go where many, many have followed.

Tim Johnson

(excerpted from a conversation with Bruce Grenville, March 9, 2007)

Cut-out silhouette (top, ill. 65) and film stills (bottom, ill. 66) © 2001 Primrose Film Productions, Ltd.

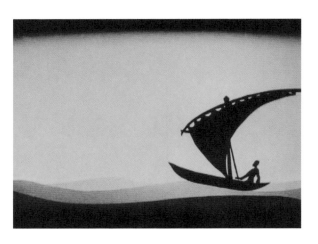

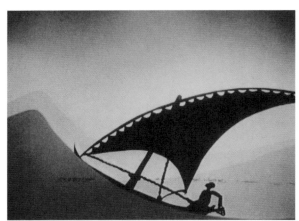

Lotte Reiniger **The Adventures of Prince Achmed**

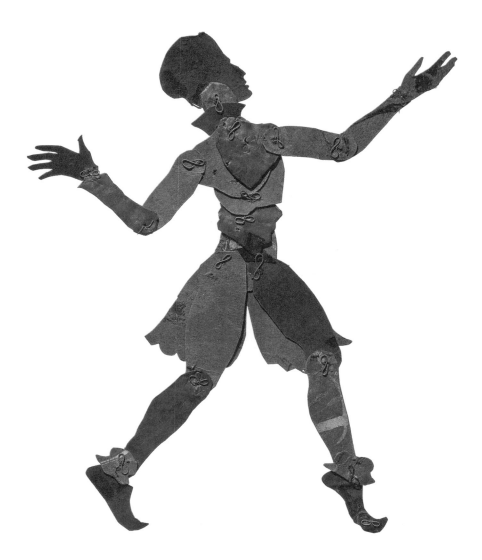

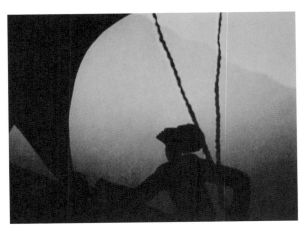

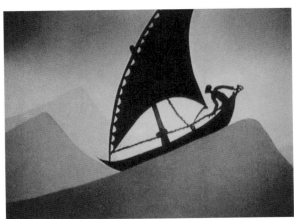

Cut-out silhouettes (top, ill. 67 and 68) and film stills (bottom, ill. 66) © 2001 Primrose Film Productions, Ltd.

BEN SHARPSTEEN

Dumbo 1941
Walt Disney Productions

I would nominate *Dumbo* as the finest animated feature film ever made. It reveals the confidence of a studio that by that time was doing its fourth feature-length animated picture, had done countless shorts, had experimented and probed and found in the art form a level of expression unrivalled by anybody else. There's a confidence in Dumbo's animation that says, "Okay he's going to look like a big, droopy-eared, silly, cute baby – but you are not going to think in that way. Using animation, I am going to treat the character with such respect and seriousness that even the pratfalls, the tripping over his ears, will have heart."

Dumbo is one of the most emotional motion pictures ever made. Bill Tytla, a famous figure in the early years of Disney, animated on *Dumbo* and did some of the most effective emotional acting ever. Because the character is silent, the acting had that extra burden of telling you what was going on inside the character's head. When *Dumbo* is joyous, afraid, scared, nervous – you know instantly. It's one of the only Disney films that used watercolour backgrounds. These are much simpler to paint than oils and, I would argue, more emotional for this kind of film. Watercolour is intimate, it's got texture, it's got saturated colours, and it's more inherently impressionistic than the realism and rigour of oils. *Dumbo*, to me, is all about emotion.

Storytelling is the earliest art because it's the way we communicate our values and what's important to us as a culture, as a family, as parents to our children. And a lot of what stories do is give us ways to overcome and deal with overpowering fears – a child's fear of the dark, fear of the unknown, fear of the boogeyman. I am offended by a film when it's cowardly, when it softens the punches. I am more amazed and impressed by those films – especially films for family audiences, like *The Wizard of Oz*, like *Dumbo* – that are able to guide a young person through his or her terror. Separation from a parent – that is a young child's absolute worst fear. So for Disney to do *Dumbo*, which has peer rejection and separation anxiety at its heart, is a sign of its confidence and maturity as an animation studio. I find its storytelling the most adventurous of any Disney film.

Tim Johnson

(excerpted from a conversation with Bruce Grenville, March 9, 2007)

ROBERT CANNON

Gerald McBoing Boing 1951
United Productions of America

Gerald McBoing Boing unites the talents of two giants of storytelling: the rhyme and story of the renowned Dr. Seuss and the gorgeous animation work of United Productions of America (UPA), a studio started in the mid-1940s. I would even argue that, although it is one of Dr. Seuss's most playful rhymes, this is a story that lives better in a short film than it does on the page, because of the critical role of sound effects.

Gerald McBoing Boing is a great story, but the real reason it's on the list is for its visual style. Every frame in it is gorgeous. And every one is done with economy. The character designs are all very, very simple; there is not a lot of line mileage and very little background painting. A low budget and a tight deadline yielded a style that is fresh, marvellous and heartfelt. They had to think about details like Gerald's mother knitting; they couldn't have her come forward and interact because they just couldn't afford to animate her, so instead she simply cycles in the background. All the focus is on Gerald – he's in constant motion. Father and mother are striking static poses that are great acting and really clear, but Gerald is the one that walks through the world and changes it as he goes, and the world reacts to him. There's a shot in the film that I have always loved. It's nighttime, and Gerald's just run away from home; he's running to get on the train, and he turns into a white-lined character on a black background. It just works.

With *Gerald McBoing Boing*, UPA studios breathed new life into animation, which was becoming rather predictable visually. The visual design of the film is so strong that you can turn the sound off and still understand the story. The palette of colours is sophisticated yet absolutely emotionally accessible. There's real danger in the reds and blacks, and when he's with his family, the film becomes hotter, more aggressive and more saturated, as the young boy's life gets more and more dangerous, more fraught. And then it shifts again at the end to a different palette, when Gerald reports to the studio. It's a marvellous piece of work by Bill Hurtz, who didn't direct or write the film but designed it. His thumbprint is all over it.

Tim Johnson

(excerpted from a conversation with Bruce Grenville, March 9, 2007)

Production cel and background (top, ill. 71) and film stills (bottom, ill. 72).
Courtesy of Columbia Pictures. All Rights Reserved.

Robert Cannon **Gerald McBoing Boing**

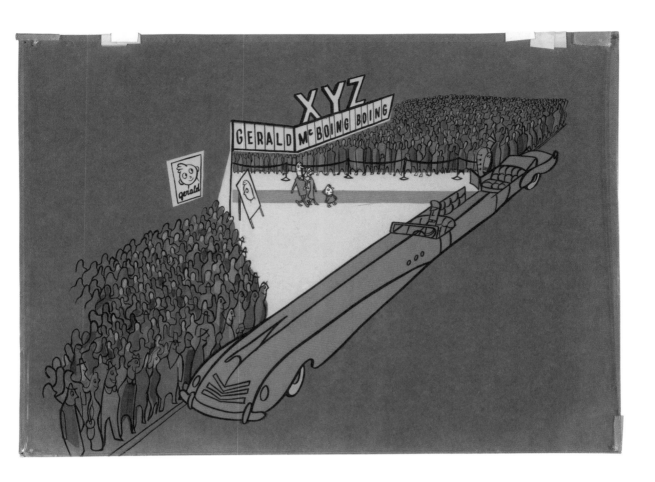

Production cels and backgrounds (top, ill. 73 and 74) and film stills (bottom, ill. 72).
Courtesy of Columbia Pictures. All Rights Reserved.

MARV NEWLAND

Black Hula 1988
International Rocketship Limited

I adore this movie. I saw it when it came out twenty years ago. Marv Newland entered the animation scene with *Bambi Meets Godzilla*, a wonderful, aggressive little piece. But I think it's important *Black Hula* be in this show. The independent animator is not somebody we've dealt with since Winsor McCay's *Gertie the Dinosaur*. Every other film on the list is a commercial enterprise of staggering size. But here comes Marv Newland, who represents a host of thousands of other artists around the world, who, because they love animation and have something to say, make important, entertaining, gut-wrenching, frightening, challenging movies. *Black Hula* reminds us how film can say things that other media can't say; and especially animation. How on earth would you tell the story of *Black Hula* with any technique other than animation? Especially drawn animation. The style is really distinct, a particular, inherently humorous, drawing style that comes alive and moves. And the message and story are literally global. *Black Hula* has something absolutely devastating to say and does it well, and I just bark out loud with laughter from what's going on. It's entertaining and funny, and it's as depressing a statement about mankind being locked in a perpetual self-destructive nightmare as you could ever make. *Black Hula* lives in all of these worlds very comfortably and natively.

There's probably no way to describe Marv Newland's style of animation except to say that it is utterly personal. There's a corporate style to even the personal visions of Tex Avery, Walt Disney or the animators at UPA. It all feels sanitized and made safe for public consumption. There's nothing corporate about *Black Hula*. This is one guy's particular drawing style. You feel as though someone took the doodles next to Marv's phone and animated them. There is no attempt to condescend to any sense of public taste. While each of the films in this selection are the products of their time and the artists that made them, Marv's is more so. By an order of magnitude.

Black Hula is pure; it's a surprisingly aggressive film, but at the same time it pulls you in and keeps you absolutely entertained. *Black Hula* is the one film I could watch over and over.

Tim Johnson

(excerpted from a conversation with Bruce Grenville, March 9, 2007)

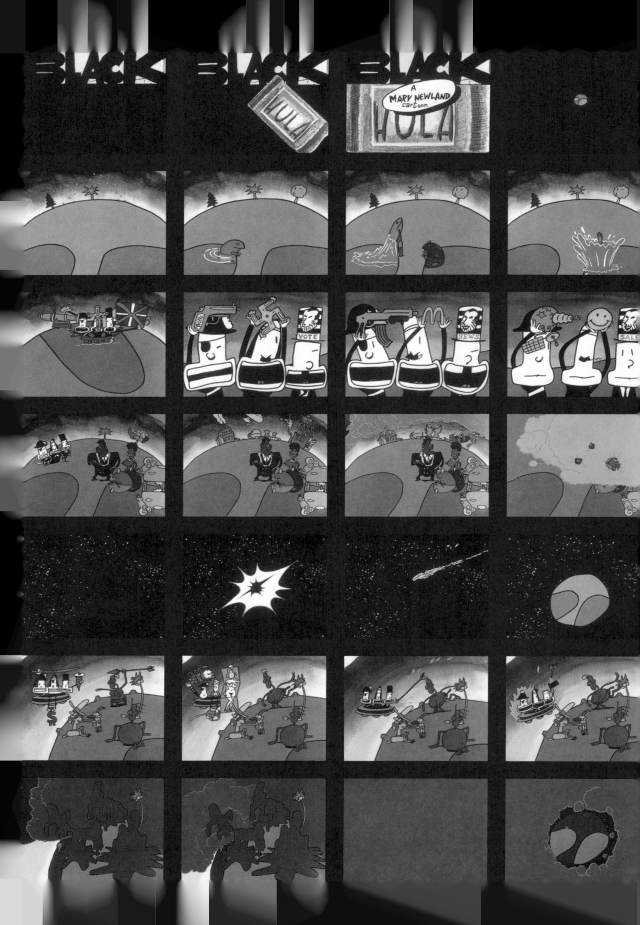

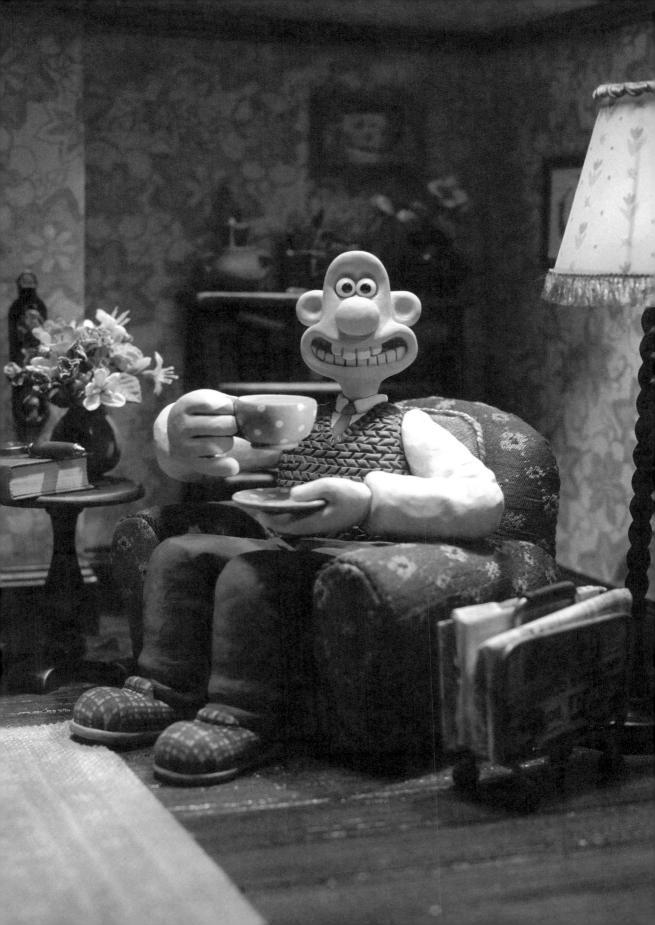

NICK PARK

The Wrong Trousers 1993
Aardman Animations

I always feel that the problem with cel animation is that it's so "untactile." People accuse computer animation of being slick, but in some ways cel animation is the slickest form of animation. Despite its many charms, you don't feel as though you can touch the characters or shake their hands; there's something missing for me. Of course clay animation, and specifically the clay animation used in *The Wrong Trousers*, has that in spades. Not only do you feel as if you could reach out and touch the characters, immerse yourself in their world, but you are also hyperaware that somebody has touched them in order to make them exist.

The Wrong Trousers has more story and jokes in its thirty minutes than you would find in most feature films. Its economy of storytelling is stunning. It's got heroes and villains, chases and captures, misunderstandings and reconciliations. There's a relationship between a man and a dog. There's a story of an inventor and his creations. There's a looming bankruptcy and eviction. There's a mystery that involves a bank robber/art thief/penguin. There's a perfectly directed and performed chase scene. A big movie, really sprawling in many ways, but its consummate storytelling doesn't make it feel that way. There are a lot of things going on in this movie.

The interaction between the penguin and Gromit offers an economy of motion that is astonishing; for example, the moment when Gromit sees the penguin in the hallway, the penguin turns, one axis of rotation, and he has no eyes. Gromit leaps, and so does the audience; we know he's a villain – he's up to no good. You have to remember that these are silent characters – the subtle interplay between the silent penguin and the silent dog offers deep, rich wells full of emotional resonance. These are the tiny economies of motion that put a smile on your face. Likewise, there's broad comedic slapstick action. And they live in the same world; the shifts are absolutely flawless. You never feel, as you might in lesser hands, the whiplash of trying to pull off that marriage of subtlety and outrageousness.

Tim Johnson

(excerpted from a conversation with Bruce Grenville, March 9, 2007)

Sc 59. Shot 4. INT. STAIRS/HALLWAY. NIGHT.

PENGUIN SLIDES OFF END OF BANISTER.

Sc 59. Shot 5. INT. HALLWAY. NIGHT.

PENGUIN LANDS IN MOVING TRAIN.

TRACKING SHOT.

Sc 59. Shot 6. INT. STAIRS/HALLWAY. NIG

MEANWHILE WALLACE IN THE WARDROBE HAS
SHUFFLED THROUGH THE DOOR AND IS FALLING
TOWARDS GROMIT,

Sc 59. Shot 6 CONTINUED.

GROMIT JUST LEAPS OUT OF THE WAY.
"YELP!"

Sc 59. Shot 7. INT. HALLWAY. NIGHT.

GROMIT MANAGES TO HANG ONTO A
LAMP SHADE

Sc 59. Shot 8. INT. HALLWAY. NIGHT.

PENGUIN TAKES A SHOT AT GROMIT.

TRACKING SHOT.

Nick Park **The Wrong Trousers**

Sc 59. Shot 9. INT. HALLWAY. NIGHT.

PENGUIN SHOOT THROUGH WIRE,
GROMIT FALLS.

Sc 59. Shot 10. INT. HALLWAY. NIGHT.

GROMIT FALLS ONTO REAR CARRIAGES
AND THE GLASS LAMPSHADE FALLS ON
HIS HEAD AS A HELMET.
TRACKING SHOT.

Sc 59. Shot 11. INT. HALLWAY. NIGHT.

PENGUIN CHECKS WHERE HE IS HEADING.

TRACKING SHOT

Sc 59. Shot 12. INT. HALLWAY. NIGHT.

PENGUINS P.O.V. OF APPROACHING PENGUIN
FLAP.

TRACKING SHOT.

Sc 59. Shot 13. INT. HALLWAY. NIGHT.

PENGUIN TAKES A SHOT AT GROMIT.

TRACKING SHOT,

Sc 59. Shot 14. INT. HALLWAY. NIGHT.

BULLET RICOCHETS OFF GROMITS HELMET.
WARDROBE CONTAINING WALLACE REACHES THE
FOOT OF THE STAIRS. TRACKING SHOT.

Storyboards (top, ill. 78 and 79) © 1993 Aardman/W&G Ltd.,
and film stills (bottom, ill. 80) © 2007 Aardman Animations Ltd.

JOHN LASSETER

Toy Story 1995

Pixar Animation Studios/Walt Disney Studios

It's been thirteen years since *Toy Story* hit theatres, and the animation world has not been the same since. It's been so influential that it's easy to forget how revolutionary a fully computer-generated feature-length film was considered to be at the time. In 1995, *Toy Story* was far from a guaranteed hit. I remember a prominent studio executive telling me that he didn't think an audience could watch computer-generated images for the requisite eighty-plus minutes – as though there were a physical limit of exposure to this newly conceived form of optical assault!

But I had no doubt. And to tell the truth, I was intensely jealous. John Lasseter had wrapped his extraordinary creativity around the primary, universal myth of all childhood: your toys move when you're not looking. What a marvellous fantasy for a film! Why had no one tackled this idea in film before? Because the idea had to wait for the technique. You couldn't have made *Toy Story* before the age of computer graphics. Better yet, the plot and principal characters were perfectly appropriate for an emerging technology that could render metal and plastic more convincingly than fur and flesh.

Lasseter and his team at Pixar took computer animation out of the world of the computer geeks and put it squarely in the hands of artists and storytellers. Just watch the appropriateness of the cinematography in *Toy Story*, how artfully the camera assumes the point of view of the small toys in their giant suburban world. Study the "actors" – Woody, Buzz and that dazzling team of toys – and ask yourself if you've ever seen more expressive performers. It's impossible to consider them merely "virtual." Soak up the scuffed textures on the walls, the change of light from day to night and from inside to outdoors. Yes, the technology continues to evolve in leaps and bounds, but *Toy Story* is just as engaging and meaningful today as it was the day it was released.

The biggest technical triumph of all was that *Toy Story* was never about technology. The film is the story of two mismatched heroes on a heartfelt journey to find their way home. The best movies are about issues that we encountered as children and re-encounter as adults. *Toy Story* is one of the greatest tales of all time, a convincing account of the anxiety we face in separation and the joy and meaning we find in reunion.

Tim Johnson

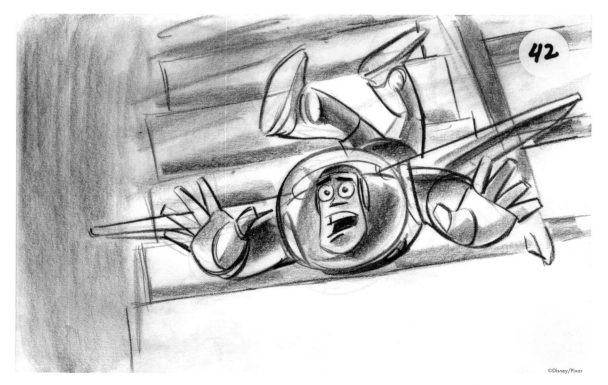

Storyboards (ill. 81 and 82) © Disney/Pixar

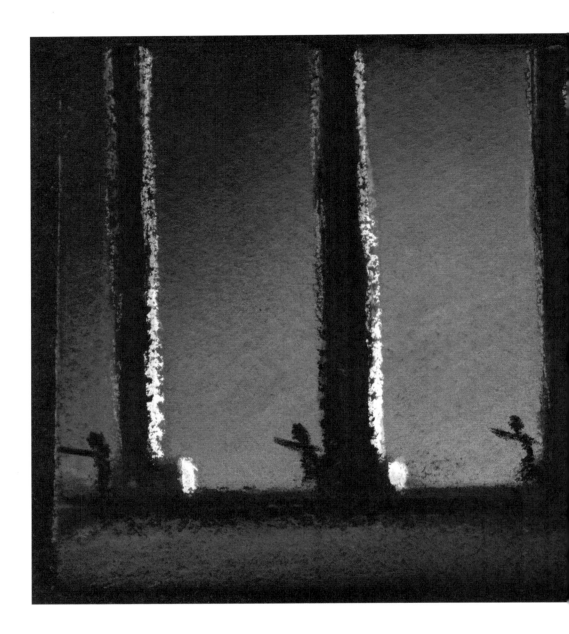

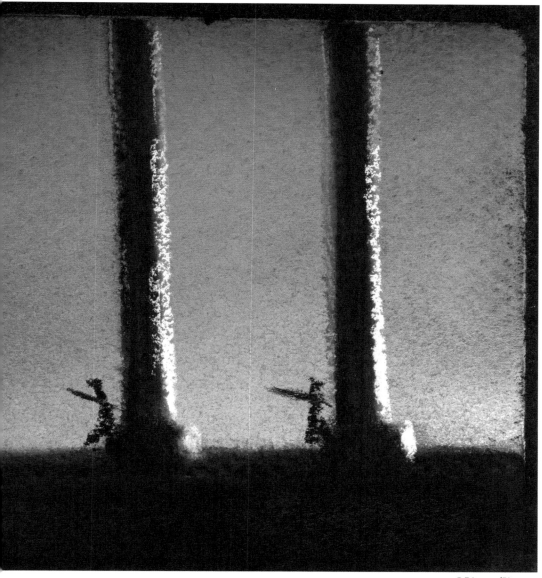

©Disney/Pixar

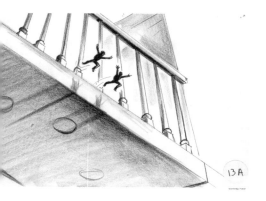

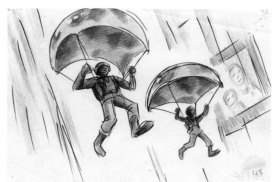

Sequence pastel (top, ill. 83), drawing (bottom left, ill. 84) and storyboards (bottom, ill. 85–87) © Disney/Pixar

Tim Johnson/Karey Kirkpatrick **Over the Hedge**

TIM JOHNSON / KAREY KIRKPATRICK

Over the Hedge 2006
DreamWorks Animation

It's interesting, in the larger context of *KRAZY!*, that *Over the Hedge* began as a comic. Michael Fry and T. Lewis had been producing it for twelve years or so. The thing about *Over the Hedge* was that it had two really great elements to it that made it attractive to feature animation. It had a comic premise: "They are not in our backyard; we're in theirs." And it offered a classic buddy relationship. The pure id-based greed of RJ and the cautious nervous guilt of Vern are essential to the movie, and they're taken directly from the comic strip. The thing that made it liberating for us was when we proposed to tell the genesis story – how did these two characters meet? That left us with the best of both worlds: ten years of comic strips to draw from, a relationship that felt sophisticated and delineated and a point of view and an attitude about human consumer culture that was really satirical, but we were free to tell whatever story we wanted.

We had T. Lewis involved from the beginning, and he did lots of character designs for us. It was a difficult drawing style to convert into CG (computer graphics) because of the thick and thin brush stroke of his line. But if you look at the pictures, the silhouettes are the same.

Point of view is at the heart of *Over the Hedge*, and this is one of the things that computer animation does so brilliantly: you can put the camera anywhere, in places a real camera could never go. This is not a film about small little animals; this is a film about gigantic humans. The camera is down with the animals, always at their height, shooting the world from their eyes. The cinematography is more akin to the æsthetics of live-action film than 2-D animation. By shallowing the focus you put yourself in the head of the character; you are in the psychological world of the characters, not just their visual world. We frequently used the CG equivalent of long lenses; we stayed in very shallow focus so that when a character was in close-up they were against dappled dark material. We guided the eye of the audience by letting everything else go dark, dark black so that it would not compete with the characters. It was through this technique, this point of view, that we were able to step outside and see ourselves for what we are.

Tim Johnson

(excerpted from a conversation with Bruce Grenville, March 9, 2007)

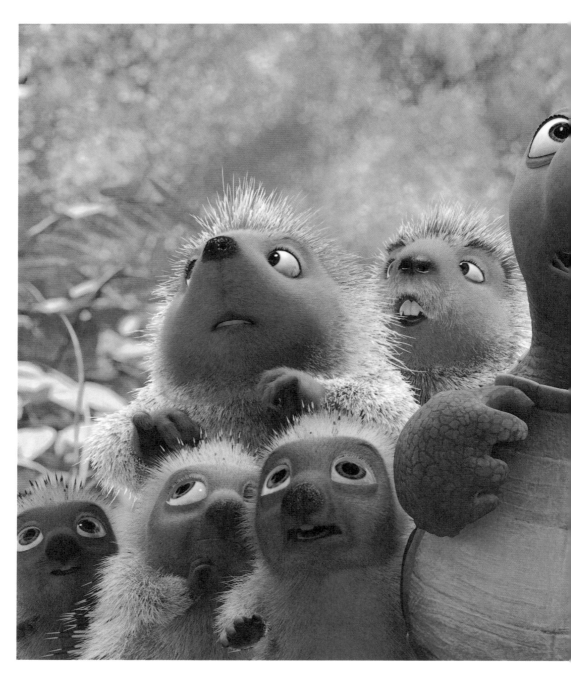

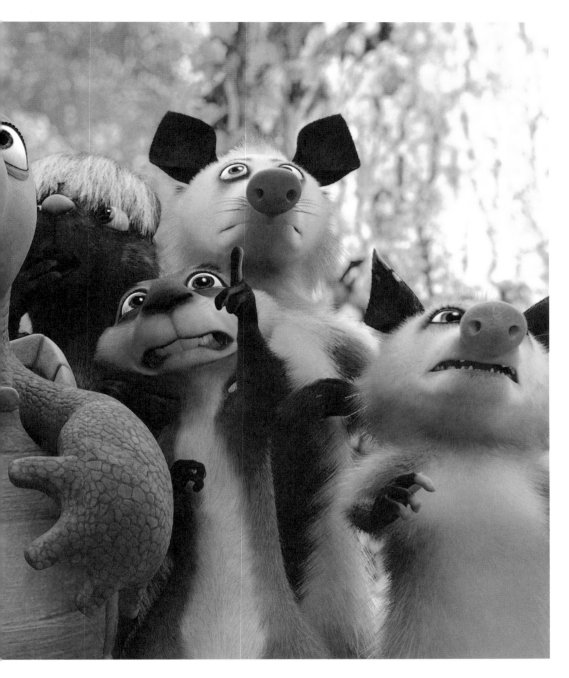

Focus test (top, ill. 88) and colour-key thumbnails (bottom, ill. 90)

WILL WRIGHT

COMPUTER AND VIDEO GAMES

READY!

TORU IWATANI

Pac-Man 1980
NAMCO/BANDAI

Pac-Man is wrapped up in the whole arcade experience. Before everyone had a home computer and a game console, you had to go to an arcade to play video games. For most people, *Pac-Man* was their first interaction with a joystick, which was an important component of the new gestural language of video games. It became a novelty, a sensation, because it was the first time most people had ever controlled something on screen. Almost immediately, players learned that the joystick moves the character; it soon becomes so instinctive that the player is no longer aware that his or her hand is controlling the game.

Although *Pac-Man* may have appeared foreign to most people, there are little aspects of it that are drawn from familiar experiences, such as playing tag or mowing the grass. These snippets of everyday life come together to make *Pac-Man* incredibly immersive and easy to understand; you can watch somebody play for about a minute and instinctively understand the rules.

Pac-Man is a two-dimensional world with a lot of constraints. It approximates the claustrophobic space of a maze and at any given moment there are only two or three directions the character can take. It is an entirely deterministic world where the ghosts – the characters you have to avoid – have pre-programmed patterns relative to your movements. If I lose a game I can recreate history, go back and replay the game and avoid my mistake.

One of the most interesting aspects of *Pac-Man* is the sound effects. It makes a really satisfying sound when you eat the dots, and when the ghosts get close to you, the tempo of the music increases to an anxiety-inducing level. It is one of the first games to use sound and colour effectively to heighten the player's emotional experience.

Pac-Man has a very seductive experiential aspect to it. The sound, colour and motion make the player genuinely feel that he or she is *Pac-Man*. When the ghosts jump on *Pac-Man*, you see players jump back from the screen as if *they* have been jumped on. It is an instinctive physical reaction. *Pac-Man* created such an immersive player experience that it was hard to replicate. Despite its rudimentary technology, people continue to play *Pac-Man* today, because it's such an engrossing game.

Will Wright

(excerpted from a conversation with Bruce Grenville, March 5, 2007)

SHIGERU MIYAMOTO

Super Mario World 1990
Nintendo

Super Mario World is about emergence – a simple set of rules that allow for a very complex system of play. If I hit a box with my head, a mushroom comes out. If I stomp on a turtle, it withdraws into its shell. If I kick the shell into my enemies, it can kill them. It's a very predictable set of rules, five or six simple dynamics, but then you start adding things together and get a very complex system. And you can learn those basic rules in the first two levels, then each level after that is just a different combination of dynamics. So, it's about building complexity out of simplicity, building one hundred complex, interesting platform levels, puzzles that you have to solve, using just a handful of very simple elements.

For its time, *Super Mario World* was an epic game. It was a gigantic world that you traversed by moving through smaller worlds, each with its own levels but joined by branches. There was a consistent language, storyline and mythology that you learned in the early levels and then developed through more elaborate interactions in later levels.

It's a side-scrolling game, which means that the whole screen just moves over a few pixels to the side as you move left or right. Graphically this gives the impression that the screen is moving smoothly, allowing for fairly elaborate graphic worlds with limited storage in simple graphics hardware. Although it is possible to imagine a link to the form, characters and backgrounds of Japanese scrolls, I think that the pedigree of this side-scrolling world is animated cartoons, where the character walks and the whole screen scrolls by. The characters and backgrounds, the physics and behaviours of the world also come from cartoons.

Visually, the design of the various levels can take your breath away. As a game player, everything I see on the screen has a functional meaning to me, but the architecture, the motion, the behaviours and configurations are very, very expressive.

Will Wright

(excerpted from a conversation with Bruce Grenville, March 5, 2007)

Shigeru Miyamoto **Super Mario World**™

Screenshots (ill. 92) © Nintendo Co. Ltd.

SID MEIER

Sid Meier's Civilization 1991
MicroProse

Sid Meier's Civilization is one of the most popular turn-based strategy games ever made for the computer. Turn-based games involve a very different psychology than real-time strategy games such as *Dune, Command & Conquer* or *World of Warcraft*. Turn-based games are very relaxed, but you also spend a lot of time playing these games in your head. *Civilization*'s origins clearly lie in board games, all the way back to chess. There is also an important link to the military and its development of very elaborate role-based war games for training purposes.

Like all board games *Civilization* is an abstraction of reality. I want my units to feel like spreadsheet elements so that they are predictable, and I can plan accordingly. *Civilization* takes a very complex, messy world and reduces it to a more symbolic representation, cutting it up into discrete pieces so that the environment seems clearer. You have, for example, a simple map with very specific terrain types: mountains, farmland, water, desert.

This was one of the first games to introduce a technology tree that you could research and uncover during the course of the game. This elaborate idea takes all the messiness of technology and simplifies it into a formal tree of developments and their connectedness, to give you a sense of how one invention led to another one, how certain things were prerequisites for others. All these aspects are abstracted to the point where you can hold them in your head and build a model of the way they're interconnected. This is very different from earlier board games, where you might be given ten tank units and five infantry units, all the pieces you would ever have. In *Civilization* the pieces evolve over time – at first you have spearmen, then you have archers and eventually you get riflemen, machine gunners, tanks, and so on. The pieces actually change over time depending on what branches of the technology you unlock.

Like no other game, *Civilization* touches upon a lot of fundamental concepts of society – weaponry, governance, religion, transportation, etc. – and integrates them into a game.

Will Wright

(excerpted from a conversation with Bruce Grenville, March 5, 2007)

Berlin
4000 BC

Germans capture New York. 20 gold pieces plundered.

German wise men discover the secret of Horseback Riding!

Greetings from Abe Lincoln, ruler and Emperor of the Americans...

OK

ID SOFTWARE

QUAKE 1996

I've never had a more immersive gaming experience than playing *QUAKE* in a dark room, sitting with my face right up to the monitor. Oddly enough, one of the biggest factors in producing this immersive experience is the lack of situational aware-ness, the lack of information. Because it is a first-person, shooter-style game, you can't see what's right behind you. When you approach a corner, you don't know what's around it until you stick your head out. The entire game takes places in tightly enclosed spaces with no open vistas but with incredibly interesting topologies. This claustrophobic effect is created by the manipulation of lighting, graphics and sound and is largely the result of designer John Carmack's fascination with light. The subtler the cues are, the more immersive the game can be. *QUAKE* and some of the other early first-person shooter games didn't spend much time developing playing concepts; instead the emphasis was on exceedingly well-executed craft: graphics, sound interaction, frame rate, etc.

In reality, they left much of the content development to the players. Rather than spending a lot of time and effort creating artificial intelligence, they basically said, "Okay we're going to make a space, and real people can go there and play *QUAKE*." *QUAKE* definitely has a pedigree that goes all the way back to cowboys and Indians, cops and robbers, capture the flag. These are very spatial games that are also very social. I think most people would tell you that *QUAKE* in its single-player mode was cool and immersive, but the game really came alive in multiplayer mode. The social aspects of multiplayer *QUAKE* feel almost like playing a pickup game of basketball.

Because *QUAKE* was designed to be easily modified – by altering the sound, graphics and source code – many people went down the path of building custom "mods." First it was just simple data-driven things, like level design or weapons, but then people started putting in tools to record game sessions. And so, for the very first time, people started using a game to make little movies. They could customize the characters and levels, and then tell a story, record it and share it with others. And this one little snippet of the *QUAKE* community went off and grew into the thing we now call "machinima" – using game engines to create short movies.

Will Wright

(excerpted from a conversation with Bruce Grenville, March 5, 2007)

Screenshots (opposite, ill. 94) and mod screenshots (above, ill. 95–97).

WILL WRIGHT

The Sims 2000
Maxis/Electronic Arts

When I was first working on *The Sims*, I was looking at what was happening in the *QUAKE* community, and I started seeing the cool stuff that people were doing because *QUAKE* was open ended and modable. And so from the very beginning, I wanted virtually every aspect of the game to be creatable by the players. *The Sims* is based on the premise that the rules of the game are as close to mundane reality as possible. Most games have always used the Walter Mitty model: let's put you in a fantastic place and let you shape the world, the kind of role playing that *Zelda* is based on. *The Sims* is almost the opposite. The initial challenge, for example, is making sure you go to the bathroom on time, go eat when it's time for lunch. It makes the mundane interesting.

The Sims is clearly focused on the player's story. That's the point of the game, and it's interesting socially because of the huge communities that have formed around it. Because the game is thematically neutral, the community has filled it with custom content, resulting in a huge amount of shared storytelling. The game goes out of its way not to invalidate the player narrative, which allows the players full ownership of the emergent story.

Another one of the fundamental ideas behind *The Sims* was that we were going to simulate the look of the characters from what I would call a "second-floor-balcony point of view." If you were standing on the second-floor balcony looking down at people on the street, what could you infer about them from their behaviour? I might see two people talking, kissing or having an argument. I couldn't hear the words they were saying, but I could roughly interpret what was going on from their body language and could fill in the rest with my imagination. In this way we managed to offload the hard parts of the simulation into the imagination of the player. I decided it was possible to simulate our characters at that level, without actually having to hear their conversations. During development we were careful to pick the right level of abstraction to keep the characters from becoming little robots, and we were always cognizant of not crossing that line that would suspend the players' belief.

Will Wright

(excerpted from a conversation with Bruce Grenville, March 5, 2007)

Screenshots and booth scene (above and overleaf, ill. 98) The Sims™ © Electronic Arts Inc.

ROCKSTAR GAMES

Grand Theft Auto III 2001
Grand Theft Auto: Vice City 2002
Grand Theft Auto: San Andreas 2003

Grand Theft Auto III (*GTA*) is a very cool game. It is an amazingly consistent world with a surprisingly simple interface, and as a player, I can do a very large percentage of the things that occur to me: I can go into the cars, I can interact with people or things that I just find on the ground, like a gun or a bike. If I go up and talk to a person, I am not exactly sure what the rule set is underneath, whether he or she is going to laugh at my joke or not. I want the world in my head to feel plausible, but I don't want to have to think about the underlying numbers or rules. *GTA* does a really good job of keeping that plausibility going.

GTA is thematically more neutral than *The Legend of Zelda*, and I am much more likely to invent my own story. I spent a lot more time in *GTA* exploring – just making my own weird activities and doing strange things – than I ever did in *Zelda*. *GTA* invites player narrative in a much deeper way. It has many of the scripted storytelling aspects of *The Legend of Zelda*, with specific gates you have to pass through, but in *GTA* you have these nodes, and when you reach one of these nodes you open up a little bit more of the world. But I'm still not allowed access to most of the world until I pass through these nodes, so it doesn't feel as linear as *The Legend of Zelda*.

It's interesting to compare the world views of *GTA* and *Civilization*. In *Civilization*, the entire world is dynamic in the sense that I can actually see it changing. Turn to turn, I can see those two guys at war over there and someone farming over there; I am aware of all these plates spinning at once. In *GTA* it's as if there's this bubble around me and everything else is basically on hold. When I cross the city, I might see different cars than last time, but I expect all the buildings to still be there and the street layout to be the same – the world won't have fundamentally changed while I'm not there.

Will Wright

(*excerpted from a conversation with Bruce Grenville, March 5, 2007*)

Shigeru Miyamoto **The Legend of Zelda®: The Wind Waker**

SHIGERU MIYAMOTO

The Legend of Zelda: The Wind Waker 2002
Nintendo

If *Super Mario World* feels like a very complex puzzle, *The Legend of Zelda* makes me feel as though I have been dropped into a very elaborate book. *Zelda* has a very definite story, a mythology – it is like a great novel with a world and characters that you think about even when you put it down. And because you can spend so much time there, in some sense it is like an alternative reality. This is one of the reasons that *Zelda* is such an excellent role-playing game. In a game like *Zelda* you can understand the basic elements of the game, like verbs and nouns. There is a language of learning in which you come to accrue things over time. I get a sword, then I get a grappling hook, a boomerang, a baton – so my nouns have increased over time, which means I can also go back to areas I have been to before and use these nouns as verbs that I didn't have before. *Zelda* was instrumental in developing this inter-operability.

Wind Waker in particular was one of the first games where they decided to take the cel-shading path, which is a very interesting choice. Cel-shading is a type of computer graphic style that is intentionally non-realistic. With its hand-drawn look and simplified shading, it's often used to mimic the look of a comic book or cartoon. *Wind Waker* has a very artistic look to it, and at first some players were turned off; Nintendo wasn't following the same path as everybody else – they were actually falling back to what people saw as a cartoonish sort of look. But if you played the game for five minutes you started realizing how well the style worked and how consistent it was. The artistry of it was subtle but amazing. The way the waves would splash and the wind would blow – it had the elegant simplicity of a woodcut print. Visually it was one of the first games to steer away from realism towards a more expressive style, and I think we are going to see more of that in the future.

Will Wright

(excerpted from a conversation with Bruce Grenville, March 5, 2007)

Spore 2008

Maxis/Electronic Arts

Spore is, in some sense, the future of games. If you take *The Sims* and *Grand Theft Auto* (*GTA*) and extrapolate from them, you'll understand where *Spore* is headed. *GTA* is a large world that you explore; *Spore* is a whole universe. *The Sims* has a tremendous amount of customizability built in; *Spore* has that times a hundred. In a sense *Spore* is establishing a trend line for the future, in which the player is directly involved in building the game at a deeper and deeper level. We want to provide the player with very simple tools that he or she can use to build anything; we want to make every aspect of the world malleable so that the player creates everything, from microscopic cells to entire planets.

If you asked everyday people, "Could you do what George Lucas does?" they would say, "No." However, if you give them high-leverage tools and a reason to play with them, I think they will surprise themselves, and after a period of time they will look around and say, "Wow! I created all these creatures and all these vehicles, buildings, cities, this whole planet." And they will realize that this entire world came from their imagination. In *The Sims* we wanted to extract a player's personality and home life. In *Spore* I am trying to extract an entire universe from a player's imagination.

Another important aspect of *Spore* is the degree to which player modifications are integrated into the game play. In truth, we will make a larger game world by getting a million players to build it for us. How are we doing this? By making the act of building the world part of playing the game. Whenever someone makes a creature, a vehicle or whatever, it gets uploaded to a server. As I am playing the game, all the other content I encounter, other worlds and other creatures, comes from things other players have made. So in a sense, the act of playing the game is also the act of building the game.

Will Wright

(excerpted from a conversation with Bruce Grenville, March 5, 2007)

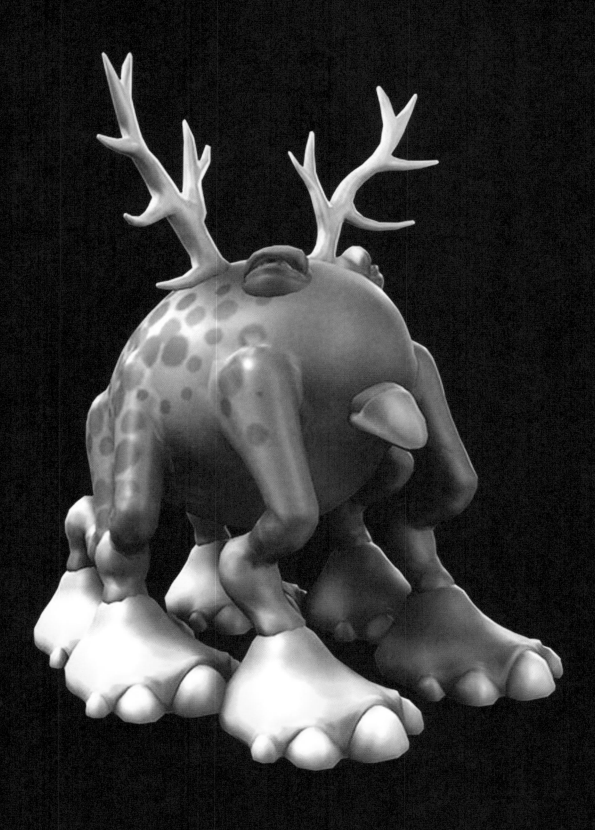

Detail of creature render (ill. 103) SPORE™ © 2006 Electronic Arts Inc.

Row 5 (foot-paw)

Row 10a (movement-dino)

Zerbot

Row 16 (mouth-herbivore-snouts)

Row 29 (eyes-mammal)

TOSHIYA UENO AND KIYOSHI KUSUMI

ANIME

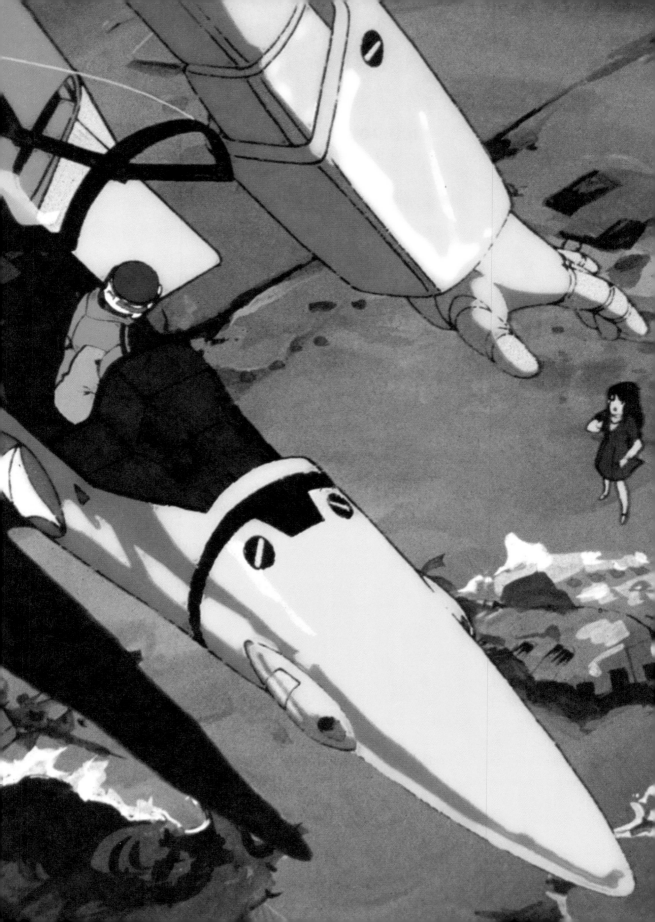

ICHIRO ITANO

[mecha design supervisor]

Super Dimension Fortress Macross 1982–1983
Studio Nue/Tatsunoko

Ichiro Itano is highly regarded for his work as an animator in major anime series such as *Mobile Suit Gundam*, *Space Runaway Ideon*, *Megazone 23* and the anime series *Super Dimension Fortress Macross* (renamed *Robotech* in North America). He is justifiably admired for his trademark elaborate ærial battles and dogfights between his *mecha* characters, mechanically transforming robots, piloted by humans, that can morph into aircraft. Anime fans love Itano for his frequent use of high-speed missiles with streaming contrails, tracing an elaborate choreography of movement they have nicknamed the "Itano Circus" (English-speaking fans call it the "Macross Missile Massacre"). The *Macross* series has a huge following among anime viewers and attracts a highly committed *otaku* and anime subculture fascinated by the romantic love triangle between the main characters as well as the elaborately crafted *mecha*.

Itano's concept of *mecha* design and his direction of the flowing ærial action is highly detailed and carefully crafted. Scenes featuring swarming attacks of missiles launched from robots or spacecraft are spectacular and have strongly influenced a younger generation of directors such as Hideaki Anno, creator of the series *Neon Genesis Evangelion*.

The dominant modes of depiction in manga and anime have been established through a contradictory combination of realism and an abstract but highly expressive sign-oriented form of representation. The realist mode grew to prominence in the military manga of the Second World War. Like elaborate dioramas, these offered panorama views of battle scenes, with detailed depictions of military technology and terrain. A similar realism and fetishism for military paraphernalia was widespread in films and photo magazines for the purposes of war propaganda. The influence of this realist mode was felt throughout the anime and manga genres and can be seen in the work of many artists, such as in the highly influential manga of Osamu Tezuka, including *Astro Boy*, *Kimba the White Lion* and *Phoenix*, and in the anime of Hayao Miyazaki, including *Nausicaä* and *Princess Mononoke*. Itano inherited these modes of representation and has in turn influenced a new generation of anime artists. Even in the age of computer graphics and live-action special effects films, the "Itano Circus" is still revered for its dynamic camera angles and elaborate choreography based on a subtle vision and imagination.

Toshiya Ueno

Ichiro Itano **Super Dimension Fortress Macross**

Film stills (ill. 104) MACROSS © 1985, 2006 Harmony Gold USA, Inc./Tatsunoko. MACROSS is a registered trademark of Harmony Gold USA, Inc. The MACROSS series is distributed under license from Harmony Gold USA, Inc.

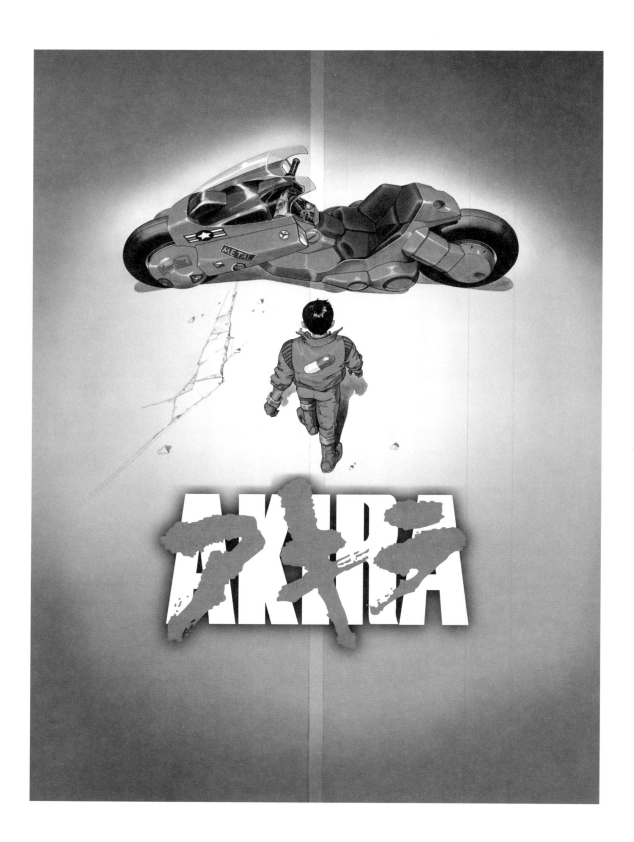

Katsuhiro Otomo **Akira**

KATSUHIRO OTOMO

Akira 1988

Akira Committee

How many times has Tokyo been destroyed? Whether by Godzilla or some other aliens, the urban space of Tokyo, and Japan as a whole, has been endlessly subjected to a historical process of "scrap and build." From the recurrent and devastating fires of the Edo period to the destructive forces of gentrification that drove Japan's bubble economy of the 1980s, the spectacle of Tokyo's destruction has fascinated its citizens and the world at large.

Katsuhiro Otomo's renowned anime film *Akira* (1988) offers one of the most memorable images of a ruined Tokyo. Set in 2019, *Akira*'s neo-Tokyo has a great void at its centre, a hole created by Akira's psychic power, which, in the aftermath of the destruction, becomes Akira's cryonic tomb. The politics and philosophy of Otomo's film become clearer when one considers that there is in fact a great void at the centre of present-day Tokyo, a vast space that contains the Imperial Palace and its grounds, and like the emperor, Akira is rendered immobile by a political force of ambiguous purpose. Against this backdrop the film plays out a fated narrative involving a gang of amphetamine-fuelled teenage street bikers; an anti-government resistance force; a secret government agency charged with investigating and harnessing the destructive psychic powers of Akira, and a small group of children who share a similar paranormal ability.

Akira's psychic power caused the ruin of Tokyo once, and a second catastrophe looms. This "second death" is a common theme in Japanese anime – so common that it can only be seen as a compulsive re-enactment of the trauma of Hiroshima and Nagasaki. Certainly it is possible and reasonable to read *Akira* as an allegory of post-war Japan – both the dream and the nightmare – with its voided centre, its ruined cityscape, a clouded government, an *enfant terrible* with indeterminate goals, and so on. But Akira is a story that resonates far beyond Japan, as witnessed in its appearance in 1997 in Sarajevo in a café near the Hotel Bosnia. On the wall were three different panels. One held an image of Mao wearing Mickey Mouse ears, the second was a portrait of Subcomandante Marcos, the official spokesperson for the Zapatista Army of National Liberation, and the third was an image from *Akira*, in which Kaneda, the protagonist, surrounded by heavily destroyed buildings, shouts, "So, it's begun!"

Toshiya Ueno

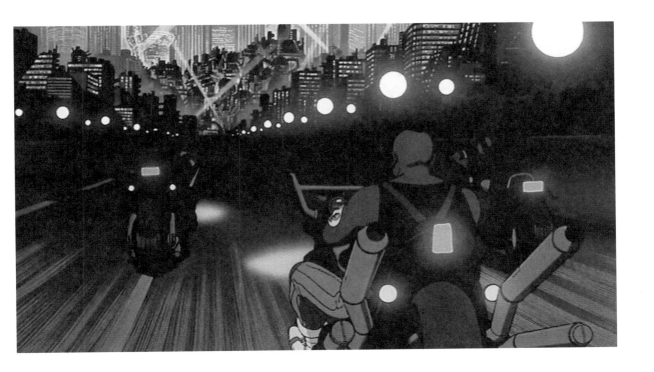

Film stills (ill. 106) © 1987 Akira Committee/Kodansha, Ltd.

MAMORU OSHII

Patlabor 2: The Movie 1993
Headgear/Bandai Visual/TFC/Production I.G.

Just as a philosopher tends only to have a few major subjects in his or her work, the same can be said of the work of anime director Mamoru Oshii. Despite the many different plots and styles of his films, Oshii's work focuses on three recurrent and closely related themes.

Throughout his career Oshii has been preoccupied with the blurring of fiction and reality, an issue that is visible from his earliest works, including *Beautiful Dreamer* (1984) and *Angel's Egg* (1985), to his more recent films such as *Ghost in the Shell 2: Innocence* (2004). This blurring can be read as a condition in which the two diametrically opposed states (human/non-human, innocent/guilty, past/future, etc.) are indistinguishable or interchangeable, and the tools that we use to make those distinctions need to be constantly reassessed and reconsidered. In *Patlabor 2* (1993), for example, it is often difficult to distinguish between the forces that defend Tokyo and those that are attacking it.

Closely related to this theme is Oshii's concern for the ambiguity between war and peace, one being a state of exception, the other a state of normality; the challenge, Oshii suggests, is to decide which is which. In *Patlabor*, Oshii exhibits his *otaku*-like fascination with the machines and actions of the military, but his film is more complex than this interest implies. Many of the war scenes in *Patlabor 2* can be linked to recent global conflicts. The missile attack on the Yokohama Bay Bridge, for example, bears a striking resemblance to the television news coverage of the 1990–1991 Gulf War and the laser-guided smart bombs that were used by the U.S. armed forces. The distinctions between the government and the terrorists are unclear as governmental forces accuse the latter of organizing a series of attacks in Tokyo. In an extended discussion between the two principal characters we are invited to consider the complex distinction between an "unjust peace" and a "just war."

Finally, Oshii's films invariably feature a triangle of lovers whose relationships reveal the illusory and ambiguous nature of love. In *Patlabor 2*, the triangle between Goto, Shobu and Tsuge echoes the film's larger themes of desire, belief and betrayal, as well as the future of Japan in the postwar global economy.

Toshiya Ueno

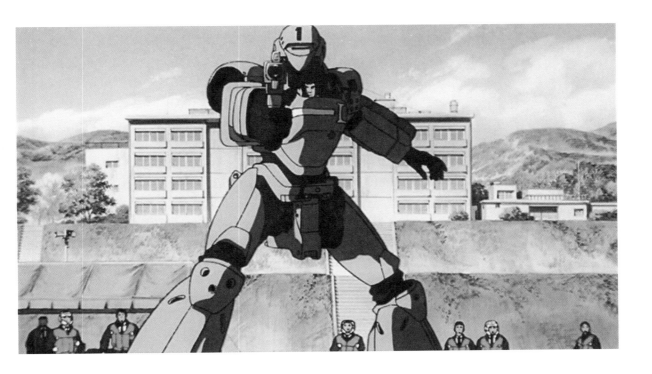

Mamoru Oshii Patlabor 2: The Movie

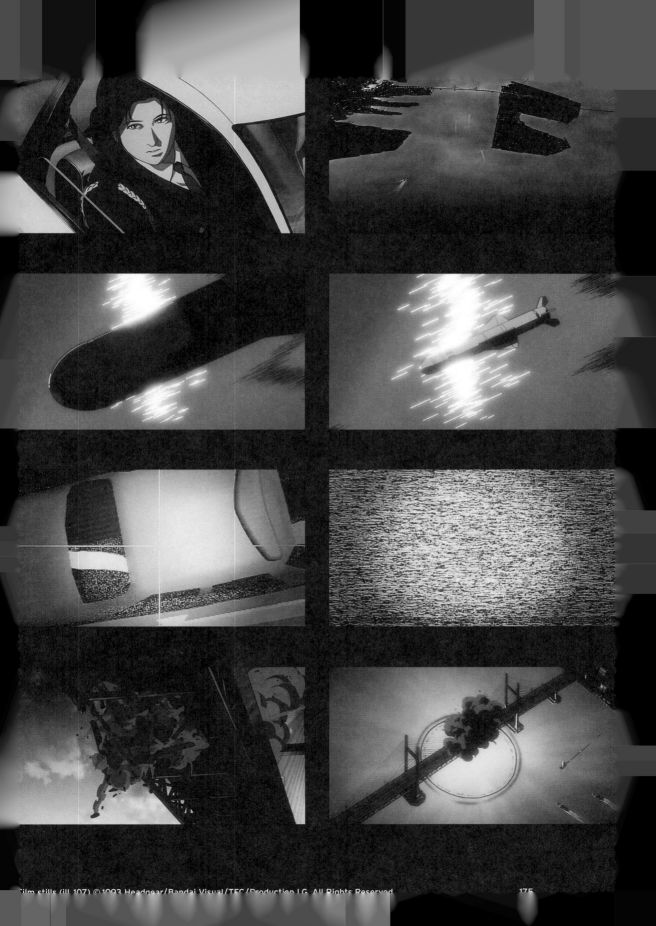

YOKO KANNO

Cowboy Bebop [soundtracks] 1998
Ghost in the Shell: Stand Alone Complex [soundtracks] 2002
Wolf's Rain [soundtracks] 2003
Victor Entertainment

Until the end of the 1980s, the soundtracks for anime television programs and films had been called *anison*, a neologism meaning "anime plus sound." Traditionally, these *anison* were low quality and little of interest could be found in their vulgar styles. However, they were much loved by anime fans, and some famous songs from popular anime are still sung as karaoke tracks. The situation changed in the early 1990s when mainstream J-pop artists began providing music for the title songs or soundtracks. Now many directors have their own favourite sound artists and composers, especially since the popularization of OVA (original video anime), direct-to-video anime that do not have a theatrical release.

Yoko Kanno's work can be located in between these two main currents. She has composed and provided the soundtracks for many types of anime in film and television, including some of the most important anime works of recent years, such as *Ghost in the Shell: Stand Alone Complex*, *Wolf's Rain*, *Cowboy Bebop*, *Card Captor Sakura*, *Brain Powered*, *Macross Plus*, *Turn A Gundam*, *Memories* and *Jin-Rho*.

She works in a wide variety of styles for her compositions and productions. In her soundtracks for *Cowboy Bebop*, which is a story about a hard-boiled detective/bounty hunter in a futuristic setting, she used a completely different musical style for each episode in the series, including jazz, hard rock, blues, hip hop and ambient techno. Through her bold and skillful emulation she is able to reach to the very core of each style of music. She is an expert at remixing, covering, simulating and appropriating various musical styles, but her virtue as a composer can never be reduced to simple imitation of others. Some types of tactical mimesis are more creative than the original, and this is the case with Kanno's work. Recognizing the character and quality of her music, many professional DJs regularly use tracks from albums of the music she composed for *Ghost in the Shell: Stand Alone Complex*.

Anime has made a significant contribution to pop and other subcultures around the world, not just visually but also musically. Yoko Kanno is one of the essential and most highly regarded composers and producers in this field.

Toshiya Ueno

STAND ALONE

COMPLEX O.S.T.

YOKO KANNO

℗&©2004 Victor Entertainment, Inc., Japan.
All Rights Reserved.
© Shirow Masamune • Production I.G / Kodansha
Distributed in North America by Bandai Entertainment, Inc.
under license from Victor Entertainment, Inc., Japan.

BANDAI entertainment™ 25199

MASAAKI YUASA

Mind Game 2004

Studio 4°C

Masaaki Yuasa started his career as an animator in the late 1980s and is celebrated as the director of the film version of *Kureyon Shinchan*, a very popular TV anime series. Yuasa acknowledges his respect for the anime films of Hayao Miyazaki, especially his masterpiece *Lupin the Third: Castle of Cagliostro*. *Mind Game* (2004) is based on a manga of the same name by Nishi Robin, with music composed and performed by Seiichi Yamamoto, a member of the Boredoms, an infamous Osaka-based noise band.

Mind Game has a slapstick storyline delivered at a rapid pace with a meticulous juxtaposition of very different anime styles and methods. Yuasa uses an elaborate combination of highly detailed, naturalistic drawings in the tradition of Miyazaki, intercut with rudimentary drawings in a jerky, stop-action style; real-time images complete with voice-overs; wildly distorted cartoon styles, and so on. This dense visual style is combined with an equally complex narrative that jumps around in time and space. The story revolves around a young manga artist, Nishi, who meets Myon, his first love from junior high school, as she is being chased and harassed by the *Yakuza*, the Japanese equivalent of the Mafia. Nishi then gets caught up in a family drama that leads to his ignominious death. But after an encounter with God he returns to the land of the living using only his *kiai*, or "guts and endurance."

The film's location is important to both its style and its content. Osaka is the biggest city in western Japan and, compared with Tokyo, is known for its folksy, easy-going lifestyle. The sisters' names – Myon and Hyon – suggest that they are Korean or Chinese immigrants, of whom there are many in Osaka and the Kansai region. But it is misleading to reduce *Mind Game* to regional narrative, for the work has a universal sense of humour and theme in its ridicule of contemporary society. Moving backward and forward in time, *Mind Game* recalls many events from the late 1950s and 1960s to the present day, often presented as if on a newsreel. With its bitter humour, the slapstick narrative provides an intensive summary of Japanese life in the modern age.

Toshiya Ueno

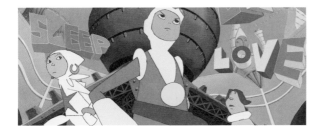

Film stills (ill. 111) © 2004 MIND GAME Project

MAKOTO SHINKAI

The Place Promised in Our Early Days 2004
CoMix Wave Inc.

Makoto Shinkai's movie from 2002, *Voices of a Distant Star*, won several awards and catapulted him to stardom in the Japanese anime scene. This is particularly impressive given that Shinkai did everything himself, from direction and scriptwriting to animation, *mise-en-scène* and editing. Following in the footsteps of the "bedroom recording" trend that blurred the line between independent music production and major record labels in the music business, Shinkai's spectacular debut announced the advent of a similar phenomenon in animation.

The Place Promised in Our Early Days (2006), Shinkai's first full-length animated feature film, is set in a fictional postwar Japan divided into separately governed northern and southern halves – an obvious reference to Korea. It tells the story of two boys who build a jet plane so that they can fly to a tall, mysterious tower on the other side of the military demarcation line. What begins as a romantic story about the boys' shared passion for a girl named Sayuri becomes increasingly dramatic when the story fast-forwards three years. Against the backdrop of an aggravated political situation, the two heroes find themselves navigating their beautiful white "Ring-wing" jet back towards the same mysterious tower to wake Sayuri – a sleeping beauty in the true sense – from her coma.

It is worth noting that the movie itself was designed as a vehicle, one that begins in reality before taking off into science fiction and fantasy. It is the fruit of a collaboration between Shinkai, who wrote and directed the story, and Ushio Tazawa, in charge of character design and animation direction, and it takes little imagination to identify the two creators with the characters in their story. This is a pattern we know also from Gainax (the renowned producers of *Neon Genesis Evangelion*) and their 1984 debut anime *The Wings of Honneamise*, the story of a space rocket launch in a small, imaginary country. All these adventures revolving around flying machines can be seen as metaphors for their young creators' launch into the animation orbit. But note that the changes in the sizes of the vehicles reflect twenty years of technical innovations, which reduced animation from an undertaking of cosmic scale to one that could be purely personal. Interestingly, Shinkai published his latest work, *5 Centimeters per Second: A Chain of Short Stories about Their Distance* (2007), simultaneously as both an anime and a novel – the oldest and most personal medium.

Kiyoshi Kusumi

Film stills (above and overleaf, ill. 112) © Makoto Shinkai/CoMix Wave

SATOSHI KON

Paprika 2006
MADHOUSE

The original story for this anime was written in 1993 by Yasutaka Tsutsui, a novelist whose writings were also the source for Mamoru Hosoda's anime, *Toki Wo Kakeru Shojo* (*The Girl Who Leapt through Time*). Tsutsui is an important figure in Japanese science fiction and pop. Fans of the 1970s counterculture manga magazine *Garo*, which contained the series *Kamui Den* (*Famous Ninja Story*), were inspired by Tsutsui's novels and essays. His writing has similarities with other contemporary genres – underground jazz, cinema, theatre, manga (notably the work of Yoshiharu Tsuge, whose work was also published in *Garo*) – and his methodology and plots reflect his interest in cultural theory and the appropriation of literary form.

The protagonist of *Paprika*, Dr. Atsuko Chiba, works as a researcher at a psychotherapy laboratory. Through the use of a special electronic device called the "DC-mini," Chiba can "jack in" to people's dreams while they are sleeping. In this dream world she takes on an alternate personality – called Paprika, "the detective of dreams" – who can turn herself into various characters, such as a monkey character from Chinese ghost stories or Tinker Bell from *Peter Pan*. But when rogue copies of the DC-mini are used to create a catastrophic mixture of dream and reality, conspiracy and conflict erupt. The images in these nightmarish scenes are overwhelming, especially a recurring surreal parade of Buddha statues, Asian fortune figures, traditional Japanese dolls, the Statue of Liberty, Shinto shrine gates and a myriad of electronic gadgets and everyday objects. They can be interpreted as an allegory of the eclectic dynamics and rapid postmodernization of consumer society in Japan.

Freudian psychoanalysis is an important inspiration for Tsutsui's writing. The relationship between Paprika and her clients has erotic undertones that recall Freudian notions of transference and conflicted relations between psychiatrist and patient; at one point Paprika, who has assumed the form of a Sphinx, questions her antagonist, who appears as Œdipus, about his homosexual devotion to the laboratory's chairman. In the final battle between Paprika and her antagonists, we are reminded of the recurring conflict between patriarchy (or homosocialism), misogyny and feminism or Japanese "bad girl" culture.

Toshiya Ueno

Film stills (ill. 113) Courtesy of Sony Home Pictures Entertainment, Inc.
© 2006 MADHOUSE / Sony Pictures Entertainment (Japan) Inc.

Satoshi Kon **Paprika**

Film stills (ill. 113) Courtesy of Sony Home Pictures Entertainment, Inc.

KIYOSHI KUSUMI AND TOSHIYA UENO

MANGA

Hisashi Eguchi **CD Covers**

HISASHI EGUCHI

Stop!! Hibari-kun! 1981–1983
CD Covers and Illustrations 1995–2007

Hisashi Eguchi was the first to introduce a pop sensibility to the world of Japanese manga. Although his work is largely unknown outside Japan, Eguchi's pioneering work paved the way for the so-called J-Pop (or Tokyo Pop), a manga-inspired blend of fashion and music that emerged as a new kind of youth culture in Japan in the 1990s.

Eguchi was inspired by the Yellow Magic Orchestra and other "new wave" techno-pop artists that sparked the Japanese music scene in the late 1970s. This new musical trend inspired many of Eguchi's regular contributions to the *Weekly Shonen Jump* manga magazine, in which he mutated the protagonists in his slapstick manga *Go Pirates Go!* from baseball rookies to a bunch of youths dressed like the members of Devo.

An alternative "new wave" manga also existed in Japan in the 1980s, represented by the likes of Katsuhiro Otomo and Fumiko Takano and inspired by French *bandes dessinés* and *shojo* (girls') manga styles, with refined techniques and serious topics. Eguchi displayed similar interests, plus the strong influence of American pop culture and entertainment, in such outstanding works as his rendition of Tatsuhiko Yamagami's *Kigeki Shinshisou Taikei*.

Influenced by the nonsense manga style of the 1970s, Eguchi single-handedly fashioned a new sketch-performance style of manga characterized by a humorous combination of nonsense and realist styles as showcased in his work *Bakuhatsu Dinner Show* (*The Dinner Show Explosion*). In 1991, the two "new waves" of Japanese manga melded together to form a single, massive wave when Eguchi took charge of the character design for the anime *Rojin Z*, written by Katsuhiro Otomo.

In the early 1990s, Eguchi's interest was shifting to illustration, and he eventually created a string of characters while working on advertising campaigns, book and magazine design and CD cover art. That said, he was never a prolific artist and seems rather distant from mainstream manga. However, as the editor-in-chief of the experimental annual magazine *Comic Cue*, he has created a stage where the next generation of manga artists, including Taiyo Matsumoto, can work free from editorial restrictions, and he has been commissioned to design CD booklets by a generation of musicians who grew up with *Stop!! Hibari-kun!* Hisashi Eguchi is an exceptional artist with a firm and important position at the crossroads of manga and music.

Kiyoshi Kusumi

Cover art for Baho, *Happenings* and *Tribute to Yasuyuki Okamura* (ill. 114 and 115)

MAMORU NAGANO

The Five Star Stories 1986–

Mamoru Nagano began his *Five Star Stories* (FSS) manga series in 1985; it now contains twelve volumes and is still running. The vast history depicted in the series spans thousands of years and was completely described at the beginning of the publication. The invention of elaborate and detailed pseudo-histories is a crucial element in Japanese manga, and few are more complex than *FSS*. Despite the many battles carried out by fighting robots called Motar Headds, Nagano himself insists that *FFS* is a fairy tale rather than science fiction.

The protagonist of *Five Star Stories* is Amaterasu, the immortal God of Light, an omnipotent and divine force who looks over the worlds and history of the Joker Star Clusters. Through magical powers Amaterasu can change his shape, face and gender. However, he seldom intervenes in human and political affairs and prefers to sit back and watch the sometimes-absurd events that he can see from his transcendent position.

As in many other anime or manga, there are strong links to music in *FSS*. The term Motar Headd, the name given to the fifteen-metre-high robots controlled by a "headdliner" pilot and a "fatima" co-pilot, is derived from the name of the British heavy metal band Motörhead, and many of the other robots and nations bear names that find their sources in music. Nagano himself is a musician and a great fan of fashion, an interest that is visible in the extensive volumes of sophisticated character, costume and accessory designs he draws.

The headdliners who pilot the Motar Headds are genetically rare individuals who are valued for their physical dexterity. Because of the complexity of controlling Motar Headds, the headdliners also need a special co-pilot to complement their operations. These fatima are (mostly) female, bioengineered androids manufactured to serve as co-pilots and love partners to the headdliners. Nagano draws on a wide range of mythic, heraldic and popular narrative sources for his characters and plots. Three principal fatima characters, for example, are named after the three Fates – Lachesis, Atropos and Clotho – of Greek mythology. One can also easily recognize the influence of Osamu Tezuka's masterwork, *Phoenix*, on the settings and designs for the Dragons who figure prominently in many of the *Five Star Stories*, and the elaborate battle scenes among the Motar Headds closely resemble the ninja battles illustrated by Sanpei Shirato in the influential underground manga *Garo*.

Toshiya Ueno

Mecha design (ill. 118)

ゴオオォォオオ

マスター！

もう少しだけ
がんばってくれ
この子も陛下の所で
直してもらおうな

汗と小便で汚れた
コクピットも
きれいに
してやりたいし

何より"ティータ"
お前の顔がみたい

もう終わりにする
ダンパーオイル
スカート
いらないものは
全てすてろ

軽くするんだ！
こっちは奴より
重い！

えっ？

ティータ！
エネルギー
ジェネレーターの
*リキッドをぬけ！
行くぞ！

わかりました！

そうだ！
勝てばあとは
何とかなる！

ゴゴゴゴゴゴ

*リキッド――エンジンや駆動部の冷却用オイルや液体のこと

18

Published page (ill. 119) and mecha design (ill. 118)

TAIYO MATSUMOTO

Black & White 1993–1994

Black & White tells the story of Kuro (Black) and Shiro (White), two orphans who grow up strong as stray cats in a place called *Takara-machi* (Treasure Town). The manga's thirty-three chapters were initially published as one-shot stories in the weekly *Big Comic Spirits* magazine in 1993–1994 and were then reworked into a feature-length anime in 2007. The original Japanese title, *Tekkon-kin-kurito*, is a mispronunciation of *tekkin-konkurito*, a reinforced concrete construction method familiar to any Japanese who were born and raised during the high-growth era, while the reshuffling of letters refers to Matsumoto's own unique visual "remix" technique.

Black & White comes across as freewheeling and wholesome, yet it is as cruel as it is wistful. The orphans swoop around the buildings Superman-style, fighting with bloody violence to keep the adults from poisoning the city with their own interests. Kuro, an adolescent on the fringes of society, tries to lighten his troubled mind with the innocent spirit of his juvenile and intellectually underdeveloped younger companion. In a nutshell, *Black & White* can be interpreted as a fable about two solitary individuals that complement each other like yin and yang. The intense companionship the boys experience is depicted without egocentrism or homoeroticism and with none of the Batman-and-Joker contrast of good and evil, but rather in the style of cosmic Taoism connecting micro and macro. A modern archetype of this kind of relationship can be traced back to Tetsuo and Kaneda in Katsuhiro Otomo's *Akira*; following this thread deeper into manga history, we get to Keiji Nakazawa's autobiographical *Barefoot Gen*, based on his experience of the atomic bombings. There are clear parallels between Kuro and Shiro and Nakazawa's two protagonists struggling to survive in the troubled postwar Japan.

Matsumoto's manga include depictions of intense violence, but these are counterbalanced by a sense of charity towards the small and weak and a strong resentment of those who suppress them. The drawing style is reminiscent of illustrations in children's literature rather than those in commercial *shonen* (boys') manga. Matsumoto's mother, Naoko Kudo, is a poet and author of children's books, and Matsumoto's work draws from the juvenile literature movement. This was launched by progressive writers and avant-garde artists in the early days of Japanese democracy in the 1920s, then shattered by Japan's imperialistic war, only to re-emerge against the backdrop of democratic education afterwards.

Kiyoshi Kusumi

97

JUNKO MIZUNO

Pure Trance 1996–1998

Pure Trance was Junko Mizuno's first full-length manga. Although the book was published by East Press in 1998, the manga first appeared in 1996 in a much-reduced booklet form as an insert in a series of compilation music CDs called *Pure Trance*. Each booklet was six to eight pages long and twelve centimetres square. Mizuno revised and expanded many of the original drawings for the *tankoban*, or collected edition of the book.

Mizuno began by producing self-published or *doujinshi* manga. But unlike most *doujinshi*, which are traditionally based on popular existing manga produced by established artists, Mizuno's were based on her own ideas. From the first volume, *Pure Trance* emerged as a fully formed world with a complex set of characters and an elaborate narrative played out in an over- and underworld. The story is set in a post-apocalyptic future, which Mizuno has acknowledged owes a debt to Katsuhiro Otomo's *Akira*. The survivors live underground with no access to real food, so they are forced to live on capsules of Pure Trance, a nutritional substitute that comes in a variety of flavours. The capsules have a side-effect that causes some people to overeat, and these Overeaters are sent for therapy to the "Overeaters Treatment Centre," run by a dominatrix, Keiko Yamazaki, who wreaks havoc on the staff and patients because of her own addictions. Mizuno's characters are almost entirely women, with the occasional male character playing only a supporting role in the narrative. "I can hardly tell if the things she does in the story are right or wrong," Mizuno has said of Yamazaki. "I wanted to depict her as a natural disaster, or something like that – with no morals or mercies. She's a wild animal and the most extreme among all the characters."

Mizuno's highly detailed and stylized drawings are rendered primarily in black ink, although she also makes liberal use of screentone transfers that allow her to add an even field of grey to the images. The characters are extraordinary, hybrid forms based in part on the *kawaii* or cute characters found in children's toys like Koeda-chan, Polly Pocket, Strawberry Shortcake and My Little Pony but combined in a grotesque hybrid style with the tropes of the Lolita Japanese fashion subculture, the stylized sexuality of S&M pornography and the gothic fantasies of European and Japanese horror stories. The result is as unpredictable as it is fascinating.

Bruce Grenville

最後の世界大戦の後、人類は荒廃しきった
地上を捨て、地下に新しい世界を築き上げた。
人の命さえも試験管の中で作り出されるこの
世界で、延命カプセル『ピュア・トランス』
の摂取過多による女性の過食症が
深刻な問題となっていた。

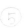

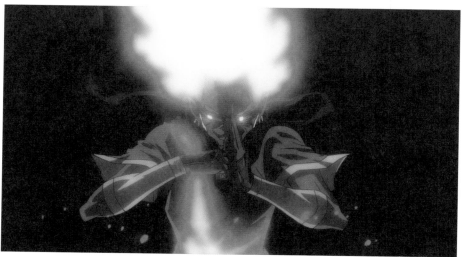

TAKASHI OKAZAKI

Afro Samurai 1994-2008

Afro Samurai was originally drawn by Takashi Okazaki for the Japanese underground manga zine or *doujinshi* called *NOU NOU HAU*. In 2007 the anime studio GONZO produced a five-episode anime version for American television. American actor Samuel L. Jackson is a co-producer of the anime and voice of the protagonist, Afro.

Afro Samurai is set in a futuristic world – with robots, mechanized weapons and lasers – that paradoxically looks a lot like feudal Japan. The principal character, Afro, is on a quest to avenge his father. The man that Afro seeks, his rival and the man that killed his father, is named Justice the Gunman. Justice is the holder of a spiritually powerful headband that makes him "Number One," the dominant samurai, the one who can rule the world. This headband can only be acquired by killing the previous holder. Afro's father held it until Justice killed him, when Afro was still a young boy. Afro, now holder of the "Number Two" headband, must fight off those who seek to usurp his position while hunting down Justice. A secret band of monks, the Empty Seven Clan, invariably come between Afro and his quest.

The bizarre compilation of futuristic elements and samurai moments is not unique to Okazaki's work. This type of techno-orientalism – a set of external and internal conditions that may be seen to frame the representation of contemporary Japanese and non-Japanese culture – can be traced back to other manga authors such as Gho Nagai, although Okazaki is not directly inspired by such precursors. *Afro Samurai* also has interesting links to the 1967 film *Branded to Kill* (*Koroshi no Rakuin*), an example of the 1960s Japanese action film or *Mu-Kokuseki Akushon*, the Japanese counterpart to Hollywood's *film noir* and the French *nouvelle vague*. The movie was directed by Seijun Suzuki and stars Joe Shishido as Hanada, a contract killer working for the *Yakuza*. He is the Number Two Killer and is desperately seeking and battling the phantom Number One Killer. These important plot similarities confirm Okazaki's nostalgic interest in Japanese culture of the late 1960s.

Toshiya Ueno

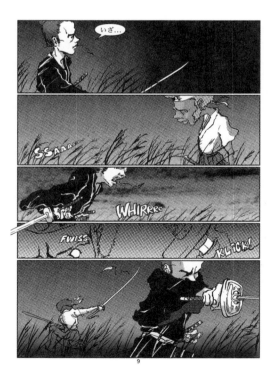

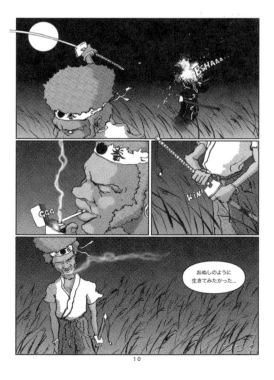

Published page (2008) (top, ill. 127) © TAKASHI OKAZAKI, GONZO
Cover of *NOU NOU HAU* vol. 00 and published pages (1994) (bottom, ill. 128–131) © TAKASHI OKAZAKI

MOYOCO ANNO

Sakuran 2001–2003

Shojo (girls') manga had its heyday in the 1950s, when they were launched one after another, introducing countless new heroines with stars in their oversized eyes. Along with the famous Takarazuka Revue – an all-female musical theatre revue using glamorous costumes and makeup – this movement helped inspire a twisted and rococo style of formal beauty in late-twentieth-century Japan. In the 1970s, Riyoko Ikeda's manga *The Rose of Versailles* – one of the bestselling *shojo* manga of all time – experienced a major boom in its incarnations as the theme of a Takarazuka Revue show and a TV anime program. However, it is the post-*shojo* manga trends since the 1990s that are most important to Moyoco Anno's work. Inspired by Kyoko Okazaki's realistic illustrations of young women's inner obsessions with love and death published not in manga but in fashion magazines, she was the most important of a group of young female manga artists – together with the likes of Banana Yoshimoto in literature and the all-girl band Shonen Knife in music – who announced the cultural era of girl power in Japan in the 1990s.

Okazaki had an enormous influence on the female manga artists that succeeded her, and among her countless followers, her former assistant Moyoco Anno is particularly remarkable. Her work ranges from comic portraits of girls and their runaway struggles with men in *Happy Mania*, to the witch fairy *Sugar Sugar Rune* that appeared in a manga magazine for school girls and was turned into a TV anime program, toys and games, to the *Hatarakiman* (Superworker) story of a female editor that was published in a magazine for men and later resurfaced as a TV anime. The diversity of her topics and the breadth of her readership reflect the power of manga in the Japanese publishing industry, irrespective of age and sex.

Sakuran (2001–2003) is, unusually for Anno, a period play set in a red-light district in the Edo period. It tells the story of Kiyoha, a young prostitute who serves her senior courtesans while gradually maturing into the woman Oiran. It is a classical *Bildungsroman*, and the story – of a woman, her sexuality, her profession and her love – could be interpreted as a metaphor for Anno's own rise from an assistant to a celebrated manga artist. For like the work of her former employer, Moyoco Anno's manga have enough appeal to inspire creators outside the realm of the genre. In 2007, up-and-coming photographer Mika Ninagawa created a live-action film adaptation of *Sakuran*.

Kiyoshi Kusumi

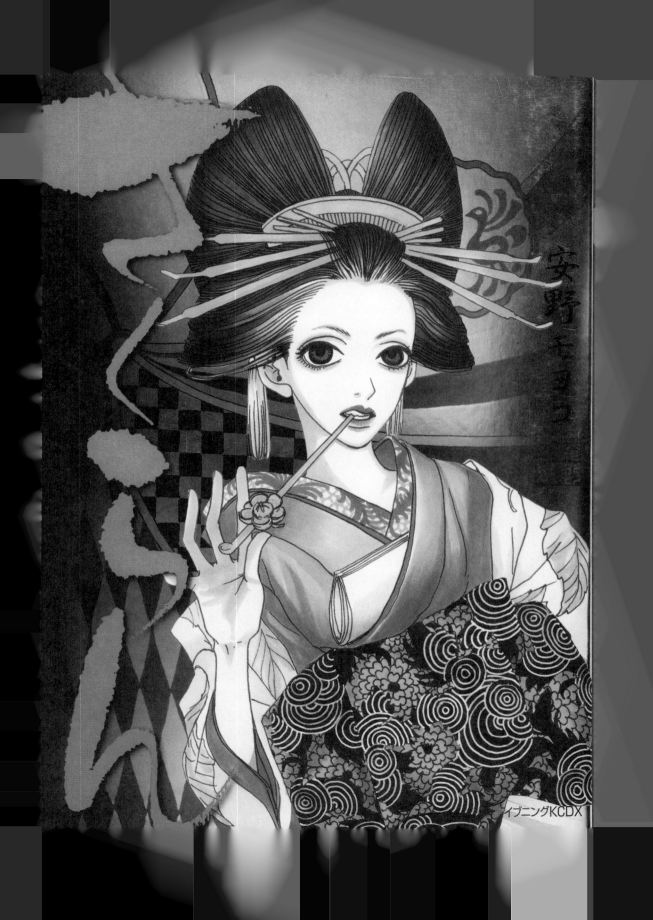

7

YUICHI YOKOYAMA

New Engineering 2004

Yuichi Yokoyama doesn't tell stories, at least not in a traditional narrative sense. His manga contain nothing but chains of dreamlike occurrences. *New Engineering* (2004), for example, features an array of bizarre construction machines that dig the earth, move rocks or lay artificial lawn. No characters appear, and the only sound throughout the piece is the screaming noise of the machines. Only at the very end, when the job is done, do a group of futuristic-looking men show up to cheer the work's completion: "Mission accomplished!" The object they look at doesn't seem to serve any specific function, and giving these men something to marvel at is obviously the sole purpose of the entire project. This point suggests that the objects in *New Engineering* may be something akin to land art for a manga landscape. The importance placed on the creation process rather than on the final result recalls Robert Smithson's 1970 film of the creation of his earthwork *Spiral Jetty*, shot from a helicopter. Like Smithson, Yokoyama uses the manga to document the making of a fictional earthwork.

In Yokoyama's manga *Travel* (2006), a number of equally strange-looking individuals take a train ride through a surreal landscape, while *Niwa – The Garden* (2007) takes the reader on an expedition through a mechanical garden forested with obscurely huge devices and grotesque objects. While the sequential, cinematic grammar of page composition and onomatopœia are normally employed to highlight the structure and rhythm of a story, Yokoyama eliminates narrative and emotive elements, making the image's algorithms and pure motion the actual spectacular features of his works.

Yokoyama studied painting at Musashino Art University and, in addition to publishing his manga in print media, has presented his drawings and paintings in contemporary art exhibitions. As someone who devotes himself in equal parts to his work as a contemporary artist and manga creator, he is an exceptionally rare case. His manga is not only informed by art history and the avant-garde but also by "absurd manga," a genre, pioneered by Hideo Azuma and introducing the celebrated Yoshida Sensha, that was catapulted from the underground to the mainstream in the 1980s. Yokoyama's hybrid work is an interesting example of how the art world can adopt the virtues of manga culture.

Kiyoshi Kusumi

55

HITOSHI ODAJIMA

Mu: For Sale 2001-2004

Illustrator and graphic designer Hitoshi Odajima is primarily known among Japanese rock fans for his artwork for the band Sunny Day Service, but he has also produced paintings with a strong pop art feel that he has shown in exhibitions. One of his few manga works is *Mu: For Sale*, a compilation of short cartoons originally published in 2001-2002 in the manga journal *Comic H*. Its presence could force us to reconsider the entire history of manga in the twentieth century.

Historically, manga production has been dominated by mainstream comics for boys and girls respectively, but there also exist alternative trends pioneered in such underground magazines as *Garo* (1964-1997). While the popular manga of Osamu Tezuka (such as *Astro Boy*, *Kimba the White Lion* and *Phoenix*) are representative of the mainstream, the work of Yoshiharu Tsuge – notably the legendary *Nejishiki* (1968) – exemplifies the alternative type. There is no direct connection between Odajima and Tsuge. But the surrealistic tastes of Odajima's manga, the protagonists who supposedly embody the author himself, and the fact that the term "Mu," which may be translated as "void" or "nil," appears in the titles of both authors' most well-known works, suggest that the stories Odajima tells could be Tsuge's own, set in the twenty-first century.

Mu: For Sale is set in the near future. The protagonist is a young employee of a company that sells voids; the reader never learns more about the "product" involved. Instead the manga portrays the man's day-to-day routine doing his absurd job, which has much in common with Tsuge's *Munou no Hito* (1985-1986), who sells odd-shaped stones collected in a dry riverbed. However, there is far too much beauty in this story of a man selling worthless and meaningless products to dismiss it as mere nonsense. While Tsuge's story was a literary work illustrating the poverty of a sort of hermit, *Mu: For Sale* combines the cool criticism of pop art as a mirror of capitalism with the clear beauty of Zen-influenced conceptual art and the boundlessness of an artificial world *à la* Philip K. Dick.

Odajima is also one half of Best Music, along with Magoo Swim keyboardist Shinichi Hosono. In 2007, the duo released the album *Music for Supermarket* (a reference to Brian Eno's *Music for Airports*), containing what might be called acoustic pop art imitating the kind of muzak that usually plays in Japanese supermarkets.

Kiyoshi Kusumi

BRUCE GRENVILLE

VISUAL ART

ROY LICHTENSTEIN
CLAES OLDENBURG

Vicki! I .. I Thought I Heard Your Voice! 1964
Girl in Mirror 1964
Eccentric Scientist 1965
Geometric Mouse 1971

Roy Lichtenstein and Claes Oldenburg are among the best-known pop artists of the 1960s to use comics and cartoons as source material for their work. Lichtenstein is justifiably famous for his paintings of the early 1960s in which he used a wide range of subjects, compositions and production techniques from the medium of comic books. In a few short years he produced a remarkable body of work that continues to define the public perception of pop art. Lichtenstein's genius lay in his ability to grasp the most compelling elements of comic composition and bring them forward for scrutiny. The ambiguity of his relationship to his subject matter is captured in these three paintings in the extraordinary exchange of looks that is both their individual and their collective subject. As viewers we are caught in an intricate matrix of glances, from artist to comic book to subject to viewer and back again. The intensity of these exchanges is amplified by sharp cropping, the use of mirrors and transmissions and the ambiguous position of the viewer. Lichtenstein's decision to capture and exploit many of the tropes of comic art not only is a tribute to that medium, but it also acknowledges his shared interest in modern cinematic language, with its close-up shots, decontextualized cropping and reflective images. His success lay in his ability to recognize the expanded world of visual culture as a site of artistic exchange and evolution.

The figure of a cartoon mouse is a recurring image in the work of Claes Oldenburg from the late 1960s onward. His famous Mouse Museum houses a massive collection of found and altered consumer objects; his Geometric Mouse sculptures and his many mouse drawings and prints offer a wry commentary on Western culture's fascination with pop culture and consumption. In keeping with this parody, Oldenburg offers his Geometric Mouse sculptures in five convenient sizes, ranging from *Geometric Mouse – Scale X*, monumental in scale and suitable for outdoor public art sites, to *Scale C*, more domestic and easily accommodated on a tabletop. He even offers a "home-made" version, *Scale D*, available as an unlimited edition.

Bruce Grenville

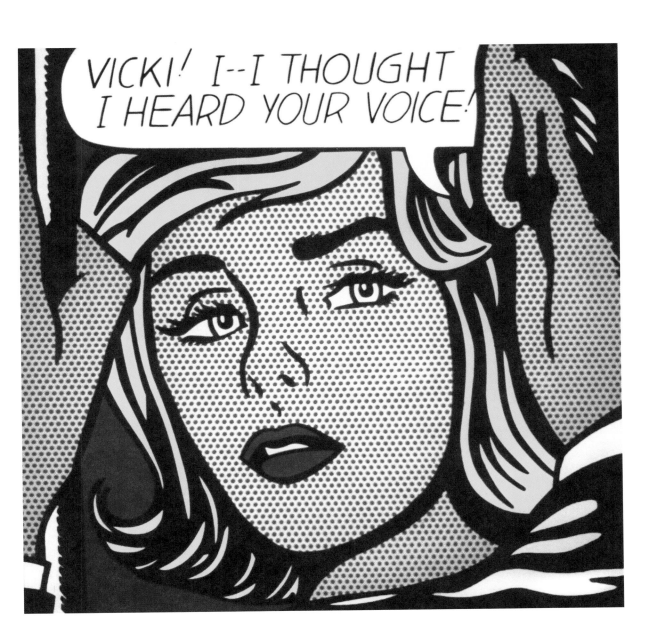

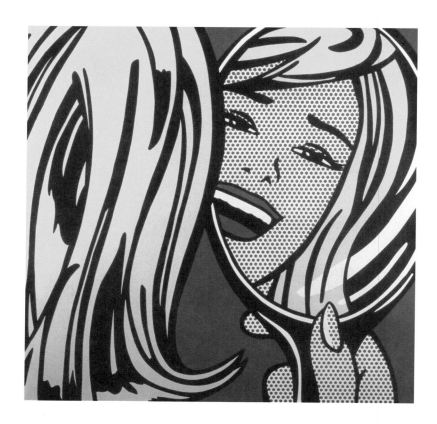

Roy Lichtenstein **Girl in Mirror** and **Eccentric Scientist**
(ill. 141 and 142) © Estate of Roy Lichtenstein/SODRAC (2008)

Claes Oldenburg **Geometric Mouse – Scale C** (ill. 143) © Claes Oldenburg

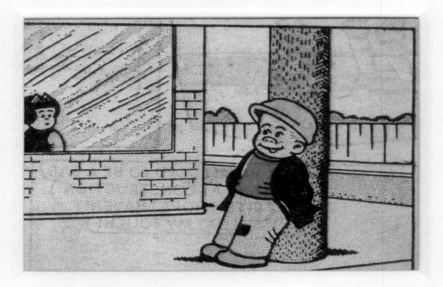

Marcel Broodthaers **Ombres chinoises**

MARCEL BROODTHAERS

Ombres chinoises 1973-1974

Marcel Broodthaers's *Ombres chinoises* is one of a handful of slide installations that he produced in the late 1960s and early 1970s. This is a seemingly simple work, nothing more than eighty slides, loaded into a slide projector, placed on a stand and projected onto the wall. The images are, for the most part, found images from popular visual culture – comics, illustrations and page plates culled from adventure stories, scientific textbooks, newspapers and illustrated books. Interspersed throughout are slides with the words "no photographs allowed," which appears in three different languages, written across them. Where artists such as René Magritte sought to point to the fundamental difference between the word and the object – *"Ceci n'est pas une pipe"* – Broodthaers aimed to collapse that difference, because no matter what we present – an object, a word, an image – it is still a representation. There is no real thing, no real art, only a context, and more often than not in the world of art, that context is the museum. The words "no photographs allowed," "photographieren verboten" and "défense de photographier" acknowledge our cultural anxiety around the question of the real and the representation and are another sharp dig at the museum. Often we will encounter that admonition in the museum, a building filled with representations, reproductions, illustrations, pictures and images of things. The museum can only confirm the primacy of its images when it denies the legitimacy of all other images.

Broodthaers's inclusion of slides of images from comics and illustrated books was intended to address a longstanding and widespread cultural anxiety regarding the hierarchy of images. In the context of the slideshow in a museum, the comics and illustrations become images among images, neither dominating nor being dominated by the other images in the space. In this context Broodthaers points to the traditional cultural hierarchies between images as a product of the museum's values, with images and words being the means by which those values are disseminated.

In many ways the slide show format chosen by Broodthaers is the perfect medium to address the character and meaning of images. The slide is both static and moving; it is an object and an image; it is one thing and many things. It is that slippage, that indeterminacy that is critical to Broodthaers's concept of art.

Bruce Grenville

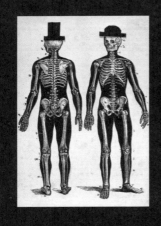

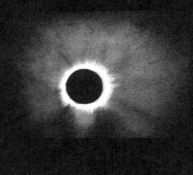

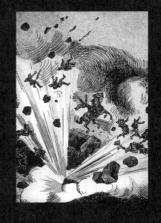

PHOTOGRAPHIEREN VERBOTEN

DEFENSE DE PHOTOGRAPHIER

RAYMOND PETTIBON

42 Drawings 1977-1985

In 1978 Raymond Pettibon had just graduated from UCLA and was working as a high-school teacher. That same year he published his first major zine, *Captive Chains*. Sixty-eight pages long with a glossy cover and newsprint interior, it included a number of pages of short comics drawn in a traditional grid format with a relatively straightforward narrative thrust. The drawings for "City Kids," for example, begin in a clean modernist style, restrained and simplified compositions that suddenly explode into an aggressive and awkward graphic style that amplifies the violence of the subject matter. Much of the rest of the zine was given over to full-page drawings, with or without text, that ranged widely in style and content but were largely focused on sex, violence and sports. On the publishing page for *Captive Chains* Pettibon highlighted what the zine would not offer: "in this issue: no bronze-skinned barbarians ... no lush science fiction, art nouveau, mythology ... ; no art as therapy for devotees of de Sade and Sacher-Masoch; no stories about peace-loving hippies vs. heartless authorities ... no superheroes for your kid brother."

In a paradox that is typical of Pettibon, this declaration is both true and false. On the one hand, his work from this period is entirely indebted to the genres and subjects that he lists, but on the other hand each instance of quotation from those genres is an act of theft without regard for the origins and intents of the images, and without any interest in attribution. Pettibon's decision to employ obscure images and genres from earlier decades, just old enough to be only vaguely familiar to his audience, allows him to produce a more complex form of irony than that offered by a simple appropriation of a current image or style. There is, in all of Pettibon's drawings of the late 1970s and early 1980s, a collision of meanings and pictorial logics that results in provocative and unsettling images. There is a parallel (but not an equivalence) in this work to the punk music that Pettibon supported during this time. The goal of that music was not simply to represent or describe an aggressive and belliger-ent state of being but rather to enact that state in the music. The same is true of Pettibon's drawing: his tight pen lines, aggressive brush strokes, sharp contours, shal-low depth, awkward perspectives, simplified colour palette and wildly unpredictable subject matter allow him, with every drawing made, to enact his resistance to a normative culture that imagines an equivalency between truth and representation.

Bruce Grenville

No Title (Not a hippie) (ill. 145)

No Title (These crabs are) (ill. 146) and *No Title (True Crime comics)* (ill. 147)

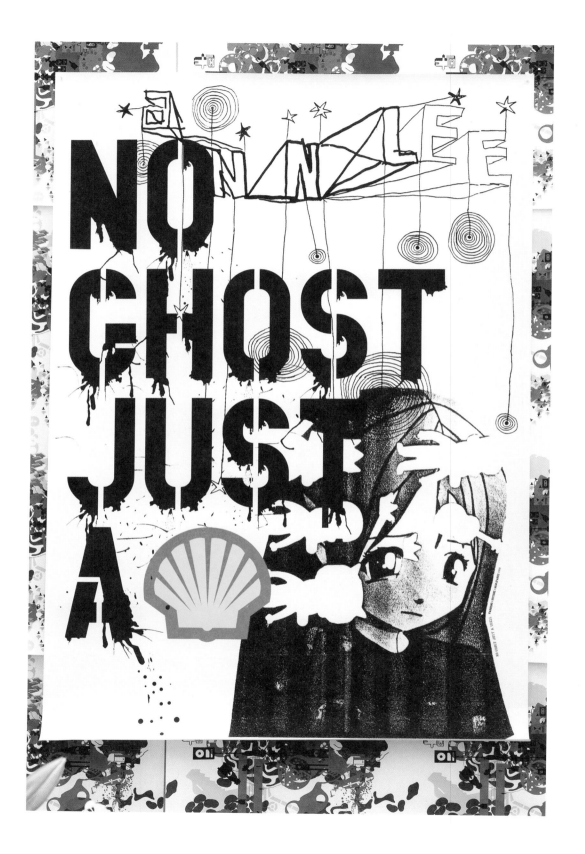

Pierre Huyghe & Philippe Parreno **No Ghost Just a Shell**

PIERRE HUYGHE & PHILIPPE PARRENO

No Ghost Just a Shell 1999–2002

No Ghost Just a Shell is a complex project composed of an ineffable subject distributed through an open-ended process of production. Pierre Huyghe describes it as "... a pagan project made of paradoxes and compromises. The origins of the project are slightly more pragmatic but do very little to unravel the paradoxes." The principal character of *No Ghost Just a Shell* is a manga character, chosen from a catalogue and bought from an agency that develops ready-made characters for manga, anime, video games and advertising production houses. This is a character, continues Philippe Parreno, "without a name, a two-dimensional image ... without a biography and without qualities, very cheap, which had a melancholic look, as if it were conscious of the fact that its capacity to survive stories was very limited."

In 2000, the character was given the name AnnLee, and a poster announcing her existence was designed by the Parisian graphic designers M/M (Paris); at that same time, Huyghe and Parreno presented videos in Paris. Later, videos by Dominique Gonzalez-Foerster, Liam Gillick, Rirkrit Tiravanija, Melik Ohanian, François Curlet, Pierre Joseph and Mehdi Belhaj-Kacem; more posters by M/M (Paris) and videos by Huyghe and Parreno; texts and publications by Molly Nesbit, Israel Rosenfield, Maurice Pianzola, Jan Verwoert, Katherine Davis, Lili Fleury, Hans Ulrich Obrist, Jean-Claude Ameisen and Luc Saucier; music by Anna Lena Vaney; and paintings and sculptures by Richard Phillips, Henri Barande, Joe Scanlan, Angela Bulloch and Imke Wagener were all added to the project. As a final gesture, AnnLee was freed from the original conditions of her representation by a legal agreement that ceded the rights of her character to an association that has agreed to withdraw it from the realm of representation.

While there was no intent on the part of the artists to propose a parallel discourse to that offered by director Mamoru Oshii in his 1995 film *Ghost in the Shell*, which was a meditation on the nature of being in a future world where human and artificial intelligence could freely merge, it is worth acknowledging the similarity between the distributed nature of anime film production, with its multiple authors and producers whose own narratives are written into the characters, and the distributed nature of Pierre Huyghe and Philippe Parreno's project, where the many authors and artists were given a voice through the character of AnnLee.

Bruce Grenville

Pierre Huyghe & Philippe Parreno, *Skin of Light* (ill. 149)
and François Curlet, *Witness Screen/Écran Témoin* still (ill. 150)

CAO FEI

Cosplayers 2004

Cosplayers, or "costume players," are people who dress up in costumes in imitation of fictional characters they admire from manga, anime and video games. Some wear homemade costumes; others buy them from specialty stores. The cosplayers then come together in groups to see and be seen. Most cosplay events take place in the most banal public settings – city streets, convention centres – creating a wonderful incongruity between the fantastic costumes and the prosaic backdrops. In her 2004 video *Cosplayers*, Cao Fei highlighted this discrepancy. Set in Guangzhou, Cao Fei's home base and the principal port in the Pearl River Delta of southern China, the video documents the convulsive economic and urban growth that has defined this burgeoning city in the past twenty years. Moving swiftly across the closely linked urban, suburban and rural areas that define Guangzhou, the cosplayers act out their drama. Their fantasy world seems no more or less improbable than the architecture they move through.

While one might interpret the video as a straightforward critique of capitalist fantasy and indolent youth culture, Cao Fei seems to suggest that these cosplayers and their public actions also mark the locus of a more complex and ambiguous set of symbolic exchanges. The public presence of these costumed characters is an act of resistance to the banal realities of everyday life on the part of a generation of Chinese adolescents who have the economic and political freedom to imagine another type of existence. By embracing a complex fantasy world of elegant violence and magical powers, they are rejecting the symbolic violence enacted on them by a culture that devalues the imaginary, the game and the masquerade. Against the forces of conformity the cosplayers assert their identity – an identity that is fluid and contingent and subject to the whims of taste, the superficiality of their characters' personality and identity and the vagaries of community life; for a cosplayer is nothing, or nobody, without a community of players.

Much of Cao Fei's work focuses on this notion of situational communities – communities that are not defined by geography, political bureaucracy or corporations but are the product of affect and desire. Cosplayers come together as individuals, gathering in public and private spaces to trace the shape of a community upon the amorphous and resistant surfaces of our urban spaces.

Bruce Grenville

Video stills (ill. 151)

Video stills (ill. 151)

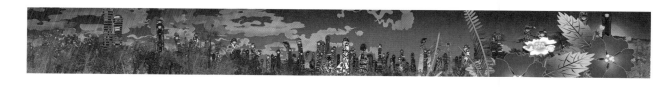

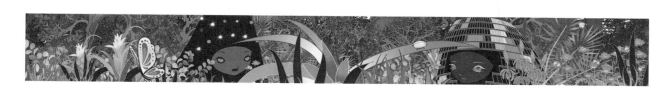

Chiho Aoshima **City Glow**

CHIHO AOSHIMA

City Glow 2005

Chiho Aoshima's *City Glow* (2005) is a phantasmagoric presence: a shifting landscape of uncanny figures, luminescent buildings and abundant vegetation in a world driven by impulses that seem incomprehensible, or at least unfamiliar. *City Glow* is a world of constant flux and movement – from day to night, light to dark, birth to death, and back again – an endless stream of becoming. The scale and the speed of the transformations confirm that this is not a world of singular or static beings. There is no equilibrium in the conventional sense but rather a recognition that morphogenesis is a fundamental state of being in the natural world. In the world of *City Glow* even the buildings are defined by these principles. They flux and flow like worms, glowing with a bioluminescent light that comes from within. This luminescence extends to all the figures and forms in the work so that when the scene turns from day to night an uncanny light defines and shapes each element.

Although it is tempting, and often fruitful, to cite the broad range of cultural references in Aoshima's work – from traditional screen painting and Shintoism to *kawaii* (cute) figures and *shojo* (girls') manga – it is equally important to address her use of new media to create images that would have been impossible to imagine only a few years ago. Aoshima's video embraces some of the fundamental principles and techniques used in contemporary anime and cartoons – process-based media that rely on computer-generated imaging technologies, especially computer graphics (CG) processes. CG elements are easily manipulated in scale and colour so that a constantly evolving image is natural to the medium. It is very easy to scale the elements of a scene, or figure up or down in size, and apply movement to the component parts. Aoshima uses the elasticity and distortion that is common to the exaggerated emotions and actions of anime and cartoons for very different purposes. In this five-monitor, seven-minute animated video, she gives the polymorphous figures of her two-dimensional prints and wall murals the movement and character we can only imagine exists in her static images. By adding movement through time and space, Aoshima helps us understand her fascination in describing the fundamental nature of the world.

Bruce Grenville

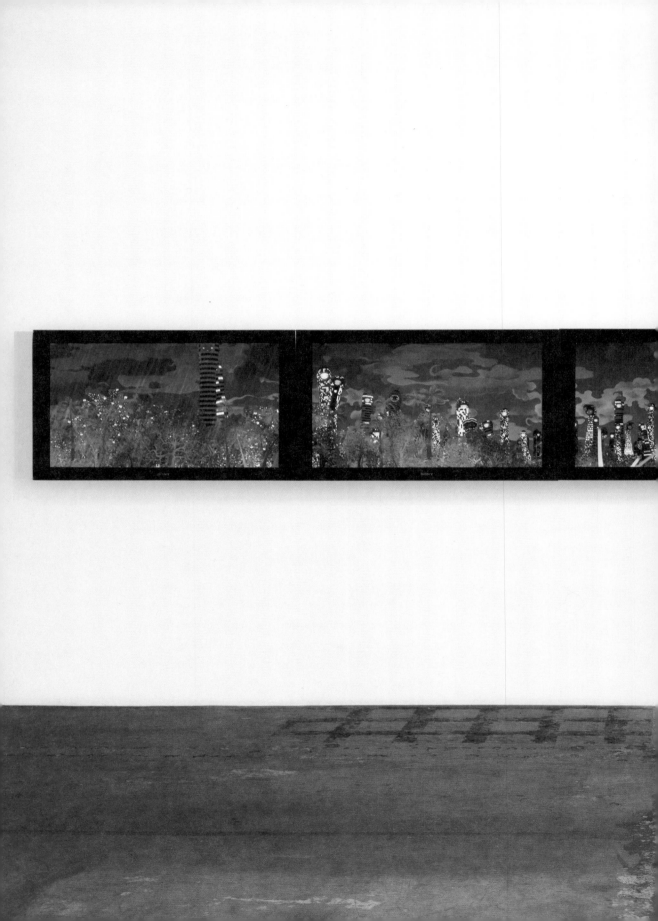

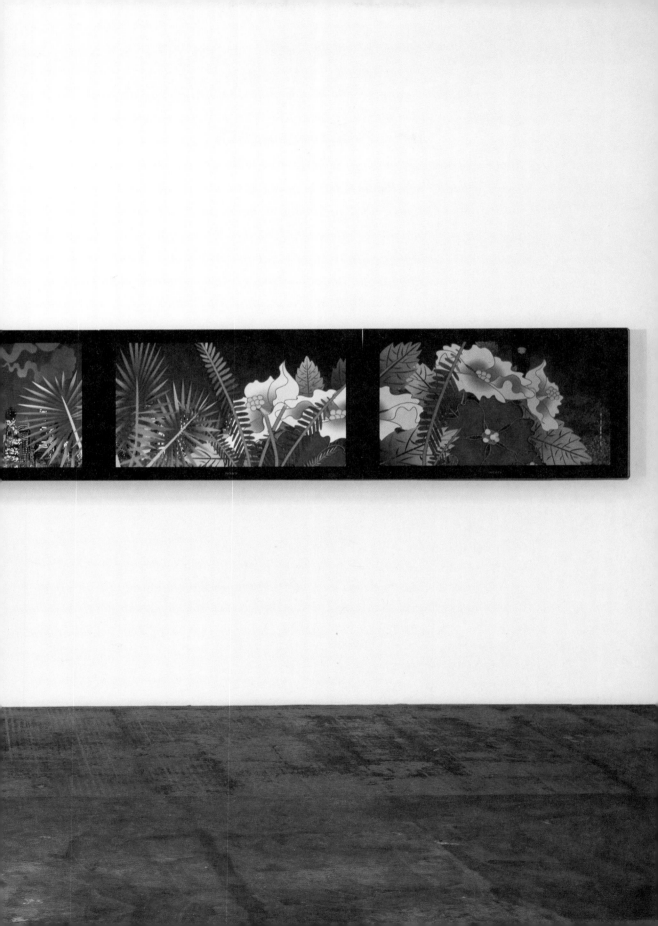

CHRISTIAN MARCLAY

Onomatopœia 2006

Comics are an art of words and images, a sequential narrative pushed forward by persistent imbalance between the two. Just as you learn to walk by discovering the power of disequilibrium to propel you forward, so too do the most effective comics seek out and exploit the imbalance between word and image, driving the reader across the page, leaping from image to text and text to image along the narrative arc. While onomatopœia wasn't invented by comic artists, it was creatively exploited by many who saw an unprecedented opportunity to link the aural, the visual and the textual in one convulsive image. And although Christian Marclay isn't the first visual artist to recognize the graphic power of the comic book image, he is among a handful that have seized upon its capacity to link sound, image and text.

Marclay's practice – one that comprises music, film, photography, video and performance – is a hybrid position in dialogue with artists such as Marcel Duchamp, Andy Warhol, Marcel Broodthaers and Bruce Nauman. And like the Dada and Fluxus artists, Marclay recognizes the poetics of the collage process and the fundamental link between image and language. The collage techniques he uses in his recent prints finds a parallel in his earlier sound-based works, in which he cut apart records, reconfigured and glued them, then played them on turntables. The prints are made up of words torn from the pages of action comic books, then collaged, enlarged and reprinted on large single sheets of paper. The violent rips and tears that define the edges of the words create their own explosive sound-images.

While onomatopœtic texts are used in comics to accentuate a critical moment in the narrative, a climax or dénouement, Marclay finds a very different purpose for them. He collapses the visual and the textual, distorting, extending and compounding the image/text so that sound, an almost forgotten but fundamental part of the equation, assumes a dominant position. In fact, Marclay makes clear his belief that both sound and silence are fundamentally important to any narrative. The image/text produces a sound in the reader's head, a sound that may or may not be uttered but is nonetheless heard, and no more so than in the hybrid form of the comic and manga where a sophisticated economy of signs allows for a compressed and dynamic narrative.

Bruce Grenville

20

9

Whomp (ill. 154)

Visshh! (ill. 155) and *Shtoom* (ill. 156)

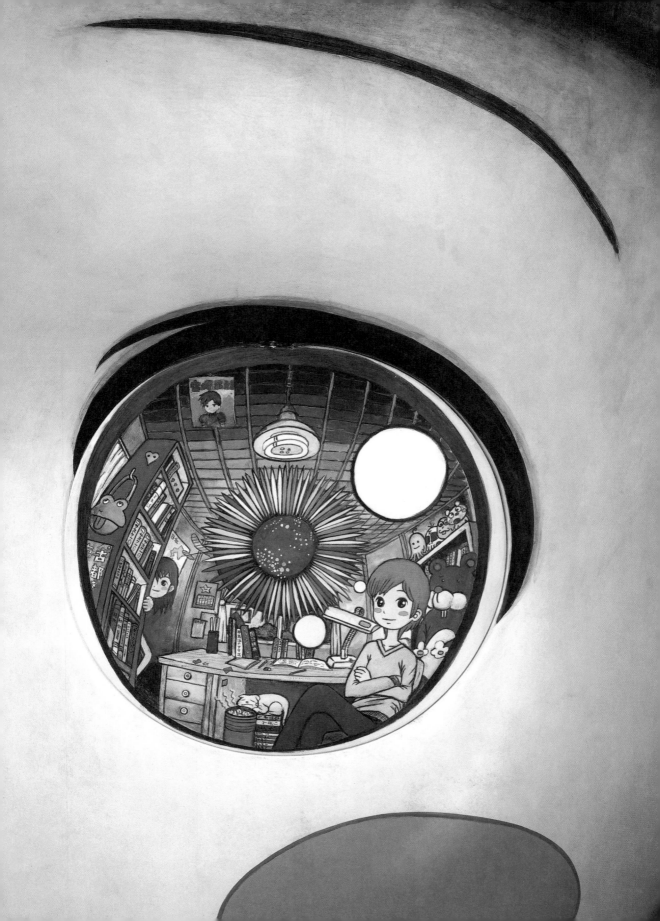

MR.

Strawberry Voice 2007

Strawberry Voice (2007) is the culmination of a body of work that has preoccupied much of Mr.'s art practice for the past ten years. Working in a wide variety of media — painting, drawing, video, performance, sculpture — he has obsessively produced images of prepubescent girls and boys. His many drawings of girls rendered on shopping receipts from convenience stores and supermarkets are at once compulsive and quotidian. The endless repetition of a character type in a standardized set of poses and compositional configurations is a nod to the commercialized origins of these images. But it also hints at a sort of fan-based, obsessive repetition and accumulation of images, objects and knowledge that is often linked to *otaku* culture in Japan.

Mr.'s focus on images of prepubescent girls and boys closely parallels the subjects and stylistic tropes of the "lolicom" genre of Japanese anime and manga. In this context, lolicom — a portmanteau of "Lolita complex" — might be described as both a psychological condition and a subject field within visual culture.

There is a confusing blend of sexuality and innocence in *Strawberry Voice* that, in a Western context, is reminiscent of Lewis Carroll's *Alice in Wonderland*. This is a world of hallucinogenic shifts in scale and perspective, a head so large that it seems to stretch the boundaries of the room, so distorted and disembodied that it can only be the product of an altered state of mind. There is a profound intent to confuse the inner and outer, surface and depth, the real and imaginary, so that we are left to doubt the very stability of the world we just left or must return to.

The child is a persistent and fundamental theme in Japanese visual culture, visible in many of the anime and manga included in this project, such as *Akira*, *Black & White*, *The Girl Who Leapt through Time* and *The Place Promised in Our Early Days*. These children are most often in conflict with authorities, and their logic and criteria interrupt societal conventions, psychic equilibriums, normative scale, authoritative hierarchies and conventional sexualities. They aren't simply *kawaii* (cute) characters but are complex protagonists, active agents of change who undermine and reveal the biases of an adult world that has betrayed them.

Bruce Grenville

Detail (ill. 157) and installation view (overleaf, ill. 158). Courtesy Lehmann Maupin Gallery, New York

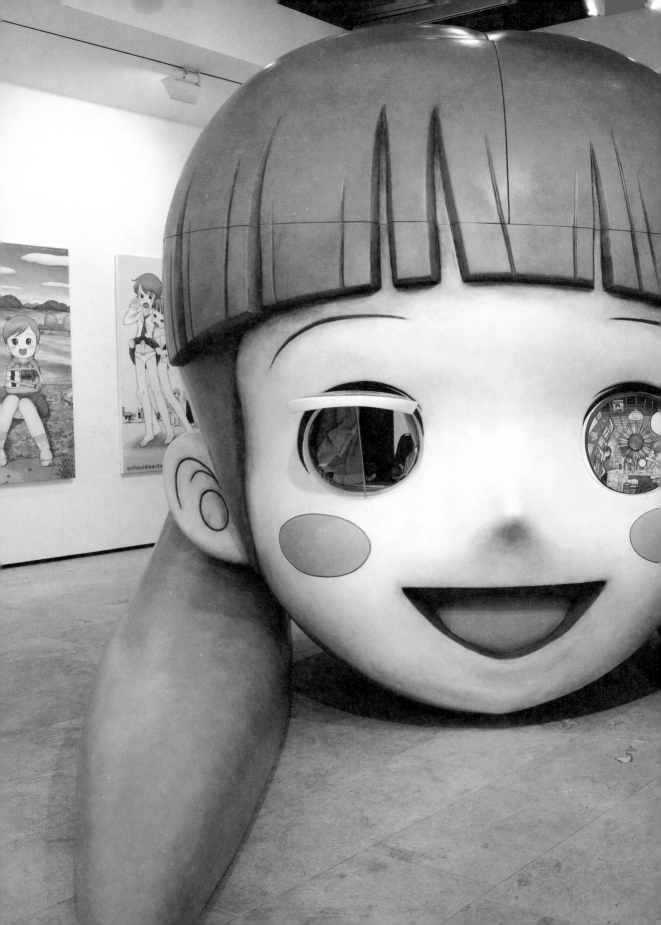

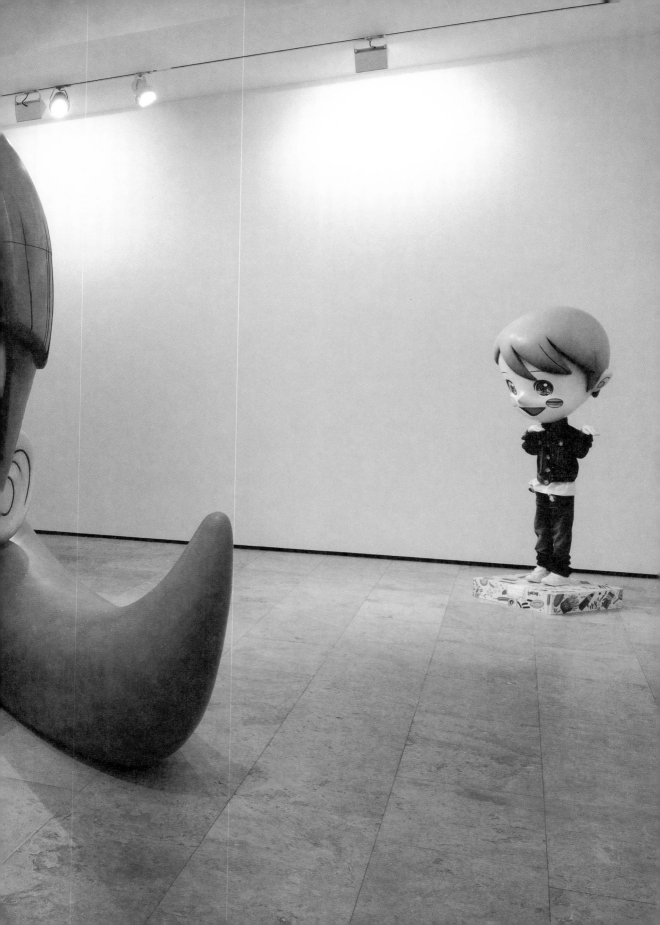

LIST OF ILLUSTRATIONS

The following list includes all the artworks in this book, in order of appearance. Note that illustrations 1–8 do not have captions where they appear, on pages i to 10, but are fully described in the list below. A complete list of works in the accompanying exhibition is available at http://projects.vanartgallery.bc.ca/KRAZY_list_of_works.pdf.

All measurements given in centimetres (height precedes width precedes depth).

Every reasonable effort has been made to acknowledge the ownership of copyright images included in this volume. Any errors that may have occurred are inadvertent and will be corrected in subsequent editions provided notification is sent to the publisher.

1
[Inside front cover]
Seth
George Sprott (1894-1975) – Chapter 20 [detail]
Published in *The New York Times Magazine*, February 19, 2007
29.2 x 24.2
Photo courtesy of Drawn and Quarterly

2
[Page 1]
Art Spiegelman
Portrait of the Artist as a Young %@&! – Pop Art* [detail of panel study], 2006

ink and marker on paper
10.2 x 11.1
Collection of the artist
Photo: Trevor Mills, Vancouver Art Gallery

3
[Page 2]
Buck Lewis
Over the Hedge [detail of "RJ" sketch], 2002
coloured pencil on paper
27.9 x 43.2
Collection of DreamWorks Animation
Used courtesy of DreamWorks Animation
Over the Hedge
® & © 2006 DreamWorks Animation LLC.
All Rights Reserved.

4
[Page 3]
Satoshi Kon
Paprika [detail of film still]
Madhouse Productions, 2006
DVD
90 minutes
Courtesy of Sony Pictures Home Entertainment, Inc.
© 2006 Madhouse/Sony Pictures Entertainment (Japan) Inc.

5
[Page 4]
Yuichi Yokoyama
New Engineering: Book [detail of page 5]
Published by East Press, Tokyo, 2004
21.0 x 14.9
Courtesy of East Press, Tokyo and Picture Box, Inc., Brooklyn
© Yuichi Yokoyama

6
[Page 5]
Christian Marclay
Whomp [detail], 2006
pigment print on Arches paper
109.9 x 145.0
Courtesy of Jay Jopling/White Cube (London) and the artist

7
[Pages 6-7]
Will Wright
Spore [screenshot]
Developed by Maxis and published by Electronic Arts, 2008
Microsoft Windows computer game
SPORE™ © 2006 Electronic Arts Inc.

8
[Page 10]
Will Wright
The Sims [hot dog vendor figure]
Developed by Maxis and published by Electronic Arts, 2008
Microsoft Windows computer game
The Sims™ © 2006 Electronic Arts Inc.

9
Anna-Lena Vaney
Asleep in the Deep: AnnLee No Ghost Just a Shell [detail], 2003
from *No Ghost Just a Shell*, 1999–2002
vinyl record and mini CD
Designed at M/M (Paris)
© 2003 ANNLEE NO GHOST JUST A SHELL

10
George Herriman

Krazy Kat [detail of preliminary drawing], 1944
ink and pencil on Bristol board
33.0 x 42.5
Collection of Tim Samuelson and Chris Ware
Photo courtesy of Chris Ware
© 2008 King Features Syndicate, Inc.
™ Hearst Holdings, Inc.

11
Gertie the Dinosaur [film poster], 1914
From *Winsor McCay: The Master Edition*
published by Milestone Film & Video
Courtesy of Milestone Films and John Canemaker

12
Art Spiegelman
Maus – Chapter 3: Prisoner of War [booklet cover]
Published in *RAW #4*, March 1982
22.7 x 15.2
Collection of the artist
Photo: Una Knox, Vancouver Art Gallery

13
Katsuhiro Otomo
Akira Part 1 [published cover]
Published by Kodansha, 1984
18.0 x 25.8
First published by *Young Magazine*, Kodansha Ltd.
© Mash·Room Co. Ltd, Tokyo.
All Rights Reserved.
Photo: Trevor Mills, Vancouver Art Gallery

14
Atelier Bow-Wow
Manga Pod, 2002
Installation view at the
4th Gwangju Biennale,
Korea, 2002
Photo courtesy of Atelier
Bow-Wow
© Atelier Bow-Wow

15
George Herriman
Krazy Kat [Sunday Page]
Published in syndicated
U.S. newspapers,
October 1, 1939
39.5 x 27.5
Photo: Trevor Mills,
Vancouver Art Gallery
© 2008 King Features
Syndicate, Inc.
™ Hearst Holdings, Inc.

16
George Herriman
Krazy Kat [preliminary
drawing], 1944
ink and pencil
on Bristol board
33.0 x 42.5
Collection of Tim
Samuelson and Chris Ware
Photo courtesy of Chris
Ware
© 2008 King Features
Syndicate, Inc.
™ Hearst Holdings, Inc.

17
Harvey Kurtzman
Corpse on the Imjin
[1st page, final drawing],
1952
pen and ink with coloured
pencil and opaque white
on paper
56.0 x 37.8
Collection of Glenn Bray
Corpse on the Imjin
material reproduced with
the permission of William
M. Gaines, Agent, Inc.
Photo: Robert Wedemeyer

18
Harvey Kurtzman
Corpse on the Imjin
[detail of 3rd page, final
drawing], 1952
pen and ink with coloured
pencil and opaque white
on paper
50.8 x 35.6
Collection of Glenn Bray
Corpse on the Imjin
material reproduced with
the permission of William
M. Gaines, Agent, Inc.
Photo: Robert Wedemeyer

19
Harvey Kurtzman
Corpse on the Imjin
[6 pages]
Published in *Two-Fisted
Tales #25*, EC Publications,
February 1952
26.0 x 18.5 each
Corpse on the Imjin
material reproduced with
the permission of William
M. Gaines, Agent, Inc.
Photo: Trevor Mills,
Vancouver Art Gallery

20
Justin Green
*Binky Brown Meets the
Holy Virgin Mary*
[published cover]
Published by Last Gasp,
1972
25.3 x 18.0
Photo: Trevor Mills,
Vancouver Art Gallery

21
Justin Green
*Binky Brown Meets the
Holy Virgin Mary* [page 7,
final drawing], 1971–1972
ink, paint and shading film
on paperboard
48.0 x 34.6
Collection of Christine
Valenza with thanks to
Albert Morse and his
passion for comic art.

Photo: Trevor Mills,
Vancouver Art Gallery

22
Justin Green
*Binky Brown Meets the
Holy Virgin Mary*
[page 38, final drawing],
1971–1972
ink, paint and shading film
on paperboard
48.8 x 34.6
Collection of Christine
Valenza with thanks to
Albert Morse and his
passion for comic art.
Photo: Trevor Mills,
Vancouver Art Gallery

23
Jerry Moriarty
Jack Survives [cover for
*The Complete Jack
Survives*, final drawing],
2007
acrylic on Bristol board
61.0 x 45.7
Collection of the artist
Photo courtesy of the
artist and Buenaventura
Press

24
Jerry Moriarty
Jack Survives
[final drawing], 1980
India ink and acrylic
on Arches paper
61.0 x 45.7
Collection of the artist
Photo courtesy of the
artist and Buenaventura
Press

25
Jerry Moriarty
Jack Survives
[final drawing], 1979
India ink and acrylic
on Arches paper
61.0 x 45.7
Collection of the artist
Photo courtesy of the artist
and Buenaventura Press

26
Lynda Barry
One Hundred Demons
[detail of cover, final
drawing], 2002
collage on paper
19.0 x 28.0
Collection of the artist
Photo: Trevor Mills,
Vancouver Art Gallery

27
Lynda Barry
*One Hundred Demons –
Resilience* [2nd page,
final drawing], 2000
ink on paper
21.5 x 28.0
Collection of the artist
Photo: Trevor Mills,
Vancouver Art Gallery

28
Lynda Barry
*One Hundred Demons –
Resilience* [3rd page,
final drawing], 2000
ink on paper
21.5 x 28.0
Collection of the artist
Photo: Trevor Mills,
Vancouver Art Gallery

29
Lynda Barry
*One Hundred Demons –
Resilience* [4th page,
final drawing], 2000
ink on paper
21.5 x 28.0
Collection of the artist
Photo: Trevor Mills,
Vancouver Art Gallery

30
Lynda Barry
*One Hundred Demons –
Resilience* [5th page,
final drawing], 2000
ink on paper
21.5 x 28.0
Collection of the artist
Photo: Trevor Mills,
Vancouver Art Gallery

31
Chris Ware
Thanksgiving –
Conversation
Published in *The New*
Yorker, November 27,
2006
27.2 x 20.1
Photo courtesy of the
artist and *The New Yorker*

32
Chris Ware
Building Stories
Published in *Nest:*
A Quarterly of Interiors,
Spring 2004
22.0 x 28.0
Photo courtesy of
the artist

33
Kevin Huizenga
Jeepers Jacobs
[4th page]
Published in *Curses*,
Drawn and Quarterly,
2006
26.6 x 20.2
Photo courtesy of
the artist

34
Kevin Huizenga
Jeepers Jacobs
[sketchbook page], 2004
pencil and felt pen
on paperboard
25.5 x 17.0
Collection of the artist
Photo: Trevor Mills,
Vancouver Art Gallery

35
Kevin Huizenga
Jeepers Jacobs
[4th page, final drawing],
2004
pencil and ink on
paperboard
43.2 x 35.6
Collection of the artist
Photo: Trevor Mills,
Vancouver Art Gallery

36
Seth
George Sprott
(1894-1975) – Chapter 13
Published in *The New*
York Times Magazine,
January 7, 2007
29.2 x 24.2
Copyright © 2007 The
New York Times Company.
Reprinted with permission.
Photo: Trevor Mills,
Vancouver Art Gallery

37
Seth
George Sprott
(1894-1975) – Chapter 13
[production rough
drawing], 2007
pencil, ink and coloured
pencil on paper
28.0 x 43.2
Collection of the artist
Photo: Trevor Mills,
Vancouver Art Gallery

38
Milt Gross
He Done Her Wrong:
The Great American Novel
and Not a Word in It –
No Music, Too
[detail of published page]
Published by Doubleday,
Doran & Company, Inc.,
1930
20.1 x 17.8
Photo: Trevor Mills,
Vancouver Art Gallery

39
Milt Gross
He Done Her Wrong:
The Great American Novel
and Not a Word in It –
No Music, Too
[two published pages]
Published by Doubleday,
Doran & Company, Inc.,
1930
20.1 x 17.8 each
Photo: Trevor Mills,
Vancouver Art Gallery

40
Philip Guston
Poor Richard
[detail of page 23,
final drawing], 1971
China ink on paper
26.7 x 35.3
© The Estate of Philip
Guston, Courtesy of
McKee Gallery, New York
Photo: Trevor Mills,
Vancouver Art Gallery

41
Philip Guston
Poor Richard [page 1,
final drawing], 1971
China ink on paper
26.7 x 35.3
© The Estate of Philip
Guston, Courtesy of
McKee Gallery, New York
Photo: Trevor Mills,
Vancouver Art Gallery

42
Philip Guston
Poor Richard [page 7,
final drawing], 1971
China ink on paper
26.7 x 35.3
© The Estate of Philip
Guston, Courtesy McKee
of Gallery, New York
Photo: Trevor Mills,
Vancouver Art Gallery

43
Philip Guston
Poor Richard [page 20,
final drawing], 1971
China ink on paper
26.7 x 35.3
© The Estate of Philip
Guston, Courtesy of
McKee Gallery, New York
Photo: Trevor Mills,
Vancouver Art Gallery

44
Philip Guston
Poor Richard [page 23,
final drawing], 1971
China ink on paper
26.7 x 35.3
© The Estate of Philip
Guston, Courtesy of
McKee Gallery, New York
Photo: Trevor Mills,
Vancouver Art Gallery

45
Art Spiegelman
Maus [page 1, final
drawing], 1972
ink and Zipatone
on Bristol board
45.7 x 30.5
Collection of the artist
Photo: Una Knox,
Vancouver Art Gallery

46
Art Spiegelman
Don't Get Around Much
Anymore [final drawing],
1974
ink, Zipatone and photo
collage on Bristol board
50.8 x 41.3
Collection of the artist
Photo: Una Knox,
Vancouver Art Gallery

47
Art Spiegelman
Pop Art
Published in *Breakdowns:*
Portrait of the Artist as
a Young %@&!*,
Pantheon Books, 2008
digital image
Courtesy of the artist

48
Kim Deitch
Boulevard of Broken
Dreams [page 1,
final drawing], 1991
pencil and ink on card
35.5 x 28.0
Collection of the artist
Photo: Trevor Mills,
Vancouver Art Gallery

49
Kim Deitch
Boulevard of Broken

Dreams [pencil sketch],
1991
pencil on paper
28.0 x 21.5
Collection of the artist
Photo: Trevor Mills,
Vancouver Art Gallery

50
Kim Deitch
*Boulevard of Broken
Dreams* [pencil sketch],
1991
pencil on paper
28.0 x 21.5
Collection of the artist
Photo: Trevor Mills,
Vancouver Art Gallery

51
Kim Deitch
*Boulevard of Broken
Dreams* [page 39,
final drawing], 1991
pencil and ink on card
35.5 x 28.0
Collection of the artist
Photo: Trevor Mills,
Vancouver Art Gallery

52
Daniel Clowes
David Boring
[detail of page 112,
final drawing], 1999
ink on paperboard
50.8 x 36.2
Collection of the artist
Photo: Trevor Mills,
Vancouver Art Gallery

53
Daniel Clowes
David Boring [pages 2-3,
final drawing], 1997
ink on paperboard
50.8 x 72.4
Collection of the artist
Photo: Trevor Mills,
Vancouver Art Gallery

54
Chester Brown
Louis Riel: A Comic Strip

Biography [page 163]
Published by Drawn and
Quarterly, 2003
22.8 x 15.0
Photo courtesy of Drawn
and Quarterly
© Chester Brown, 2002

55
Chester Brown
*Louis Riel: A Comic Strip
Biography* [panel 77,
final drawing], 2001
ink on paper
18.5 x 19.3
Collection of the artist
Photo: Trevor Mills,
Vancouver Art Gallery
© Chester Brown, 2002

56
Chester Brown
*Louis Riel: A Comic Strip
Biography* [panel 113,
final drawing], 2001
ink on paper
19.0 x 18.5
Collection of the artist
Photo: Trevor Mills,
Vancouver Art Gallery
© Chester Brown, 2002

57
Alison Bechdel
*Fun Home: A Family
Tragicomic* [page 144]
Published by Houghton
Mifflin Harcourt Publishing
Company, 2006
22.9 x 15.2
Copyright © 2006 by
Alison Bechdel. Used by
Permission of Houghton
Mifflin Harcourt
Publishing Company.
All Rights Reserved.
Photo: Trevor Mills,
Vancouver Art Gallery

58
Alison Bechdel
*Fun Home: A Family
Tragicomic* [page 144,
line art], 2005

pencil and India ink
on paper
35.6 x 28.0
Collection of the artist
Copyright © 2006 by
Alison Bechdel. Used by
Permission of Houghton
Mifflin Harcourt
Publishing Company.
All Rights Reserved.
Photo: Trevor Mills,
Vancouver Art Gallery

59
Alison Bechdel
*Fun Home: A Family
Tragicomic* [page 144,
preliminary drawing],
2005
pencil and India ink
on paper
28.0 x 21.6
Collection of the artist
Copyright © 2006 by
Alison Bechdel. Used by
Permission of Houghton
Mifflin Harcourt
Publishing Company.
All Rights Reserved.
Photo: Trevor Mills,
Vancouver Art Gallery

60
Shaun Tan
The Arrival [page 9,
final drawing], 2006
pencil on paper
23.5 x 33.0
Collection of the artist
Photo courtesy of the
artist and Lothian Books,
Melbourne

61
Shaun Tan
The Arrival [page 47, first-
dummy drawing], 2002
pencil and tape on paper
20.0 x 26.0
Collection of the artist
Photo courtesy of the
artist and Lothian Books,
Melbourne

62
Shaun Tan
The Arrival [page 47,
final drawing], 2006
pencil on paper
23.5 x 33.0
Collection of the artist
Photo courtesy of the
artist and Lothian Books,
Melbourne

63
Winsor McCay
Gertie the Dinosaur
[film stills]
Box Office Attractions,
1914
35 mm transferred to DVD
12 minutes
Stills from *Winsor McCay:
The Master Edition*
published by Milestone
Film & Video
Courtesy of Milestone Films
and the Cinémathèque
québécoise

64
Winsor McCay
Gertie the Dinosaur
[no. 310, production
drawing], 1914
ink on rice paper
18.5 x 23.5
Woody Gelman Collection,
The Ohio State Cartoon
Research Library
Photo courtesy of
The Ohio State Cartoon
Research Library

65
Lotte Reiniger
*The Adventures of Prince
Achmed* [cut-out
silhouette], 1926
cardboard, chalk, wax,
wire
22.0 x 19.0
Collection of the
Filmmuseum Düsseldorf,
Germany
Photo: Horst Kolberg

66
Lotte Reiniger
*The Adventures of Prince
Achmed* [film stills]
Comenius-Film
Production, 1926
35 mm film transferred
to DVD
72 minutes
Stills from *The Adventures
of Prince Achmed*
published by Milestone
Film & Video
Courtesy of Milestone
Film and the British Film
Institute
© 2001 Primrose Film
Production Ltd.

67
Lotte Reiniger
*The Adventures of Prince
Achmed* [cut-out
silhouette], 1926
cardboard, chalk, wire
21.0 x 20.0
Collection of the
Filmmuseum Düsseldorf,
Germany
Photo: Horst Kolberg

68
Lotte Reiniger
*The Adventures of Prince
Achmed* [cut-out
silhouette], 1926
cardboard, chalk, wax, wire
22.0 x 18.0
Collection of the
Filmmuseum Düsseldorf,
Germany
Photo: Horst Kolberg

69
Mary Blair
Dumbo [storyboard
panel], 1941
watercolour on paper
21.0 x 22.2
The Glad Family Trust
© Disney Enterprises, Inc.

70
Ben Sharpsteen

Dumbo [film stills]
Walt Disney Productions,
1941
35 mm film transferred
to DVD
64 minutes
© Disney Enterprises, Inc.

71
Robert Cannon
Gerald McBoing Boing
[production cel and
background], 1950
ink and paint on Mylar
and paper
26.7 x 31.8
The Glad Family Trust
All Rights Reserved.
Courtesy of Columbia
Pictures
Photo courtesy of
Amid Amidi

72
Robert Cannon
Gerald McBoing Boing
[film stills]
United Productions
of America, 1951
35 mm transferred
to DVD
8 minutes
All Rights Reserved.
Courtesy of Columbia
Pictures

73
Robert Cannon
Gerald McBoing Boing
[production cel and
background], 1950
ink and paint on Mylar
and paper
26.7 x 31.8
The Glad Family Trust
All Rights Reserved.
Courtesy of Columbia
Pictures
Photo courtesy of
Amid Amidi

74
Robert Cannon

Gerald McBoing Boing
[production cel and
background], 1950
ink and paint on Mylar
and paper
26.7 x 31.8
The Glad Family Trust
All Rights Reserved.
Courtesy of Columbia
Pictures
Photo courtesy of
Amid Amidi

75
Marv Newland
Black Hula [scene 6,
production background
and cel set-up], 1988
ink and paint on Mylar
and paper
28.6 x 37.2
Collection of the artist
Photo: Trevor Mills,
Vancouver Art Gallery

76
Marv Newland
Black Hula [film stills]
International Rocketship
Limited, 1988
35 mm film
5 minutes

77
Nick Park
The Wrong Trousers
[detail of film still]
Aardman Animations,
1993
DVD
30 minutes
© 2007 Aardman
Animations Ltd.

78
Nick Park
The Wrong Trousers
[scene 59, storyboard],
1992
pencil on paper
7.0 x 5.0
Collection of Aardman
Animations

The Wrong Trousers
© 1993 Aardman/W&G Ltd.

79
Nick Park
The Wrong Trousers
[scene 59, storyboard],
1992
pencil on paper
7.0 x 5.0
Collection of Aardman
Animations
The Wrong Trousers
© 1993 Aardman/W&G Ltd.

80
Nick Park
The Wrong Trousers
[film stills]
Aardman Animations,
1993
DVD
30 minutes
© 2007 Aardman
Animations Ltd.

81
Bud Luckey
Toy Story [storyboard],
1995
pencil on paper
14.0 x 21.6
Pixar artwork is on loan
from the archives of Pixar
Animation Studios.

82
Bud Luckey
Toy Story [storyboard],
1995
pencil on paper
14.0 x 21.6
Pixar artwork is on loan
from the archives of Pixar
Animation Studios.

83
Ralph Eggleston
Toy Story [sequence
pastel, Green army men],
1995
pastel on paper
10.2 x 20.9
Pixar artwork is on loan

from the archives of Pixar Animation Studios.

84
Bob Pauley
Toy Story [Martian Model Packet Drawing], 1995
pencil on paper
21.6 x 45.7
Pixar artwork is on loan from the archives of Pixar Animation Studios.

85
Jason Katz
Toy Story [storyboard], 1995
pencil and marker on paper
14.0 x 21.6
Pixar artwork is on loan from the archives of Pixar Animation Studios.

86
Joe Ranft
Toy Story [storyboard], 1995
pencil and ink on paper
14.0 x 21.6
Pixar artwork is on loan from the archives of Pixar Animation Studios.

87
Joe Ranft
Toy Story [storyboard], 1995
pencil and ink on paper
14.0 x 21.6
Pixar artwork is on loan from the archives of Pixar Animation Studios.

88
Tim Johnson and Karey Kirkpatrick
Over the Hedge [focus test], 2006
digital image
Courtesy of DreamsWorks Animation
® & © 2006 DreamWorks Animation LLC.
All Rights Reserved.

89
Tim Johnson and Karey Kirkpatrick
Over the Hedge [film still]
DreamWorks Animation, 2006
35 mm transferred to DVD
87 minutes
Courtesy of DreamWorks Animation
® & © 2006 DreamWorks Animation LLC.
All Rights Reserved.

90
Tim Johnson and Karey Kirkpatrick
Over the Hedge [colour-key thumbnails], 2006
digital images
Courtesy of DreamWorks Animation
® & © 2006 DreamWorks Animation LLC.
All Rights Reserved.

91
Toru Iwatani
Pac-Man [screenshots and characters]
Developed by NAMCO, 1980
arcade game
Courtesy of NAMCO BANDAI Games America Inc.
PAC-MAN® © 1980 NAMCO BANDAI Games America Inc.

92
Shigeru Miyamoto
Super Mario World™ [character art and screenshots]
Developed and published by Nintendo, 1991
Super NES game
Courtesy Nintendo

93
Sid Meier
Sid Meier's Civilization [screenshots]
Developed and published by MicroProse, 1991

MS-DOS computer game
© Firaxis Games, Inc.

94
id Software
QUAKE [box cover art and screenshots]
Developed and published by id Software, 1996
Microsoft Windows computer game
© 1996 id Software, Inc.
All Rights Reserved.

95
Robin Walker, John Cook and Ian Caughley
Team Fortress [screenshot], 1996
QUAKE multiplayer mod

96
Neil Manke
Starship [screenshots]
Developed and published by Black Widow Games, 1997
QUAKE multiplayer mod

97
Neil Manke
Soldier of Fortune [screenshots]
Developed by Black Widow Games and published by Rysher Entertainment, 1997
QUAKE single player mod

98
Will Wright
The Sims [screenshots and booth scene]
Developed by Maxis and published by Electronic Arts, 2000
Microsoft Windows computer game
The Sims™ © 2006 Electronic Arts Inc.

99
Rockstar Games
Grand Theft Auto III [screenshots]

Developed by DMA Design and published by Rockstar Games, 2002
Microsoft Windows computer game
© 2008 Rockstar Games.
All Rights Reserved.

100
Rockstar Games
Grand Theft Auto: Vice City [screenshots]
Developed by Rockstar North and published by Rockstar Games, 2003
Microsoft Windows computer game
© 2008 Rockstar Games.
All Rights Reserved.

101
Rockstar Games
Grand Theft Auto: San Andreas [screenshots]
Developed by Rockstar North and published by Rockstar Games, 2005
Microsoft Windows computer game
© 2008 Rockstar Games.
All Rights Reserved.

102
Shigeru Miyamoto
The Legend of Zelda®: *The Wind Waker* [character and screenshots]
Developed and published by Nintendo, 2003
Nintendo GameCube game
Courtesy Nintendo

103
Will Wright
Spore [creatures and production drawings]
Developed by Maxis and published by Electronic Arts, 2008
Microsoft Windows computer game
SPORE™ © 2006 Electronic Arts Inc.

104
Ichiro Itano
[mecha design supervisor]
*Super Dimension Fortress
Macross* [film stills]
Studio Nue/Tatsunoko
Production, 1982–1983
DVD
36 episodes: 30 minutes
each
Courtesy of ADV Films
Macross © 1985, 2006
Harmony Gold USA
Inc./Tatsunoko. MACROSS
is a registered trademark
of Harmony Gold USA Inc.
The MACROSS series is
distributed under license
from Harmony Gold USA
Inc.

105
Katsuhiro Otomo
Akira [film poster], 1988
72.0 x 51.0
Based on the graphic
novel *Akira* by Katsuhiro
Otomo. First published
by *Young Magazine*,
Kodansha, Ltd.
© 1987 Akira Committee/
Kodansha, Ltd.

106
Katsuhiro Otomo
Akira [film stills]
Akira Committee
Company Ltd., 1988
DVD
124 minutes
Based on the graphic
novel *Akira* by Katsuhiro
Otomo. First published
by *Young Magazine*,
Kodansha, Ltd.
© 1987 Akira Committee/
Kodansha, Ltd.

107
Mamoru Oshii
Patlabor 2: The Movie
[film stills]
Headgear/Bandai
Visual/TFC/Production

I.G., 1993
DVD
100 minutes
© 1993 HEADGEAR/
BANDAI VISUAL/TFC/
PRODUCTION I.G.
All Rights Reserved.
www.bandaivisual.us

108
Yoko Kanno
*Cowboy Bebop/NO DISC –
Original Soundtrack 2*
Manufactured and
distributed by Victor
Entertainment, 1998
CD
50 minutes, 23 seconds
© 1998 Victor
Entertainment Inc., Japan.
All Rights Reserved.
Photo: Trevor Mills,
Vancouver Art Gallery

109
Yoko Kanno
*Ghost in the Shell:
Stand Alone Complex
Original Soundtrack*
Distributed in North
America by Bandai
Entertainment, Inc.,
under license from Victor
Entertainment Inc.,
Japan, 2004
CD
72 minutes, 48 seconds
© 2004 Victor
Entertainment Inc., Japan.
All Rights Reserved.
© Shirow Masamune,
Production I.G., Kodansha
Photo: Trevor Mills,
Vancouver Art Gallery

110
Yoko Kanno
*Wolf's Rain Original
Soundtrack 2*
Manufactured and
distributed by Victor
Entertainment, 2004
CD
68 minutes

© 2004 Victor
Entertainment Inc., Japan.
All Rights Reserved.
Photo: Trevor Mills,
Vancouver Art Gallery

111
Masaaki Yuasa
Mind Game [film stills]
Studio 4°C, 2004
DVD
103 minutes
© 2004 MIND GAME Project

112
Makoto Shinkai
*The Place Promised in Our
Early Days* [film stills]
CoMix Wave, Inc., 2004
DVD
90 minutes
© Makoto Shinkai/CoMix
Wave

113
Satoshi Kon
Paprika [film stills]
Madhouse Productions,
2006
DVD
90 minutes
Courtesy of Sony Pictures
Home Entertainment, Inc.
© 2006 Madhouse/Sony
Pictures Entertainment
(Japan) Inc.

114
Hisashi Eguchi
Happenings [CD cover art]
Released by BMG Japan,
1998
12.0 x 12.0
© BMG Japan

115
Hisashi Eguchi
*Tribute to Yasuyuki
Okamura* [CD cover art]
Released by Bounce
Records, 2002
12.0 x 12.0

116
Hisashi Eguchi

Stop!! Hibari-kun! –
Volume 2 [final drawing],
1983
ink on paper
17.6 x 11.2
Collection of the artist
© Hisashi Eguchi

117
Hisashi Eguchi
Stop!! Hibari-kun! –
Volume 4 [final drawing],
1984
ink on paper
17.6 x 11.2
Collection of the artist
© Hisashi Eguchi

118
Mamoru Nagano
The Five Star Stories
[mecha design]
Published in *F.S.S.
Designs 1: Easter; A.K.D.*,
Kadokawa Shoten, 2005
29.7 x 23.6
© 2005 EDIT

119
Mamoru Nagano
The Five Star Stories –
Volume 1 [page 18]
Published by Newtype
100% Comics, 1987
21.0 x 16.6
© TOYS PRESS 1987

120
Taiyo Matsumoto
Black & White 1 [cover]
Published by Shugakukan,
1994
21.0 x 14.2
© SHOGAKUKAN/
Matsumoto Taiyou, 1994
Photo: Una Knox,
Vancouver Art Gallery

121
Taiyo Matsumoto
Black & White 1 [page 97]
Published by Shugakukan,
1994
21.0 x 14.2

© SHOGAKUKAN/
Matsumoto Taiyou, 1994

122
Taiyo Matsumoto
Black & White 1 [page 96]
Published by Shugakukan,
1994
21.0 x 14.2
© SHOGAKUKAN/
Matsumoto Taiyou, 1994

123
Junko Mizuno
Pure Trance
[detail of page 004,
final drawing], 1998
pen and ink on card
20.0 x 20.0
Collection of the artist.
Courtesy jaPress/
Last Gasp
© Junko Mizuno,
1998/2005

124
Junko Mizuno
Pure Trance [page 004,
final drawing], 1998
pen and ink on card
20.0 x 20.0
Collection of the artist.
Courtesy jaPress/
Last Gasp
© Junko Mizuno,
1998/2005

125
Junko Mizuno
Pure Trance [page 005,
final drawing], 1998
pen and ink on card
20.0 x 20.0
Collection of the artist.
Courtesy jaPress/
Last Gasp.
© Junko Mizuno,
1998/2005

126
Takashi Okazaki
Afro Samurai [film stills]
STUDIO GONZO, 2007
DVD
5 episodes: 25 minutes each

© 2006 TAKASHI
OKAZAKI, GONZO/
SAMURAI PROJECT

127
Takashi Okazaki
Afro Samurai
[pages 22-23]
Published by Tor/
Seven Seas, 2008
digital image
© TAKASHI OKAZAKI,
GONZO

128
Takashi Okazaki
Afro Samurai
[cover]
Published in *NOU HOU
HAU* vol. 00, 1998
digital image
© TAKASHI OKAZAKI

129
Takashi Okazaki
Afro Samurai [2nd page],
1994
digital image
© TAKASHI OKAZAKI

130
Takashi Okazaki
Afro Samurai [7th page],
1994
digital image
© TAKASHI OKAZAKI

131
Takashi Okazaki
Afro Samurai [8th page],
1994
digital image
© TAKASHI OKAZAKI

132
Moyoco Anno
Sakuran [cover]
Published by Kodansha,
2003
18.2 x 13.0
© Moyoco Anno 2003
Photo: Una Knox,
Vancouver Art Gallery

133
Moyoco Anno

Sakuran [page 35]
Published by Kodansha,
2003
18.2 x 13.0
© Moyoco Anno 2003

134
Moyoco Anno
Sakuran [page 34]
Published by Kodansha,
2003
18.2 x 13.0
© Moyoco Anno 2003

135
Yuichi Yokoyama
New Engineering: Book
[page 7]
Published by East Press,
Tokyo, 2004
21.0 x 14.9
Courtesy of East Press,
Tokyo and Picture Box,
Inc., Brooklyn
© Yuichi Yokoyama

136
Yuichi Yokoyama
*New Engineering: Dress
up 1* [pages 54 and 55]
Published by East Press,
Tokyo, 2004
21.0 x 14.9
Courtesy of East Press,
Tokyo and Picture Box,
Inc., Brooklyn
© Yuichi Yokoyama

137
Hitoshi Odajima
Mu: For Sale [cover]
Published by Shobunsha,
2004
21.0 x 14.7
© 2004 Odajima Hitoshi
Photo: Una Knox,
Vancouver Art Gallery

138
Hitoshi Odajima
*Mu: For Sale – Afterlife
of a DJ* [9th page,
preliminary drawing]
2002
ink on paper

36.5 x 25.6
Collection of the artist

139
Hitoshi Odajima
*Mu: For Sale – Afterlife
of a DJ* [6th page,
preliminary drawing], 2002
ink on paper
36.5 x 25.8
Collection of the artist
© 2004 Odajima Hitoshi

140
Roy Lichtenstein
*Vicki! I .. I Thought I
Heard Your Voice!*, 1964
enamel on steel
106.7 x 106.7
Private Collection
Photo: Eduardo Calderon
© Estate of Roy
Lichtenstein/SODRAC
(2008)

141
Roy Lichtenstein
Girl in Mirror, 1964
enamel on steel
106.7 x 106.7
Private Collection
Photo: Eduardo Calderon
© Estate of Roy
Lichtenstein/SODRAC,
(2008)

142
Roy Lichtenstein
Eccentric Scientist, 1965
enamel on steel
91.4 x 91.4
Private Collection
Photo: Eduardo Calderon
© Estate of Roy
Lichtenstein/SODRAC,
(2008)

143
Claes Oldenburg
*Geometric Mouse –
Scale C*, 1971
anodized aluminum,
paint, steel
48.3 x 50.8 x 33.0

Collection Walker Art
Center, Minneapolis
Gift of Kenneth E. Tyler,
1985
© Claes Oldenburg

144
Marcel Broodthaers
Ombres chinoises,
1973–1974
slide projection, 35 mm
slides
Collection of the Estate
of Marcel Broodthaers
© Estate of Marcel
Broodthaers/SODRAC
(2008)

145
Raymond Pettibon
No Title (Not a hippie),
1982
ink and coloured pencil
on paper
27.9 x 20.3
Courtesy Regen Projects,
Los Angeles
Photo: Trevor Mills,
Vancouver Art Gallery

146
Raymond Pettibon
No Title (These crabs are),
1982
ink and coloured pencil
on paper
27.9 x 20.3
Courtesy Regen Projects,
Los Angeles
Photo: Trevor Mills,
Vancouver Art Gallery

147
Raymond Pettibon
*No Title (True Crime
comics)*, 1982
ink and coloured pencil
on paper
27.9 x 20.3
Courtesy Regen Projects,
Los Angeles
Photo: Trevor Mills,
Vancouver Art Gallery

148
M/M (Paris)
*AnnLee: No Ghost Just
a Shell*, 2000 with *Wall-
paper Poster 1.1 (AnnLee
Colours: Anywhere out
of the World)*, 2000
Installation view of *No
Ghost Just a Shell* at Van
Abbemuseum, 2003
4-colour silk screen
on paper
176.0 x 120.0
Collection Van
Abbemuseum, Eindhoven,
The Netherlands
Photo: Peter Cox,
Eindhoven,
The Netherlands

149
Pierre Huyghe &
Philippe Parreno
Skin of Light, 2002
from *No Ghost Just
a Shell*, 1999–2002
neon, transformers
78.7 x 55.8
Courtesy Marion Goodman
Gallery, New York

150
François Curlet
*Witness Screen/Ècran
Témoin* [video still], 2002
from *No Ghost Just
a Shell*, 1999–2002
single-channel video
installation
Collection Van
Abbemuseum, Eindhoven,
The Netherlands
Photo: Peter Cox,
Eindhoven,
The Netherlands

151
Cao Fei
Cosplayers [video stills],
2004
single-channel video
installation
8 minutes

Courtesy of Cao Fei,
Vitamin Creative Space

152
Chiho Aoshima
Stills from *City Glow*,
2005
Collaboration with
animation designer
Bruce Ferguson
Courtesy of the artist and
Blum & Poe, Los Angeles
© 2005 Chiho Aoshima/
Kaikai Kiki Co., Ltd.
All Rights Reserved.

153
Chiho Aoshima
City Glow, 2005
Collaboration with
animation designer Bruce
Ferguson
Installation view of
*Asleep, dreaming of
reptilian glory* at Blum &
Poe, Los Angeles, 2005
Courtesy Blum & Poe,
Los Angeles
© 2005 Chiho Aoshima/
Kaikai Kiki Co., Ltd.
All Rights Reserved.
Photo: Joshua White

154
Christian Marclay
Whomp, 2006
pigment print on Arches
paper
109.9 x 145.0
Courtesy Jay
Jopling/White Cube
(London) and the artist

155
Christian Marclay
Visshh!, 2006
pigment print on Arches
paper
101.6 x 268.3
Courtesy Jay
Jopling/White Cube
(London) and the artist

156
Christian Marclay

Shtoom, 2006
pigment print on Arches
paper
109.9 x 112.2
Courtesy Jay
Jopling/White Cube
(London) and the artist

157
Mr.
Strawberry Voice [detail],
2007
FRP, iron, various
materials
295.0 x 274.0 x 300.0
Courtesy Lehmann
Maupin Gallery, New York
© 2007 Mr./Kaikai Kiki
Co., Ltd.
All Rights Reserved.
Photo: Bill Orcutt

158
Mr.
Strawberry Voice, 2007
with "Penyo-Henyo" Spring
Breeze Edition "Snack
Time," 2004– 2006 and
"A Field Close To Heaven –
Dreams and Reality," 2007
Installation view of Mr.
solo exhibition at
Lehmann Maupin Gallery,
New York, 2007
Courtesy Lehmann
Maupin Gallery, New York
© 2007 Mr./Kaikai Kiki
Co., Ltd.
All Rights Reserved.
Photo: GION

159
[Inside back cover]
Junko Mizuno
*Pure Trance: Kaori
the Nurse*
Produced by KidRobot,
2007
plastic, pigment
23.0 x 14.0 x 8.0
© Junko Mizuno, 2007
Photo: Trevor Mills,
Vancouver Art Gallery

CONTRIBUTORS' BIOGRAPHIES

CO-CURATORS

Bruce Grenville (b. 1956, Canada) is Senior Curator at the Vancouver Art Gallery. He has organized many group exhibitions, including *The Uncanny: Experiments in Cyborg Culture*, a thematic survey of the image of the human machine in art and popular culture from the early nineteenth century to the present. He was the co-ordinating curator of *Massive Change: The Future of Global Design*. The *Massive Change* exhibition and international tour is a project by Bruce Mau Design and the Institute without Boundaries, commissioned and organized by the Vancouver Art Gallery.

Tim Johnson (b. 1961, United States) is an animator and director who first gained critical attention with his direction of the "Homer3" segment of *The Simpsons* Halloween special in 1995, where he transformed the two-dimensional Homer into 3D. Johnson made his feature-length directorial debut in 1998 with DreamWorks' first computer-animated feature, *Antz*, starring the voices of Woody Allen, Sharon Stone and Sylvester Stallone. His most recent film, *Over the Hedge* (2006), was both a critical and commercial success and further solidified Johnson's reputation as one of the preeminent animation directors in Hollywood.

Kiyoshi Kusumi (Japan) is a free-lance writer and cultural critic living in Tokyo. He was formerly the editor-in-chief of the Japanese art journal *BT Magazine*. Kusumi is currently the editor of the Japanese manga magazine *Comickers* and is credited with identifying and naming the "Nouvelle Manga" movement. He is an established art critic and

cultural theorist and is considered a global authority on manga.

Seth is the pen name of Gregory Gallant (b. 1962, Canada), a comic book artist and writer. Considered one of the best cartoonists of his generation, Seth has an evocative graphic style that has made him one of the most recognizable and sought-after comic artists working today. His work has been featured in *The Washington Post*, *Details*, *The New York Times*, *Spin* and *The New Yorker*, and he has contributed cover illustrations for a diverse range of publications, including Fantagraphics' bestselling *Complete Peanuts* series.

Art Spiegelman (b. 1948, Sweden) was born in Stockholm and immigrated with his family to Queens, New York, in 1951. Spiegelman is an American comic artist, editor and advocate for the medium, best known for his role in co-founding the influential *RAW* magazine and for his Pulitzer Prize–winning comic memoir, *Maus*. Spiegelman has been instrumental in the development of the medium, through his support for emerging comic artists and for his role in creating a broader acceptance of comics as an art form.

Toshiya Ueno (Japan) is a sociologist, media theorist and critic who lives and works in Japan and Amsterdam. He is currently an associate professor in the Expressive Cultures Department at Wako University, Tokyo. He has written numerous articles, essays and reviews on media, rock/pop music, film, contemporary art, architecture and urban design.

Will Wright (b. 1960, United States) is a computer game designer and co-founder of the game development

company Maxis. He is best known for creating groundbreaking and genre-defining computer games like *SimCity* and *The Sims*. His upcoming release, *Spore*, is the most highly anticipated computer game of the past decade, and the game's scope and level of player interactivity are expected to revolutionize the industry. He is considered an industry pioneer and one of the most influential and innovative designers of our time.

COMICS

Lynda Barry (b. 1956, United States) is an American cartoonist, author and playwright. She began publishing her strip, *Ernie Pook's Comeek*, in 1977 when *Simpsons* creator Matt Groening included her work in the Evergreen State College student newspaper. Her strips are syndicated in over fifty newspapers, she has contributed strips to *Esquire*, *Mother Jones* and *Salon.com* and she has published fifteen books.

Justin Green (b. 1945, United States) is an influential American comic artist and an important member of the underground comix movement. Green is widely known for his 1972 comic, *Binky Brown Meets the Holy Virgin Mary*, which established the confessional-autobiography comic book genre. Green currently contributes strips to a variety of monthly magazines, including *Sign of the Times* and *Pulse! Magazine*.

George Herriman (b. 1880, United States, d. 1944) was an American cartoonist who began his career at age seventeen working as an illustrator and engraver for *The Los Angeles Herald*. His strip, *Krazy Kat*, made him a household name, and his deceptively

simple drawing style and narrative approach attracted the attention of artists and intellectuals of his era. He is one of the acknowledged masters of the comic medium and in 1999 *The Comics Journal* named *Krazy Kat* the greatest example of the art form in the history of the medium.

Kevin Huizenga (b. 1977, United States) is a comic artist who began self-publishing mini-comics as a high-school student in 1993. In 2001 *The Comics Journal* named Huizenga "Minimalism Cartoonist of the Year," and he won the Ignatz Award for outstanding story for *Ganges #1* in 2007. His singular voice and considerable artistic talent have made him one of the most highly regarded cartoonists of his generation.

Harvey Kurtzman (b. 1924, United States d. 1993) was a prolific American cartoonist and editor, widely considered to be one of the most influential cartoonists of the twentieth century. Kurtzman began his career in the 1930s as a freelance cartoonist and writer and first received recognition for his one-page *Hey Look!* strips that filled out the back of *Archie* comics. He is best known for founding the groundbreaking *MAD* magazine, for his war comics *Front Line Combat* and *Two-Fisted Tales* and for his comic strip, *Little Annie Fanny*, which he contributed to *Playboy* magazine for twenty-six years.

Jerry Moriarty (b. 1938, United States) is an artist whose work exhibits a painterly approach to cartooning. He received critical acclaim for his 1984 comic book *Jack Survives*, which was published as a "one shot" by Art Spiegelman and Françoise Mouly's magazine, *RAW*. Moriarty has taught at the School of Visual Arts in New York for the past forty years and continues to exhibit his sequential paintings.

Chris Ware (b. 1967, United States) is one of the most innovative and critically acclaimed comic artists working today. He has been publishing his own comic, *The ACME Novelty Library*, since 1993 and has contributed to *The New Yorker*, *The New York Times*, *Blab!*, *Nest*, *RAW*, *Speak Magazine* and *Zero Zero*. His "graphic novel," *Jimmy Corrigan – The Smartest Kid on Earth*, was included in the 2002 Whitney Biennial of American Art.

"GRAPHIC NOVELS"

Alison Bechdel (b. 1960, United States) is best known for her bi-weekly strip, *Dykes to Watch Out For*, which she began publishing in alternative publications in 1983. In 2006 Bechdel achieved both critical and popular acclaim for her "graphic novel," *Fun Home: A Family Tragicomic*, an autobiographical tale that recounts her troubled relationship with her father. *Fun Home* was selected as one of the best books of 2006 by both *The New York Times* and *The Times of London* and was shortlisted for the National Book Critics Circle Award.

Chester Brown (b. 1960, Canada) was born in Montreal and began his comic career at the age of twelve when a local paper, *The St. Lawrence Sun*, published one of his strips. After moving to Toronto at age nineteen, Brown began to self-publish a mini-comic called *Yummy Fur* in which he serialized *Ed the Happy Clown*. His "graphic novel," *Louis Riel: A Comic Strip Biography*, was selected as one of the best comics of 2003 by *Time Magazine* and was nominated for an Eisner Award in 2004.

Daniel Clowes (b. 1961, United States) was born in Chicago and studied art at the Pratt Institute in Brooklyn. Clowes began publishing his first comic books series, *Lloyd Llewellyn*, in

1985 and since then has contributed to *Details*, *The New Yorker*, *Blab!*, *Cracked*, the *Village Voice* and *The New York Times Magazine* and has published eight "graphic novel" collections. The 2001 movie *Ghost World* was based on his "graphic novel" of the same name, and he received an Academy Award nomination for best-adapted screenplay.

Kim Deitch (b. 1944, United States) was an important figure in the underground comix movement of the 1960s and 1970s. Deitch began his career contributing strips to the New York underground newspaper *The East Village Other*, where he introduced Waldo the Cat and Uncle Ed, the India Rubber Man, two of his most famous characters. Deitch continues to publish books and comic book series and has contributed work to *RAW*, *Pictopia*, *Zero Zero*, *Details* and *Little Lit*.

Milt Gross (b. 1895, United States, d. 1953) was a cartoonist who wrote comics in a Yiddish-inflected English dialect. His first success was *Gross Exaggerations*, an illustrated column in *The New York World*, which he anthologized in *Nize Baby* in 1926. Throughout the 1920s and 1930s Gross continued to produce strips, *Count Screwloose of Tooloose*, *Banana Oil*, *Dave's Delicatessen*, *That's My Pop*, and books, *De Night in De Front From Chreesmas* and *He Done Her Wrong*.

Philip Guston (b. 1913, Canada, d. 1980, United States) began his artistic career as a Social Realist painter in the 1930s, though he achieved critical acclaim through his association with the Abstract Expressionist group in New York in the 1950s and a signature style that he referred to as "abstract impressionism." In the 1960s he began to abandon pure abstraction and returned to figurative painting, adopting a representational

style that was strongly influenced by cartoon imagery.

Shaun Tan (b. 1974, Australia) is an award-winning author and illustrator of children's books, including *The Red Tree* and *The Lost Thing*. Tan also contributes political cartoons to *The Western Review* and was the art editor of the now defunct *Eidolon Magazine*. *The Arrival*, his most recent publication, has received critical acclaim in Australia and secured Tan his first North American publishing deal.

ANIMATED CARTOONS

Robert Cannon (b. 1909, United States, d. 1964) began his career as an animator at Walt Disney Studios. In 1940, along with a few Disney colleagues, Cannon made a campaign film for Franklin Roosevelt, and he used his profits from the film to establish a rival animation studio, United Productions of America (UPA). Cannon helped to develop UPA's signature minimalist style, and he is considered one of the most inventive designers of the period.

John Lasseter (b. 1957, United States) is an animator and the chief creative officer at Pixar Animation Studios and Walt Disney Feature Animation. Lasseter is a founding member of Pixar, where he oversees all of Pixar's films as an executive producer. He directed *Toy Story*, *A Bug's Life*, *Toy Story 2*, *Cars* and the upcoming *Toy Story 3*. He has been nominated for six Academy Awards and has won twice.

Winsor McCay (b. 1866, Canada, d. 1934, United States) was a prolific artist and pioneer of both animation and cartooning. His early animated films exhibited a level of technical expertise, draftsmanship and narrative sensibility that far outshone the work of his contemporaries. He is best known for the newspaper comic strip *Little Nemo in Slumberland*, which ran from 1905 to 1914, and the 1914 animated short, *Gertie the Dinosaur*.

Marv Newland (Canada) is an independent animator and director whose experimental, and often subversive, films are heralded by industry insiders. In 1975 Newland settled in Vancouver and established International Rocketship Limited, which produced animated commercials, to finance more controversial and experimental shorts. Newland has produced and directed more than ten animated shorts and was the subject of a retrospective at the Pacific Cinémathèque in 2006.

Lotte Reiniger (b. 1899, Germany, d. 1981) was a director and animator who is an acknowledged pioneer of both the silhouette film and the multiplane technique. In the nearly seventy films she directed and animated, Reiniger perfected the use of subtle body movement to express emotion. Her 1926 film *The Adventures of Prince Achmed* is widely believed to be the earliest surviving animated feature.

Nick Park (b. 1958, England) is a British animator who has achieved international acclaim in the field of stop-motion animation with clay. He has been nominated for the Academy Award five times and has lost only once – to himself. He joined Aardman Animations in Bristol in 1985 and is best known for creating the characters Wallace and Gromit, who have starred in three animated shorts and one feature-length film.

Ben Sharpsteen (b. 1895, United States, d. 1980) began his career as an animator and director for Walt Disney Studios in the 1929. Best known for his direction of the 1941 Disney film, *Dumbo*, Sharpsteen directed more than thirty films for the famed animation studio and acted as a producer on an additional thirteen films. He won two Academy Awards in 1959 for his production work on two documentaries.

VIDEO GAMES

id Software is a computer game development company based in Mesquite, Texas, and founded by John Carmack, John Romero, Tom Hall and Adrian Carmack. The company found critical and commercial success with its contributions to the first-person-shooter genre with *DOOM* and *QUAKE*, which attracted a devoted following of hard-core gamers. id Software is best known for developing games with visually stunning imagery and graphic violence.

Toru Iwatani (b. 1959, Japan) was a video game designer in the 1980s and created one of the most popular arcade games of all time, *Puckman*, better known by its American title *Pac-man*. He joined the computer software company NAMCO in 1977, where he started his career in the video game business. Toru continued to work as an executive at NAMCO until March of 2007, when he left to pursue a teaching career at the Tokyo Polytechnic University.

Sid Meier (b. 1954, United States) is a renowned American programmer and designer of some of the most commercially and critically successful computer games of all time. Meier founded MicroProse with Bill Stealey in 1982, where he developed the *Civilization* franchise for which he is best known. In 1996 Meier co-founded Firaxis Games with Jeff Briggs, where he continues to design strategy games.

Shigeru Miyamoto (b. 1952, Japan) is one of the world's most celebrated game designers and one of the fathers of modern video-gaming. He is the creator of the *Mario*, *Donkey Kong*, *Legend of Zelda*, *Star Fox* and

Pikmin video game franchises for Nintendo game systems and one of the first designers to introduce narrative into video game design. He is currently the Director and General Manager of Nintendo Entertainment Analysis and Development.

The Rockstar Games label was founded in 1998 and is the development division of Take-Two Interactive Software. With nine studios operating throughout the world, Rockstar Games has firmly established its reputation as one of the most prolific and popular video game developers. It is best known for the *Grand Theft Auto* and *Man Hunt* series.

ANIME

Ichiro Itano (b. 1959, Japan) is an anime director, animator and screenplay writer. He first gained recognition working on the original *Gundam* series in 1979, where he created what would later be termed the "Itano Circus," the highly stylized and acrobatic aerial mecha combat scenes. His distinct approach to mecha combat revolutionized the treatment of these scenes in the anime medium and has made him one of the most critically acclaimed and highly sought-after animators in Japan.

Yoko Kanno (b. 1964, Japan) began her career composing music for Japanese television dramas and commercials before moving into film. She is now the most highly sought-after composer of anime scores and has developed a cult following among anime enthusiasts. She has contributed music to popular anime series including *Cowboy Bebop*, *Ghost in the Shell: Stand Alone Complex* and *Wolf's Rain*.

Satoshi Kon (b. 1963, Japan) is a highly regarded Japanese animator at MADHOUSE studios. After graduating from Musashino Art University, Kon began his career working with Katsuhiro Otomo on both manga and anime projects, and he later worked under Mamoru Oshii as a background artist on *Rojin Z* and *Patlabor 2: The Movie*. Kon's films, *Perfect Blue*, *Millennium Actress*, *Tokyo Godfathers* and *Paprika*, are all characterized by psychological complexity and the blurring of fantasy and reality.

Mamoru Oshii (b. 1951, Japan) is a Japanese animation and live-action film writer and director. He graduated in 1976 from the Tokyo Liberal Arts University and began working as an animation director at Tatsunoko Production. He is one of the most prolific animation directors of our time and has found critical and commercial successes with the *Patlabor* and *Ghost in the Shell* series.

Katsuhiro Otomo (b. 1954, Japan) is a manga artist and anime director. He began his career serializing *Domu* [*A Child's Dream*] in 1980 and established the dark, futuristic themes that would characterize his later work and secure his place as one of the preeminent manga artists of his generation. *Akira*, which took nearly ten years and two thousand pages to complete, was made into an animated film in 1988 with Otomo acting as director, writer, designer and senior illustrator.

Makoto Shinkai (b. 1973, Japan) is an anime director and animator. Despite his young age, Shinkai has received critical acclaim for his anime films, and critics have branded him the "new Miyazaki." His first film, a five-minute animated short done in monochrome, *She and Her Cat*, won the grand prize at the 2000 DoGA CG Animation contest. His most recent project, *5 Centimeters per Second*, premiered in March of 2007 to overwhelmingly positive reviews.

Masaaki Yuasa (b. 1965, Japan) is an animator who made his directorial debut with the 2005 film *Mind Game*. After graduating from university in 1987, Yuasa started working at an animation production company and began his successful career as a freelance animator. He is best known for his work on the *Crayon Shin-chan* television series and for his signature style that favours a rough æsthetic rather than the polished, smooth look of big-budget anime.

MANGA

Moyoco Anno (b. 1971, Japan) is a manga artist whose *Josei* manga, manga for and about adolescent females, has attracted considerable attention in Japan. Her manga *Sakuran* was reconfigured into a live-action film, and her series *Flowers & Bees* and *Sugar Sugar Rune* have been published in English and are becoming increasingly popular in North America. Her æsthetic style is simple and elegant and contributes to the emotional impact of her narratives.

Hisashi Eguchi (b. 1956, Japan) is a manga artist who first came to prominence with his work *Stop!! Hibari-kun!*, which was originally serialized in *Weekly Shonen Jump* from 1981 to 1983. After achieving success with his popular manga, Eguchi began designing book, magazine and CD covers and initiated a second career as a freelance animator. His distinctive graphic style has become a fixture in Japanese popular culture over the past twenty years.

Taiyo Matsumoto (b. 1967, Japan) is a manga artist who first received critical attention when he won the "Comic Open" contest in *Comic Morning* magazine in 1986 with his entry "Straight." Educated in Europe, Matsumoto draws on the æsthetics of Japanese manga and the narrative structure of European comics to create unique and distinctive work. He has received critical attention for

his unconventional and often surrealistic imagery and is widely considered one of the most influential manga artists of his generation.

Junko Mizuno (b. 1973, Japan) is an artist, designer and manga illustrator. Mizuno created her first manga, *Pure Trance*, as serialized inserts for trance music CDs. Mizuno employs what is known as the *kawaii noir* style in both her manga and her art, juxtaposing childlike, cute imagery with violence and terror. Mizuno's designs have been used to create T-shirts, calendars, postcards, vinyl figurines and plush animals.

Mamoru Nagano (b. 1960, Japan) is an animator, illustrator and manga artist. He creates mecha manga and anime, a popular Japanese science fiction genre that features militaristic giant robots. His manga series *The Five Star Stories*, which he has been publishing since 1986, exhibits a level of imagination and formal innovation not typical of this genre. His use of elongated lines, delicate curves and intricate detailing distinguishes his work from that of his peers.

Hitoshi Odajima (b. 1972, Japan) is a manga artist, illustrator, designer, writer and musician and a graduate of the Kuwasawa Design School. An active participant in the Tokyo art scene, Odajima's work casts a critical eye on his generation. Odajima is one half of the electro-pop band Best Music, and he combines his passion for music and art by designing cover art for CDs.

Takashi Okazaki (b. 1967, Japan) is an illustrator, designer, painter and manga artist. He is a founding member of the NOU NOU HAU collective, which published a magazine of independent and experimental manga. His *Afro Samurai* manga was featured in the inaugural issue of *NOU NOU HAU* and was later reconceived as an anime television program on the Spike Network in the U.S.

Yuichi Yokoyama (b. 1967, Japan) is a painter and manga artist who has published widely in Japan and France. His work appears frequently in the alternative manga magazines *Comic Cue* and *Mizue*. Yokoyama challenges popular manga conventions in his limited dialogue, use of geometric forms and reconstruction of space of the frames. Critics most often classify him as part of the "neo-manga" movement.

VISUAL ART

Chiho Aoshima (b. 1974, Japan) is represented by Kaikai Kiki, an artist enterprise founded by Takashi Murakami. She has exhibited widely since her inclusion in Takashi Murakami's *Super Flat* exhibition in 2000 and opened a solo show at the Miró Foundation in Barcelona, 2008. Her recent works include digitally rendered drawings, animation and large-scale murals, which have been displayed in both museums and public spaces.

Marcel Broodthaers (b. 1924, Belgium, d. 1976, Germany) began his career as a poet who had contact with the Belgian Surrealists, including René Magritte, who would later be a significant influence on his art. In 1958 he started to publish articles that he illustrated with his own photographs and soon began to produce works in various media that displayed his interest in objects and the juxtaposition of word and image. After his first exhibition in 1964, Broodthaers exhibited found objects, drawings, prints, books, films, slide projects and installations.

Cao Fei (b. 1978, China) is a Chinese multidisciplinary artist who graduated from Guangzhou Academy of Fine Arts in 2001. Working in theatre, performance, digital video and photography, she is considered one of the most innovative and exciting artists of her generation. In 2006 she was named the Best Young Artist at the Chinese Contemporary Art Awards.

Pierre Huyghe (b. 1962, France) is an acclaimed multi-disciplinary artist. He trained at the École Nationale Supérieure des Arts Décoratifs and started his artistic career with the painters group Les Frères Ripoulin along with other French artists Nina Childress and Claude Closky. Huyghe's art practice examines the problematic relationships between history and memory and reality and fantasy. Huyghe lives and works in Paris and New York.

Roy Lichtenstein (b. 1923, United States, d. 1997) studied at the Art Students League in New York and the School of Fine Arts at Ohio State University. In 1961 Lichtenstein began to make paintings based on comic-strip figures and began to experiment with Benday-dot grounds for which is he known. From the 1960s until the time of his death Lichtenstein continued to investigate the contradiction of representing three-dimensional objects on a flat surface.

Christian Marclay (b. 1955, United States) was born in California and raised in Switzerland where he attended the École Supérieure d'Art Visual before returning to the United States to attend the Massachusetts College of Art in 1980. Marclay's work focuses on the relationship between sound, photography, video and film. His work has been included in exhibitions at the Venice Biennale, Centre Pompidou, Paris, San Francisco Museum of Art and the Whitney Museum of Modern Art. He lives and works in New York.

Mr. (b. 1969, Cupa) graduated from the Sokei Academy of Fine Art and Design, Japan. He first gained international recognition in 2000 through his participation in Takashi Murakami's

groundbreaking exhibition, *Super Flat*. He has exhibited widely over the last ten years in Tokyo, Asaka, Nagoya, and internationally in New York, Chicago, Minneapolis, London and Paris.

Claes Oldenburg (b. 1927, Sweden) immigrated with his family to Chicago in 1936 and moved to New York City in 1956, where he first came into contact with artists making early performance-based work. He is one of the pioneers of pop art in America and had his first solo exhibition at the Museum of Modern Art in 1969. He was the subject of a retrospective organized by the National Gallery of Art and the Guggenheim Museum, New York in 1995. Oldenburg lives and works in New York.

Philippe Parreno (b. 1964, Algeria) is based in Paris. Parreno's work investigates the nature of an image and the modes of its exhibition, and he often works collaboratively with other artists, including Pierre Huyghe and Douglas Gordon. He has recently had exhibitions at the Royal College of Art Galleries, London, Musée d'art Moderne de la Ville de Paris, the Museum of Modern Art in San Francisco and the Kunstverein Münich.

Raymond Pettibon (b. 1957, United States) lives and works outside of Los Angeles, where he has been an influential figure in the art community since the early 1980s. A cult figure among underground music devotees for his early work associated with the Los Angeles punk rock scene, Pettibon has acquired an international reputation as one of the foremost contemporary American artists working with drawing, text and artist's books. Retrospectives of his work have been held at the Philadelphia Museum of Art, the Santa Monica Museum of Art and the Museum of Contemporary Art, Los Angeles.

− compiled by Stephanie Rebick

ACKNOWLEDGEMENTS

This project began as a conversation with my colleagues here at the Vancouver Art Gallery, and were it not for the tenacity and ambition of Kathleen Bartels, Director, and Daina Augaitis, Chief Curator, this exhibition and publication could not have happened. Both immediately saw the potential in these diverse but connected fields of artistic production, and both urged and nurtured its growth into a major exhibition and the accompanying publication you hold in your hands. I am grateful for their insight, creativity and support.

I owe a great debt to Glenn Entis, the former Chief Visual and Technical Officer for Worldwide Studios, Electronic Arts. Glenn's immediate and sustained passion for this project and willingness to share his insights and imagination gave much to the exhibition's final shape and ambitious scope. Sylvie Gilbert, Senior Curator at the Walter Phillips Gallery and the Banff International Curatorial Institute, generously provided a forum for me to workshop this exhibition in its earliest stages and to receive feedback from a knowledgeable and articulate community of artists, curators, critics and publishers who attended her *Comic Craze* exhibition and conference in 2006. I thank Sylvie and the participants in that workshop for their early enthusiastic feedback and critical comments.

My co-curators and co-authors − Tim Johnson, Kiyoshi Kusumi, Seth, Art Spiegelman, Toshiya Ueno and Will Wright − are among the most active and sought-after practitioners in their respective fields. Despite their own crushing workloads they gave generously of their time and willingly shared their extraordinary insight and experience. They suffered my endless questions, urgent queries and improbable deadlines with grace and good spirit. Without their wisdom and collaboration neither exhibition nor publication would have been possible.

Many others, through conversation and correspondence, shared their knowledge and time to assist in the conceptualization and production of this exhibition. I thank Michael Darling, Cindy Burlingham, Makiko Hara, Rene DeGuzman, Anthony Kiendl, Ben Portis, Chris Ware, Chester Brown, Chris Oliveros, Tom Devlin, Robin Fisher, Chris Brayshaw, James Chang, Brian Wideen, Linda Stanfield, George Borshukov, Jeff O'Connell, Wendell Harlow, Kyohei Sakaguchi, Tomoko Yamada, Miki Okabe, Kodama Kanazawa, Jason McLean, Shinobu Akimoto, Sylvie Laberge, Lucy Bradshaw, Ocean Quigley, Sheng-mei Ma, Finnigan Canadensis, Kim Edwards, Hamza Walker, Junko Mizuno, Jerry Moriarty, Randy Lee Cutler, Marv Newland, Kevin Huizenga, Kim Deitch, Alison Bechdel, Roxana Marcoci, Hadrien Laroche, Arpad Sölter, Doina Popescu and Jeffrey Black.

Others have played a critical role in securing works for the exhibition and providing expert advice. I thank

Mariska Nietzman, Tim Blum, Shaun Regen, Alvin Buenaventura, Ron Turner, Colin Turner, Dan Nadel, Lynda Barry, Dan Clowes, Shaun Tan, Yuichi Yokoyama, Christiane Berndes, Marica Vissers, Marie Puck-Broodthaers, Dr. Sabine Lenk, Kieran Argo, Craig Burnett, Stacy Bengston Fertig, Mike Glad, Sophie Byrne, Andreas Thein, Yuki Minami, Christine Valenza, David McKee, Anders Bergstrom, Dr. Lucy Shelton Caswell, Denis Kitchen, Glenn Bray, Sayaka Toyama, Steve Nix, Shin Furukawa, Elyse Klaidman, Kim Donovan, DeAnn Cobb, Rod Humble, Matt Ryan, Amid Amidi, Shinobu Akimoto, April Jones, Patrick Buechner, Richard Heller, Rose Lord, Karen Lambright Johnson, Andrew Kevin Walker, Marco de Blois, Darlan Monterisi, Melinda Ferrar, Dennis Doros, Amy Heller, LeJarie Battieste and Chad Kime.

The Vancouver Art Gallery staff played a critical role in the success of this exhibition and publication. It is an honour to work with colleagues who so willingly shared their enthusiasm and knowledge. Special thanks must go to Stephanie Rebick, who threw herself wholeheartedly into this project and applied her formidable research skills, infallible organization, convincing letter writing, unerring eye, droll skepticism and seemingly limitless and uncanny knowledge of even the most arcane fields of visual culture, to guarantee its completion. Everyone who has worked on this project will agree that it could not have happened without her effort. Bruce Wiedrick is a constant and creative colleague. His excellent co-ordination and communication regarding all aspects of this project ensured its success. A project like this takes years to realize, and many of the staff made a critical contribution at key points along the way. I thank Paul Laroque, Tom Meighan, Steven Endicott, Dana Sullivant, Karen Love, Angela Mah, Kimberly Bates, Marie Lopes, Sadira Rodrigues, Karen Benbassat, Cindy Richmond, Henri Robideau, Jenny Wilson, Susan Sirovyak, Susan Currie, Monica Smith, Emilie O'Brien, Cheryl Siegel, Wade Thomas, Derek Brunen, Matt Smith, Glen Flanderka, Rory Gylander, Dwight Koss, Paula O'Keefe-Blitz, Michael Trevillion, Steve Wood, Allison Chambers, Una Knox and Rosemary Nault for notable contributions.

This book was realized through the collaboration of the Vancouver Art Gallery, Douglas & McIntyre and the University of California Press. Scott Steedman, Associate Publisher at Douglas & McIntyre, has been a creative collaborator in this enterprise. His goodwill, patience and critical skills are gratefully acknowledged. Mark Timmings has been a longstanding and much valued partner in design, and I am grateful for his keen eye and abundant ideas. Trevor Mills bears the brunt of our ambitions but never fails to deliver the best possible images, and I thank him for his unstinting efforts. Danielle Currie works well below the radar, clearing reproduction rights; this project posed a new kind of challenge, and I am grateful to Danielle for never flinching. The many images in this book are critical to its success, and I thank Tanya Brodsky, John Bobeldyk, Sharron Traer and Alexandra Gaty for their part in securing them.

We have received valuable financial support from a number of agencies in the cultural community. We take this opportunity to thank: Consulat général de France à Vancouver et CULTURESFRANCE, the Consulat Général of France to Vancouver; The Goethe-Institut, Toronto; The Japan-Canada Fund, administered through The Canada Council for the Arts.

Special thanks go to Yoshiharu Tsukamoto and Momoyo Kaijima, the principals of Atelier Bow-Wow, Tokyo. They conceived the exhibition design and in doing so added immeasurably to the character and the meaning of the project. I also thank Simon Morville and Jessie Turnbull for their part in this process.

I thank Joe Earle, Director of the Japan Society Gallery, New York, for his enthusiastic interest in the exhibition and the opportunity to present a remixed version in his galleries.

Finally, I thank my family, Elizabeth, Lucy and Alice, who provided thoughtful comments, timely criticisms and an unerring eye. They generously gave over our house to piles of comics and manga, endless screenings of anime and cartoons and the pulsing of video games, and forgave my extended travel and inopportune absences from family events, all in aid of this exhibition and book.

– Bruce Grenville

Publication copyright © 2008 by Douglas & McIntyre and the Vancouver Art Gallery

Individual texts copyright © 2008 by Bruce Grenville, Tim Johnson, Kiyoshi Kusumi, Seth, Art Spiegelman, Toshiya Ueno and Will Wright

For copyright of individual images, see detailed information on pages 264–272

08 09 10 11 12 5 4 3 2 1

Published in conjunction with *KRAZY! The Delirious World of Anime + Comics + Video Games + Art*, an exhibition organized by the Vancouver Art Gallery, by Bruce Grenville, Senior Curator, and co-curators Tim Johnson, Kiyoshi Kusumi, Seth, Art Spiegelman, Toshiya Ueno and Will Wright, presented from May 17, 2008 to September 7, 2008.

Douglas & McIntyre Ltd.
2323 Quebec Street, Suite 201,
Vancouver, British Columbia,
Canada V5T 4S7
www.douglas-mcintyre.com

University of California Press
Berkeley and Los Angeles, California
University of California Press, Ltd.
London, England

Vancouver Art Gallery
750 Hornby Street

Vancouver, British Columbia
Canada V6Z 2H7
www.vanartgallery.bc.ca

LIBRARY AND ARCHIVES CANADA CATALOGUING IN PUBLICATION

Krazy! : the delirious world of anime + comics + video games + art / Bruce Grenville [senior curator].

Published in conjuction with an exhibition at Vancouver Art Gallery, May 17 - Sept. 7, 2008.

ISBN 978-1-55365-354-7

1. Comic books, strips, etc. – Exhibitions. 2. Animated films – Exhibitions. 3. Animated films – Japan – Exhibitions. 4. Video games – Exhibitions. 5. Art, Modern – 21st century – Exhibitions. I. Grenville, Bruce II. Vancouver Art Gallery.

NX430.C32V34 2008
709.05'07471133 C2008-900596-1

LIBRARY OF CONGRESS CATALOGING-IN-PUBLICATION DATA

KRAZY! : the delirious world of anime + comics + video games + art / edited by Bruce Grenville ; with Tim Johnson ... [et al.]. p. cm.

Catalog of an exhibition held at the Vancouver Art Gallery, May 17 - Sept. 7, 2008.

Includes bibliographical references and index.

ISBN 978-0-520-25784-9 (pbk. : alk. paper)

1. Animated films – Exhibitions. 2. Comic books, strips, etc. – Exhibitions. 3. Electronic games – Exhibitions. I. Grenville, Bruce. II. Johnson, Tim, ca. 1962- III. Wright, Will (William Ralph), 1960- IV. Vancouver Art Gallery.

NC1765.K73 2008
741.5074'71133 – dc22 2008010505

Cover image by Daniel Clowes

Editing by Bruce Grenville and Scott Steedman

Copyediting by Derek Fairbridge

Cover and text design by Timmings & Debay Design

Image preparation by Trevor Mills and Una Knox, Vancouver Art Gallery

Printed and bound in Canada by Friesens on acid-free paper

Douglas & McIntyre gratefully acknowledges the financial support of the Canada Council for the Arts, the British Columbia Arts Council, the Province of British Columbia through the Book Publishing Tax Credit, and the Government of Canada through the Book Publishing Industry Development Program (BPIDP) for its publishing activities.

University of California Press, one of the most distinguished university presses in the United States, enriches lives around the world by advancing scholarship in the humanities, social sciences, and natural sciences. Its activities are supported by the UC Press Foundation and by philanthropic contributions from individuals and institutions. For more information, visit www.ucpress.edu.

The Vancouver Art Gallery gratefully acknowledges the financial support of the City of Vancouver; the Province of British Columbia through the B.C. Arts Council and Gaming Revenues; the Canada Council for the Arts; the Government of Canada through the Department of Canadian Heritage.

Presenting Sponsor:
American Express Foundation

Major Sponsor:

Supporting Sponsor:

Additional Project Support: